stepping through the ashes

September 11, 2001 Two hijacked airliners crash into the

twin towers of the World Trade Center in New York City. A third hijacked plane slams into the Pentagon,

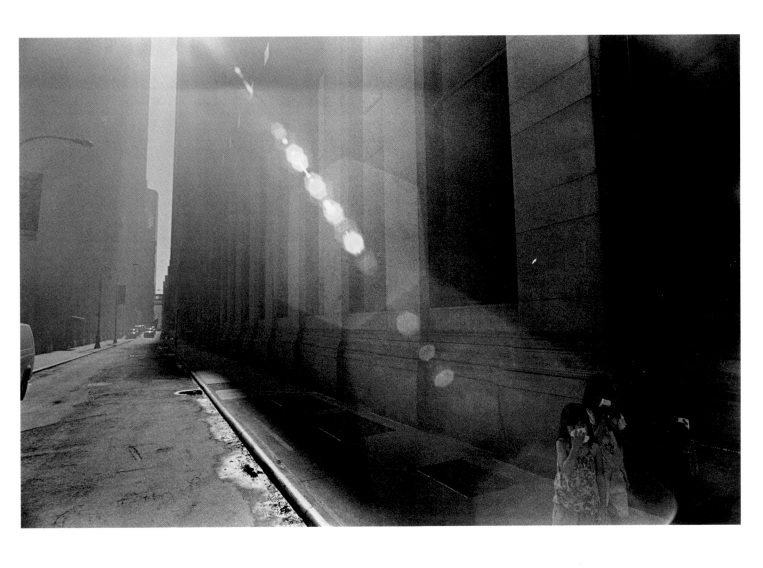

a fourth into a field in rural Pennsylvania.

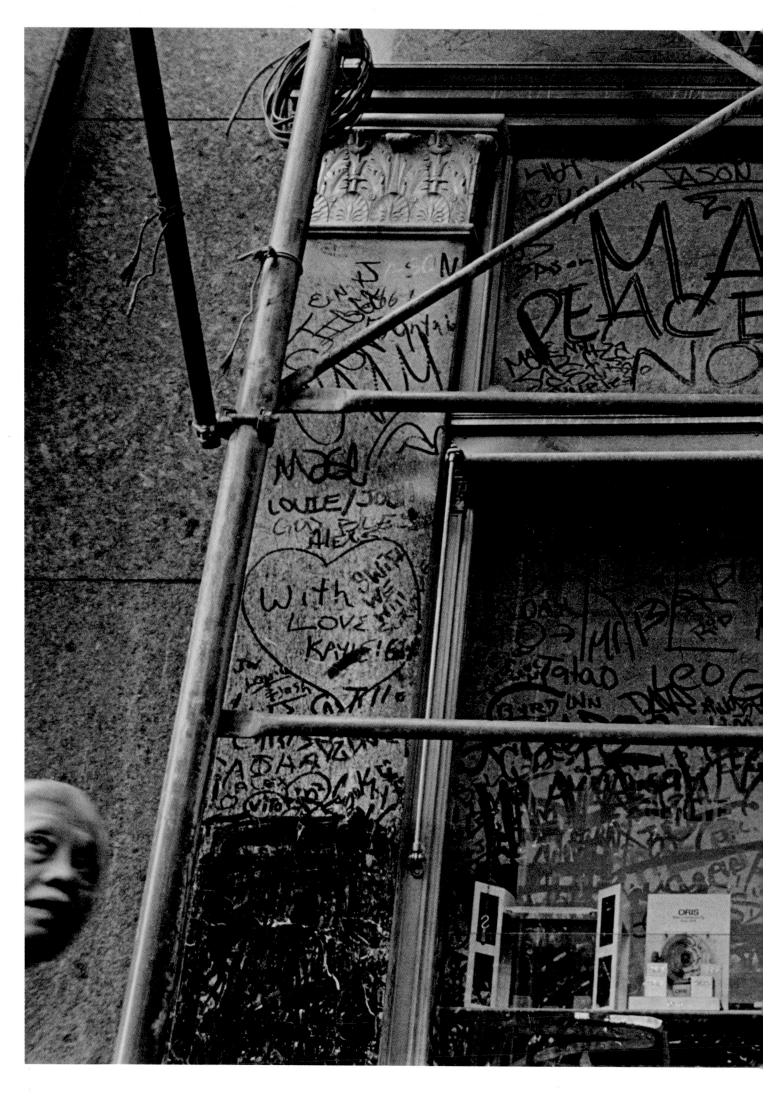

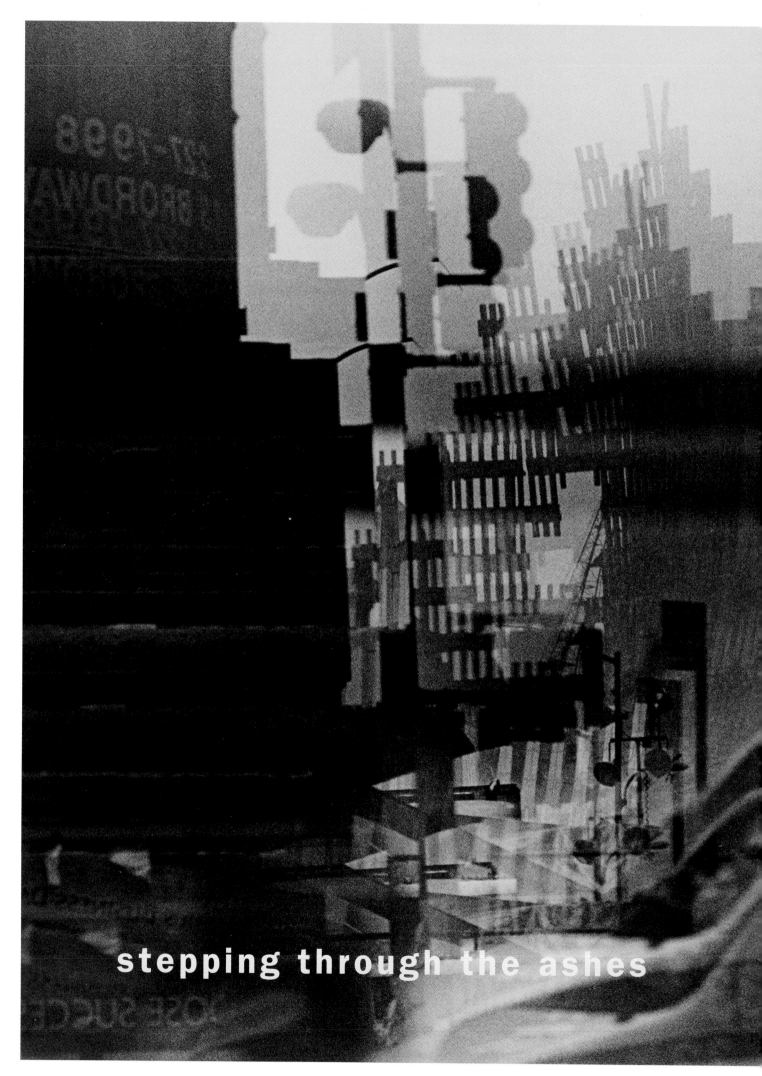

stepping through the ashes

Eugene Richards Janine Altongy

Aperture

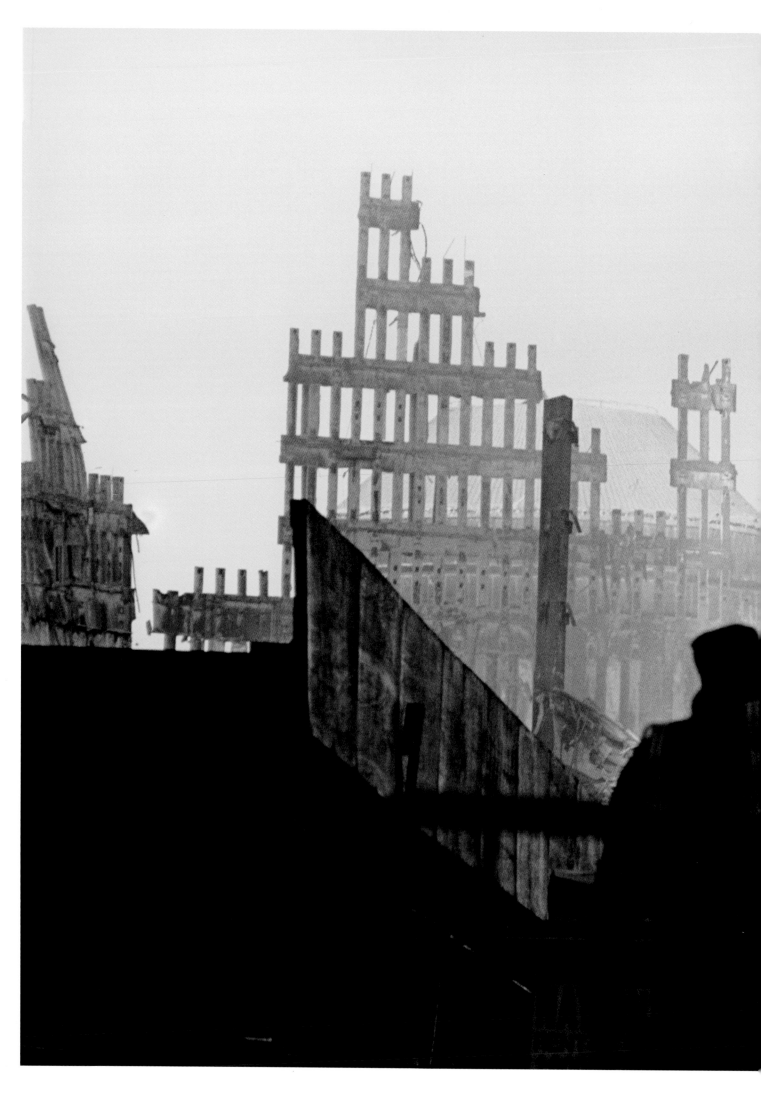

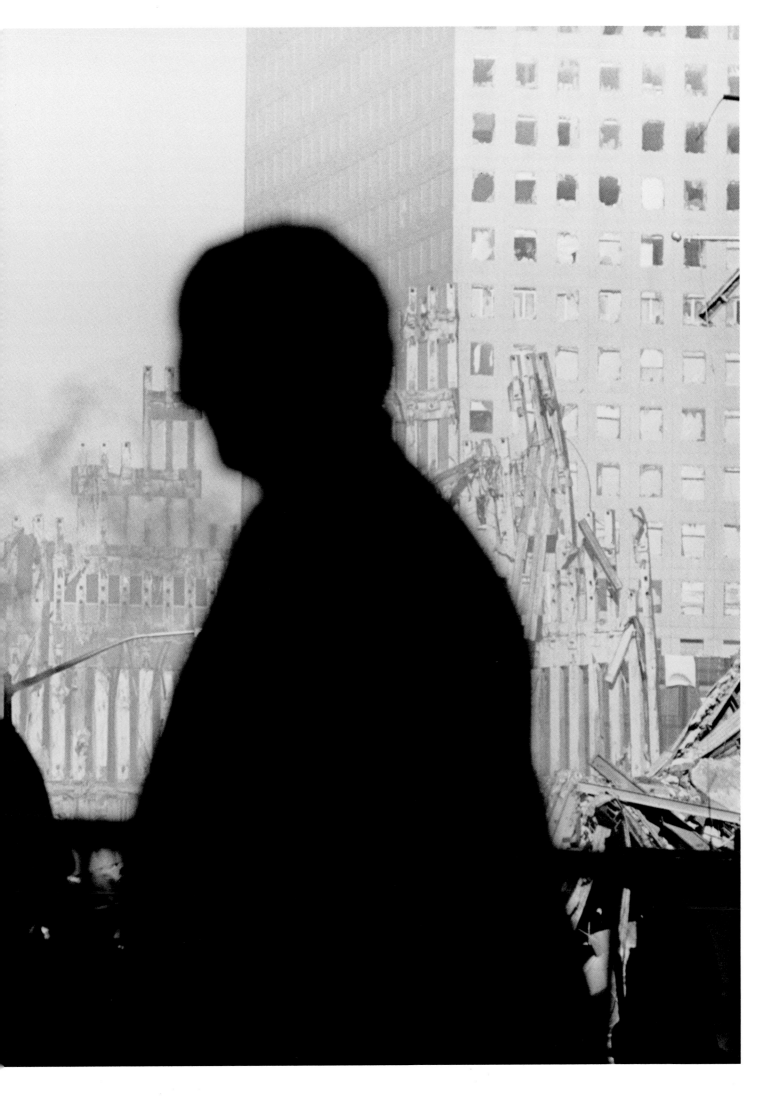

KAREN DOWNES SILBERMAN: Thunder. It was thunder coming towards us. It all happened within about three seconds. A big crash, a burst of fire, things flying all over the place. Chairs. I was on the 99th floor, near the window. I believe I saw a body, because we were so close to the North Tower. The force of the plane hitting it threw me down. A man who worked in the office picked me up. I said, "Please come with me. I'm afraid. I don't want to go through this alone. I want a man with me." He picked me up and said, "You'll be okay. Go. I love you." He grabbed me and kind of pushed me out.

MARIAN FONTANA: I dropped the phone and that's when the second tower came down. I just knew. Everybody was . . . I had my friend here, and she said, "I'm sure he's fine," and I said, "No, he's not." I started to get hysterical. They all were like, "Marian, you don't know. He probably didn't even get there yet." But I just knew.

DAVID PAGAN: There were people up in the windows and on the roof, screaming. You couldn't make out what they were saying. And there were three helicopters flying around. After I'd seen the people that jumped—I counted forty-three bodies—I couldn't watch anymore. When I heard the bodies hit, I knew without looking that it was bodies.

KAREN DOWNES SILBERMAN: Don't ask me why I picked that stairwell; it might have been the closest one. And everybody talked on the way down. "Are you okay up there, Karen?" "I'm okay, what about you?" "I can't breathe." "Okay, deep breaths." "I can't breathe." I said, "Deep breaths." They told us everything was secure. "Go back to your offices."

Some people were going back to their offices. One man, I said to him, "Don't go." I didn't start panicking yet, kept going down the stairs. We just kept walking. Walking. And then we felt a tremor; it rocked the building. You had to hold on, like on a rollercoaster. I guess that's when the second plane hit. And the creaking. The building, like RRRRRRRR. The heat was everywhere. Above me I heard people screaming. I heard people falling. "Lord help me."

MARIAN FONTANA: Wives from the firehouse started to call, saying they thought they saw him on TV, and then I started to doubt my own inner instincts. Friends started to come into the house. We were all on our cell phones and telephones, and people trying to call hospitals and get any information at all. And that started that whole day from hell, where we were just pacing. I wanted to go down there. I called my friends in Tribeca to see if they could get as close as possible, even though nobody's cell phone was working. . . .

I just knew. I don't know why I knew. I just knew Dave was in there and that he was pretty high up and—just because I know him—I know if he thought people were in there and were burning, he would have run in.

DAVID PAGAN: I kept walking around the roof. I kept looking at City Hall, but as I was looking around, that's when the first building dropped. It kept dropping, dropping, dropping, dropping. The other building was still up. It kept dropping and dropping. It disappeared, completely disappeared. It was dark, pitch-black, and all you could see was flames. The smoke—it looked like clouds. All the smoke coming in between the buildings; when it hit a wall, it would rise up. And the people were running and screaming; the sound echoed

between the buildings. And we heard car alarms and explosions and then. . . . Why did God leave me here to witness this?

Me and the other guys started working at seven AM, and around eight, we had gone downstairs to take debris from the roof, from the demolition work that we did. When the first building was hit, I was out on the street, but when the second plane hit, I was back up on the roof. I felt it on my face—a mist, like a fog. It was jet fuel from the plane. I wanted to get down, to go outside and run across the street. I ran into the hallway and pressed the button for the elevator, but the elevator wouldn't come up. And then I didn't want to leave. I kept feeling that something was telling me, "Dave, stay here. Don't go."

We didn't think the buildings would fall. I was thinking there was a sprinkler system. And when the first plane hit, it wasn't that bad. The sprinkler system should have been able to handle that. A lot of people should have gotten away. There were so many people. . . . That's another thing. Those helicopters. They could—isn't it possible?—couldn't they drop a rope? Why didn't they? I don't understand . . . why didn't they?

FF CHRISTOPHER GUNN: I was at my second job; I used to work part time at Sears. The first person who came in said, "There's a fire at the Trade Center." And I know that my fire company is right over the bridge. Anything at the Trade Center, we go. Right away. Just as I got to the phone, someone else had walked in and said, "A plane hit the Trade Center." I said, "Oh, man." I'm hoping it's a little Cessna; you know, no damage.

I took the phone right away and called the firehouse. I got Shawn Powell on the phone. I said, "What's going on? Are you going?" He said, "The truck's already on their way; we're leaving right now." The truck got dispatched on the first alarm, I guess, and the engine got dispatched on the second. I told him to be careful. And that was it.

I pulled up at the firehouse, was rushing into the Trade Center like everybody else. I guess I walked past Paul Mitchell's van, but never noticed it. You know, tunnel vision; get in, get your gear, get going.

JOHN CARTIER: When Tower One had gotten hit, my brother James called me. . . . And I know what he was thinking. My sister, Michelle, worked for Lehman Brothers; she was on the forty-something floor. At that point, we didn't know what floor she worked on. So he calls me and says Michelle's building had just been hit by a plane. The phone call was very brief. He was mobilizing me to join with him to get to her. I got my helmet, and you know, rode like . . . I didn't do nothing less than ninety going up side streets to get there.

En route, he called me again; this second phone call went to my voicemail. It went, "John, Michelle's cell phone number is 1-516—Whoa! What the hell was that?" So that had to be the exact moment of impact in his building, Tower Two. I had gotten about a block and a half away from the Trade Center; you couldn't go any further. There were ATF guys, FBI, you know, police, regular police, firemen, EMS—everybody was there. And I ran up alongside St. Paul's Church, the one that faces the Trade Center. I couldn't stay in one spot, because the police came and pushed you along. I was zigzagging and zigzagging. At the same time, another one of my sisters was trying to get in touch with James. She spoke to him for a few minutes and then the connection got cut off. Then she spoke to him again and asked him, "Where are you?" He said, "I'm on the 105th floor; we're stuck." She said, "Are you okay?" He said, "I'm okay." She asked him, "Are you alone?" He said, "No, I'm not alone." He said, "Tell everybody I said hello; tell Mommy and Daddy that I love them." Then he said, "I've got to go; we're going to try to move now."

Me and Michelle did find each other in the midst of all that. We were standing at St. Paul's Church, waiting for James to come out, just waiting for him to come out the same way she did. And then instead of him coming out, you know, the world crashed around us. . . .

KAREN DOWNES SILBERMAN: We kept going down. I just said, "God, please help me live." Finally we were very close to the end, and as we were going out, I felt like we were in a morgue. There were bodies out there. There was rubble out there. You could see people buried underneath

that. We got outside and the two girls I was with immediately got on cell phones. For some reason, I said to them, "Get off your damn phones. We've got to go." I did look back once, and I saw the buildings on fire, but we really didn't talk, just kept walking.

PAUL KRIEG: Everyone was on the phones calling loved ones and such. I sat down, caught my breath, and then walked down onto the trading floor, looking up amongst all the monitors. There were TVs with C-SPAN on, so I started watching. At that point just a huge sound, VOOOMMM, then the whole AMEX building shook violently; the cable lost its reception for about three seconds. The whole Exchange just went, "Holy Shit!" and people were screaming, and you could hear feet running. Someone came over the loudspeaker, saying, "Look, as of now we are going to have a delayed opening by an hour. Once again, we believe that it's safer to stay inside than to go out. But of course, you have to make your own decisions on this, and we'll report back to you."

There was a girl, Krista, that I worked with from Brooklyn. We were the most junior traders amongst our firm, so it was very important to us, until we got the word that the Exchange was not open, that we stick around. Because we're like the mailmen, we're always there so you can get in and out of your trading position. Well, she had already kind of started going into shock and all she could say was, "Paul, I've got a Metrocard, I've got a Metrocard, Paul; we can take my card and we can ride the subway home." By this time, we learned that the Pentagon had been hit and that the other flight had crashed in Pennsylvania. There was a total of eight planes that were reported to have been hijacked, so in our minds there were four more planes still out there. Everybody started teaming up. All the folks from Staten Island would travel together, all the people uptown and so forth. Before we left, they were still coming over the loudspeaker, saying, "The American Stock Exchange is closed. We still believe that it is safer to stay inside than out, but it is up to you. We are in no way saying that you need to stay here. It is your choice. God be with you."

NORMA MARGIOTTA: That morning, my husband Chuck wasn't supposed to be working. He had just finished an overtime in Brooklyn. He had relieved another person—they always help each other out that way. For some reason, I called home to find out if he had picked up the children from school. That's when I found out that Chuck . . . he was coming home and I guess he heard everything that was going on. He made it to Rescue 5; Rescue 5 is the closest to the Verrazano Bridge. So he jumped on with that company, jumped on the rig and went out to help.

So my father-in-law picked up the kids. I came home as soon as possible, and I turned on the TV, and . . . I kept on beeping him. Whenever I'd beep him, he'd always answer the beep.

FF CHRISTOPHER GUNN: Paul Mitchell's wife had been calling all night, trying to get information, and nobody had the answers. The guys told me, "Maureen's been calling all night. What should we tell her?". . . But even then, we believed there's no way he's gone. Paul—we called him "Big Daddy"—he kind of ran our firehouse for years. There's always one person in every firehouse who's arms and legs above everybody else; you always look up to them. He was that person. So we were thinking he's alive, trapped somewhere.

We didn't know who was alive and who was dead, and we didn't know who was there and who wasn't. Paul Mitchell was off-duty. He wasn't working, so nobody knew where he was. We had no record of it. So Maureen was doing her own footwork, calling around: "Has anybody seen him?" By about midnight, I knew something was wrong. Because I was there at the site, and I managed to call my wife. Like most men, though, I don't call home ever. I'm just bad with that. But that day I managed to get in a phone call, actually twice. It was hard to get through, because the lines were down and cell phones weren't working. But whenever somebody got through—if one guy got through to his wife, we'd tell her to contact all the wives. We'd give *her* a list of who was there and who was okay because we all have each other's home phone numbers. So when I found out that Maureen hadn't received a call. . . .

LT. WILLIAM RYAN: After we put the fire out on that guy—the chauffeur from 65 who was trapped in his rig—I'm walking down what I think is Liberty Street and going to head up into where I think the South Tower is. I see this figure coming at me through the dusk, and I can barely make him out. It ended up being Little Frusci, Greg Frusci. I knew his father, a lieutenant, so I knew who he was. He's a young kid. I figured he had six months on the job.

So I'm like, "Yo, Fooch, what's up?" He's in a daze. He goes, "Bill, they're all dead." I said, "Who's all dead?" "The guys from 5." I'm like, "Where are they?" Because at this point we're trying to put pieces together. "They're in the tower." I go, "Yeah, but why aren't you with them?" He goes, "Warchola wouldn't let me go." So I'm thinking this guy was confused. I gave him one of the bottles of water out of my backpack and we sat for a little while. He was telling me that he went to get on the truck, and Warchola told him, "Don't get on the truck; I don't want you coming." This is around nine o'clock; they were one of the first companies there. So he ran and got on the fire truck on the other side where the lieutenant wouldn't see him. When they got to the buildings, Warchola turned around and said, "You little fuckin' prick. If I find you in this building I'm gonna fuckin' kill you!" This is Mike Warchola, a senior lieutenant, twenty-seven years on the job.

So the kid runs around from the North Tower, and figures he'll go down to 10 and 10, that firehouse on Liberty Street, to see if maybe he could do something over there. And he's standing in front of 10 and 10 when the South Tower collapses. He gets blown through the firehouse and comes out the back door. He gets up, starts walking his way through the pile, figures he's got to find his company . . . he's one of the guys who kept saying, "Oh, I've got to find my company." Then he gets knocked back again when the North Tower falls. He survived both collapses. And he's covered with dust, pure white. He could hardly talk, his mouth. . . . I'm like, "Fooch, you're a lucky guy." At this point, he doesn't know what happened. He doesn't know, like I don't know. We just knew there was a lot of dust and shit was going on.

NORMA MARGIOTTA: For a while, they kept on saying that he was at the hospital. We did a lot of running around from hospital to hospital. We never stopped, never stopped. Never gave up hope. They assigned a firefighter, Tom DelPino, to the family. We would go throughout the city and bring Chuck's pictures, just to see if somebody had seen him. When you'd get to the hospitals, all you'd see is the fire department. Their uniforms were all over the floor, their helmets, their boots. I asked them—the nurses, whoever was in charge, I don't even remember—if I could just touch one of the helmets, if they would allow me to. You'd just want to touch it and get a feeling of it. I was just looking, looking for his boots. Or his torn overcoat.

The kids were waiting for their father. They were waiting for him to come home, just hoping that he was at the hospital, the way everyone said. That he was critically ill, burned. The kids were saying, "It doesn't matter how burned he is; he's alive, Ma."

OFFICER MITCHELL COTO: A fireman approached me, and this guy, apparently he had just run out of his firehouse, because he only had on his helmet, black shoes, white socks, blue shorts, and a blue T-shirt. We talked maybe two seconds. He told me that he was a Navy SEAL, how he'd never seen anything like this, how the government had failed us by not warning that something could possibly happen this way. And the next thing out of his mouth was, "Run," and he took off running. You could actually hear a moan, a huge moan coming out of the building. It was bending, the top of the building was . . . the metal . . . the structure was starting to bend. Then the whole thing started coming down.

Everything turned pitch black. I made a left turn, but there was nowhere to run. There was a fire truck behind me. When I turned to look, as I'm trying to get myself under the fire truck, I saw the fireman disappear into the debris.

ARJAN MIRPURI: Our son Rajesh, he was not married yet. Whenever we talk about him getting married and going to stay separate, he say no, he cannot do that. He wants to live with us, with parents.

Actually, three weeks he was not in town. Tuesday was the first day after three weeks he went for work. And he went to World Trade Center. He must have been there maybe fifteen minutes before this happened. So he was not even here for three weeks and then suddenly on his first day. . . . So this was his destiny.

We didn't speak with him. No, I wish. That's what we are just thinking all the time, how he was feeling. We kept on calling him on the cell; nothing was going through. We didn't know that he was in World Trade Center. . . . All these fire and police people, especially, went to rescue the people inside and going up on the floors. Their intention was they were going to bring them out. Nobody realized that buildings were coming down. They went down just like paper.

PAUL KRIEG: There were after-sounds, where the building was falling further, which was scaring people, and they would scream. Slowly, people that we knew from the Exchange started coming inside the lobby. One broker, he actually was sort of, like myself, not scared. If anything, he was almost excited to go out and push through this, and survive. One person gave Krista his socks. I offered my shoes, but at that point she had already sunk deep into shock. She kept mentioning that she couldn't feel anything, that she was completely numb.

The dust outside was kind of a rich brown, more of a khaki color. It was already an inch to two inches thick on the ground, like fresh snowfall. There were areas where people hadn't walked yet. As we were walking, we saw two police cars. It seemed like all they had on were their lights until they were about twenty feet away from us, when we could hear the siren, and then almost instantly, the sound was gone as soon as they passed us. People were emerging from out of cracks and from underneath trucks. It was odd, like something you would see in a movie. Everyone started walking, and we kept going south and east and south and east.

OFFICER MITCHELL COTO: I pulled myself out from underneath the fire truck, because I thought that I was going to get burned alive, and I ran around the side of the truck; that's when the debris really started coming down hard. I felt something warm on the side of my face; later I realized I had cut my ear open. By that time, it was just pitch-black. You were inhaling debris, smoke . . . between the vomiting, the debris in your eyes, everything, you couldn't see. . . . It was actually like death. I thought that this was the end. And then I tried to give it a last shot, to try to make it out. So I took a running start with my head down. I took maybe three or four steps when I went headfirst into another fire truck that was parked there. I bounced off of it, got up, put my head down on the truck and just gave up. I just said, "This is it; it's going to consume us all." I started thinking of my mother—that she just lost two kids, two of her sons, two out of three. Within a second I must have had like ten thousand different thoughts.

A little more of the building started coming down, and that's when something hit me in the back. I tried to climb around the side of the truck; when I did, I made it inside the cab. That's when the rest of the building came down. It was dead silent. The lights were on in the truck, but you couldn't see anything because of the black smoke.

Every time I inhaled, I'd vomit right back out. I tried to open the cab door, but it wouldn't open. I saw nothing, but you could hear the firemen's little personal alarms. And people were screaming on the radio. Hearing the people scream and crying, the screaming, the panic. . . . Some lady jumped into a fire truck and got on the radio and was screaming, "I'm trapped, I'm suffocating, I'm dying. Please, somebody help me!" The fire dispatchers were trying to calm her down, but she never came back over the radio.

The Maydays were coming over like crazy. And personal alarms were going off. I would hear the mike key up, and they were transmitting, and I'd hear the beeper alarm going off— you wouldn't hear any voice. And the dispatcher was trying to say, "Where are the Maydays? Where are the Maydays?" "Mayday on the top tower." "Where are you in the top tower?" "I don't know." And the "I don't know" part is what made it hard, because if you know you're on the corner of Vesey, all right, we know we've got to go to Vesey. But these guys didn't know where they were.

Two or three minutes go by. I look through the rearview mirror and now I can see the blue sky. I used my feet and pushed my back up against the mid-console, and got the door open. As I'm walking, the papers are coming down. They're still on fire.

Lt. William Ryan: I didn't know the Pentagon was hit until I called my wife at four-thirty or five that afternoon, whenever it is we moved back for Building 7 to collapse. It took an hour and a half to get everybody back, out of that pile, and that was with all that screaming going on. Not everybody had ham radios like they usually have. So in order to get the message to someone, say, three hundred, four hundred yards away, it was all done by shouting, or by somebody physically walking over there. And a lot of the guys didn't want to leave. They knew their brothers were in the pile; they were desperate to get to them.

I went back into the pile and stayed till about one o'clock in the morning. As I was walking to the ferry . . . I was looking at every car I passed to see if there were keys in it. I'm like, "Son of a bitch, should I hotwire one of these cars? Nah." There were a couple of other firemen on the ferry; we just sat near each other. We were trying to put together the pieces of the day. Not much was said, really. We talked about how tired we were, how we just wanted to go home and take a shower. Then when I got on the Staten Island Rapid Transit . . . I cried the whole way home. I didn't know how many guys were in there, but I just knew. No one was alive. There was no way. When I got home, I told my wife. I said, "Whoever they haven't found, they're already dead." She's like, "How do you know?" I'm like, "I know."

The guys on the boat, basically what we said was, "No one's walking out of there." Because there was just so much carnage, so many fires. When you'd go past some holes, where there was space in the I-beams where you'd try to go down, the heat . . . it would drive you back. You couldn't even walk within ten, fifteen, twenty feet of the shit. It was just so hot! I'm like, "If anyone's in there, there ain't no way they're breathing." There were no computer terminals, no desks, no doors. There were no doorknobs—nothing. Two hundred stories of office building, and what's left? Nothing, just dust. If concrete and steel can't make it, what's the human body going to do? Nothing. Nothing at all.

Steve Spavone: There were people's arms, all those arms sticking out of windows, waving to a rescue helicopter. While Dave Pagan and I stood here on this roof, we watched forty-three people jump from the North Tower. What struck me the most was these two people jumping hand in hand, a man and woman. I said a prayer for them. . . . I don't go to church much. I'm a Roman Catholic, but I was devastated so bad by that. As a Roman Catholic, I don't believe in suicide, I can't justify it, but I just hope that that was taken into consideration, that there was some exception taken in this case. . . . I don't think I could have jumped. I would have had to have somebody push me.

Suzanne Ryan: Billy didn't get home until after midnight, covered in soot. He just sat on the front porch. He had a look that he had for about a month afterwards—that blank stare. Just kept saying, "They're all dead, they're all dead."

All day I had been trying not to get emotional, because I didn't want my kids flipping out. And my sister was on a plane that morning; at that point we didn't even know where she was. Billy's mother didn't handle it well at all; she was kind of flipping out. And Billy's brother . . . Kevin was also doing bad. Between all the millions of phone calls I got—"Is Billy all right? Is Billy all right?"—the priest from St. Rita's called. When they finally had mass—oh, he fell apart; the priest was crying up on the altar. That broke my heart, because *he* felt guilty. Because here he was, he's supposed to be the support for everybody, and he lost it. At that point, we knew Charlie Margiotta was missing. I said, "Billy, have you heard anything about Charlie?" And he goes, "If he was there, I would have known." Because you probably would have known. Charlie was very flamboyant. You could see him from miles away. He had a different walk than everybody else, and he had a loud voice. He was big. The priest knew Charlie, because Charlie was very involved in the church, so he just lost it. And that broke my heart. When Billy came home that night, I said, "Oh, Father Austin called to see if you were all right."

So Billy called him and gave the priest a pep talk on the phone! I'm sitting there looking at him. Billy almost died—all his friends. And he's telling Father Austin, "Just hang in there."

CHRISTOPHER JOHNS: I had just graduated from embalming school in August, then passed the National Board, so I became a funeral director on the day of the catastrophe. But at the time I was also the Director of Security and Special Operations for the Staten Island Borough President. A little before nine, my beeper went off. When I called in, they said a plane, a small Cessna hit the World Trade Center. Then the Office of Emergency Management beeped me. As I was talking to them, I heard this huge crash. It was the second plane that hit. Now I'm being called into work, but I couldn't go, because I was handling a funeral. We stood on the side of the church and watched the World Trade Center fall.

As soon as I could, I went to work. The first thing we decided was to set up a triage down at the new Yankee Stadium here on Staten Island, right across the street from Borough Hall, next to the ferry. The visiting nurses went down, the Red Cross was down, Staten Island Hospital was down there—everybody was down there. Except nobody was coming over.

Then we're told, "Look, it doesn't look like there are going to be a lot of survivors." So now we decide to get ready for bodies. So the Deputy Borough President made a call to Harlan Hook, a container port that has refrigerated trucks, to bring them down to the stadium when the bodies come over. We commandeered a couple of skating rinks for a temporary morgue. But the bodies weren't coming over. I didn't understand it, so I spoke to the Chief Medical Examiner, who said, "I don't think you're going to get anything out of those buildings."

DAVID PAGAN: There's a restaurant down in the lobby of our building. We broke the door open. I cut cold cuts, I brought food for the firemen and water. I laugh about it now, but the cash register—I broke it open. Not to rob them, but to give the firemen quarters to call their families. There was so much chaos, they didn't know how to hang up the IVs. I ran to the basement and brought up an electrical extension cord and tied them up. Everyone was professional, but I guess because of what happened, they couldn't think. Then they told us to take all the tables out, to set up a morgue for the bodies. We did that. They brought bags of ice. Then they started bringing bodies and body parts and that's when I said I've got to get out of here.

When I got home that night, about twelve o'clock, the only channel on TV was Channel 2, CBS. And when they started showing everything I'd seen, it happened all over again. I couldn't hear. I could see the TV, but I couldn't hear what the newscaster was saying. He was speaking, and I kept seeing the buildings, the planes. Then I started crying.

OFFICER MITCHELL COTO: Duane. I found out what his name was later. Duane was vomiting like crazy. But, like I told him, "If we're going to live, we have to get out of here now." So we got another two or three blocks when we ran into a New Jersey Fire Department, and they hosed us down, started getting the debris off of us. When I looked at Duane's back, he must have had a one-foot gash where you could see his spine. But it wasn't actually on the spine, it was sideways, like a gash. I told him that he had a pretty big cut, and he goes, "You know what? I don't feel that right now. Thanks for not leaving me back there."

With that, I turned around. Everything was focused on finding my brother. My mom didn't know where he was. She thought that he was actually working in the building, in one of the towers. So I started heading back down the West Side Highway, but I couldn't get but a few feet because I'd go back, help somebody, take them to the fire truck. . . . There were so many things going on. I was in the back of an ambulance, I was in the middle of the street. So many people were screaming. You didn't know who, what, where, which way to run. At some point I remember jumping on the hood of a car when they thought that the gas line had erupted and that it was going to blow. The driver took me about half a block and then stopped and told me to jump in the car. He was from the Office of Emergency Management. He had been driving a big boss, and he goes, "I think I lost him. And I'm not waiting for him; let's get out of here."

24

It was so chaotic. Nobody really had a plan, because the first command center was destroyed; the Office of Emergency Management was destroyed. The Port Authority Police Department—their office was destroyed. Somewhere along the line, there was a guy in a wheelchair. He was in the middle of the block, saying that he had a pipe bomb and that he was going to blow everything up. So I had to take another street just to get around this moron, who actually didn't have anything on him. He just seized the moment to try to scare people.

PAUL KRIEG: We were about two blocks away from the South Ferry when we heard the North Tower come down. Nobody flinched. Everyone knew what was going on, but we knew that we were far enough away that even if it was tipping over, it wouldn't make it to us. There was no additional sense of urgency; if anything, there was almost a sense of relief.

All this time, Krista had been walking in her socks. I kept asking everyone we were passing if they might have extra shoes with them, and no one did. I even asked a number of bums with their shopping carts, because who knows what kind of crap they have. I remember one lady looking at me like, "You've got to be kidding." I kept asking Krista if she needed to wear my shoes for a while, and she kept saying, "Paul, I just want to get home and see my children; I'm fine, I'm fine." Luckily, there was so much ash, it created padding for her feet.

As we were going underneath the FDR Drive, we were passing all these commercial fishing outfits, and I was thinking, "They've got to have boots." So I started asking everyone, and most people kept saying, "No no no no." Finally we ran across a boss who sent a worker up with a pair of flip-flops. So I took Krista's wet socks off, and dried her feet, and put them into the flip-flops. An occasional ambulance would come by, but besides that, everyone just walked across the Brooklyn Bridge.

People said very little, only to maybe offer water to one another. I recall one old man saying, "Gosh, lucky we made it out," and his friend responding, "I don't go down that easy." But it wasn't until we got to the other side of the bridge that we first met people who were waiting for their loved ones. That's when people were losing their shit, when it was absolutely heart-wrenching. You couldn't pay attention to them; you just had to focus on walking.

I remember arriving home. I hit the buzzer. I thought it was just my girlfriend Alice at home, but it turned out that it was Alice and all of our friends from the neighborhood who didn't go to work. They had all come to be with her, because since nine o'clock she hadn't heard a word from me. People from our building who were actually in the Trade Towers had gotten home hours before I did. She could hardly talk to me at first; she was just crying.

FF CHRISTOPHER GUNN: Chief told us that 207 and 110, both companies in our house, were gone. 110 was on the twenty-first floor of the North Tower when the South Tower went down. The chief told the guys to get out, but they didn't come *running* down. They checked every floor. "Is anybody here?"—making sure everybody was out, not realizing what had happened to the other building. They got down and, like, God! . . . Actually, they stopped underneath the overpass, the walkway. They were sitting there, and then the officer said, "You know what? I really don't like it here. Let's go a little further." Right after that, the walkway came down and crushed everything.

We didn't find out until four o'clock in the afternoon that 110 was alive; it was such a victory. That gave us hope that, well, maybe the other guys just haven't gotten back to their quarters. Maybe they're busy looking for guys, and haven't called in and said, "I'm okay."

KAREN DOWNES SILBERMAN: I took a ferry over to Hoboken, but what I felt was so degrading was, when we got there, they hosed us down. Because they were afraid of toxins, which I didn't know about. "What do you mean, you're hosing me down? Why am I the victim? I didn't do anything wrong. I just want to go home. Please get me home to my house." I was cold and in shock at that point. I just wanted to get home. I said, "Please take me home."

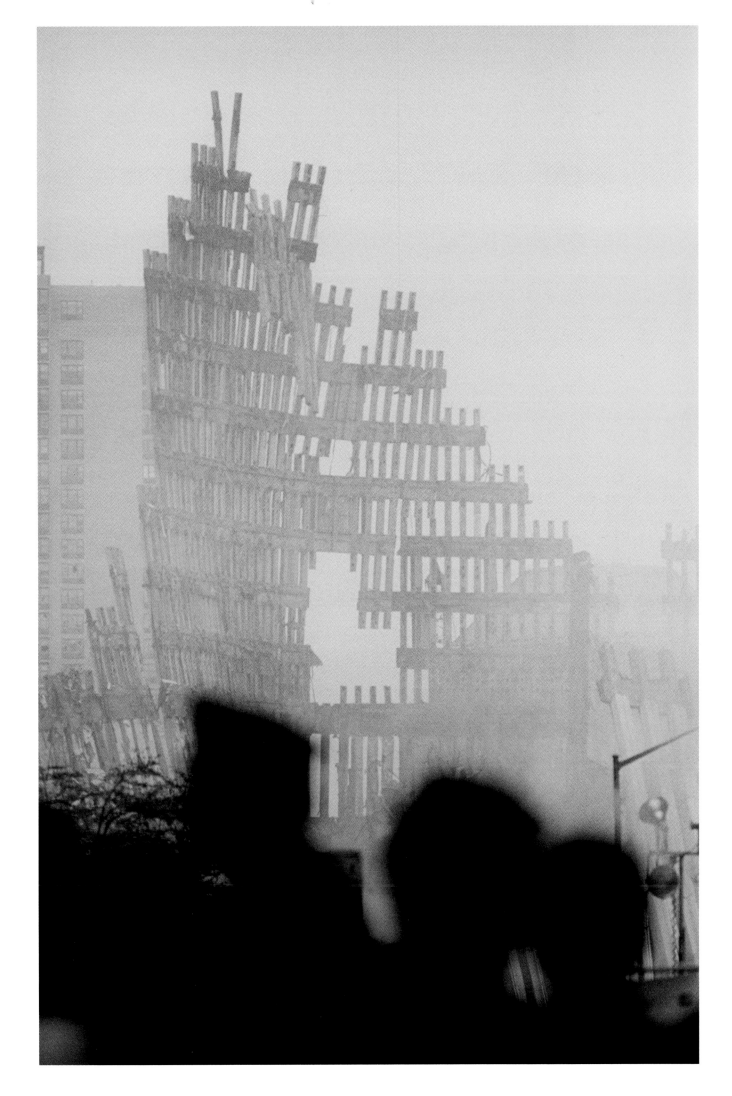

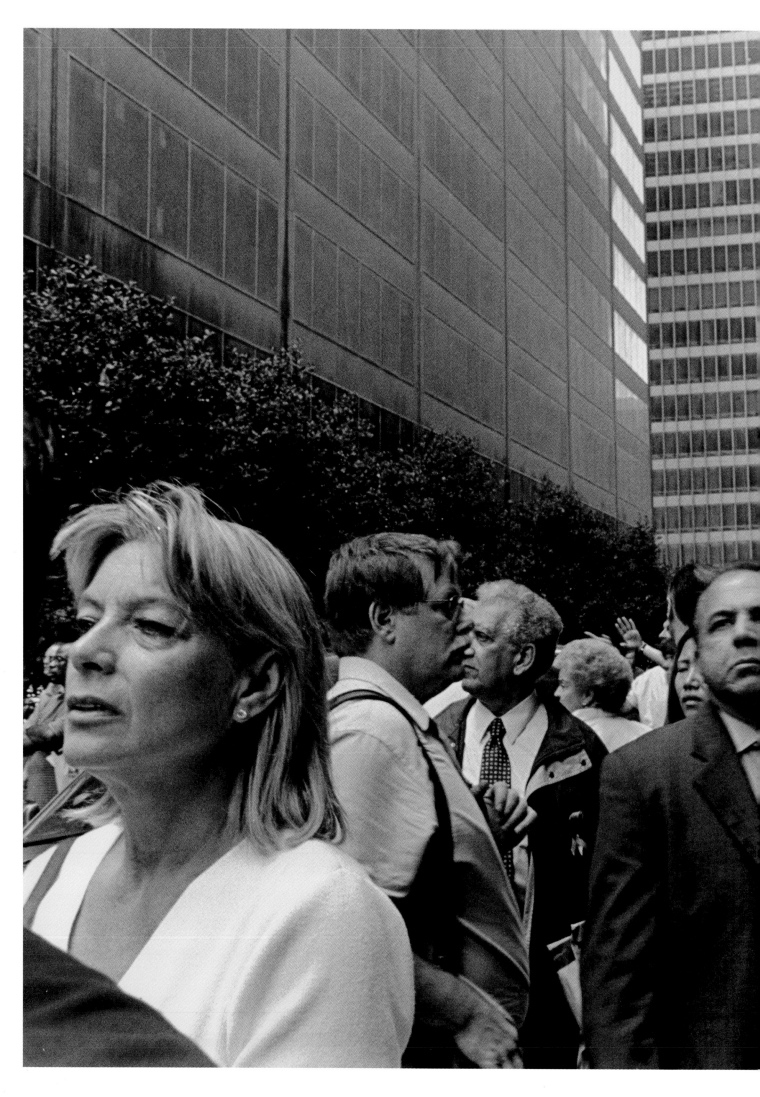

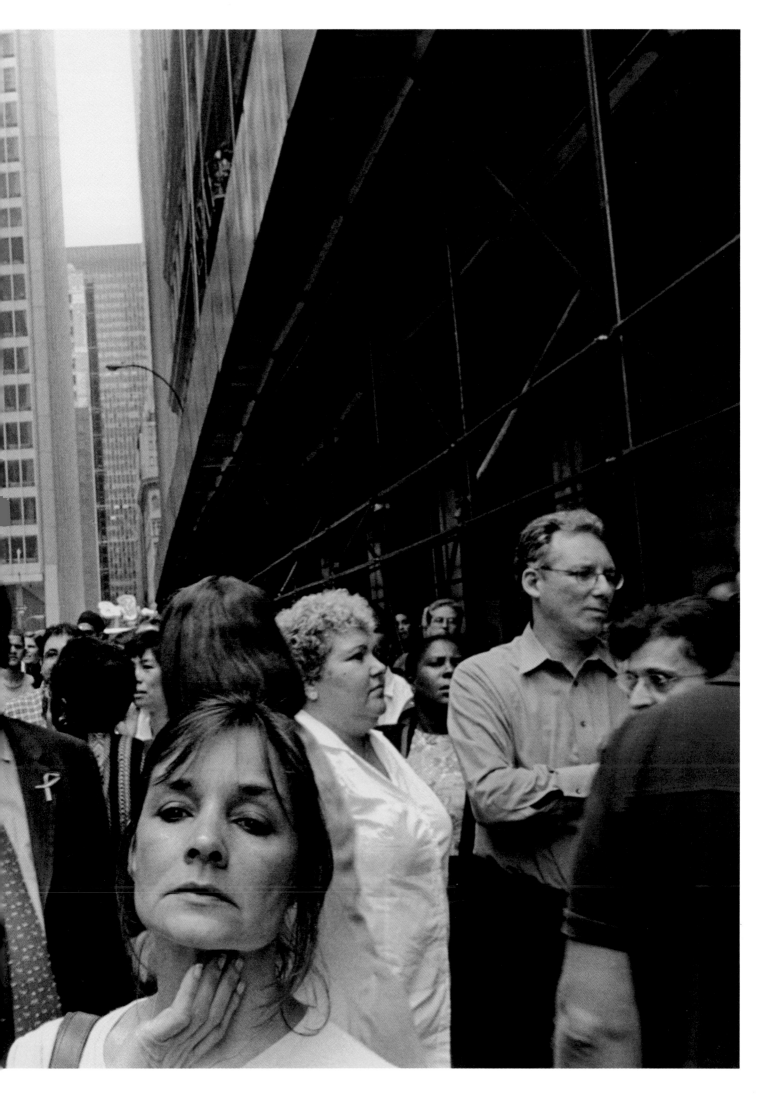

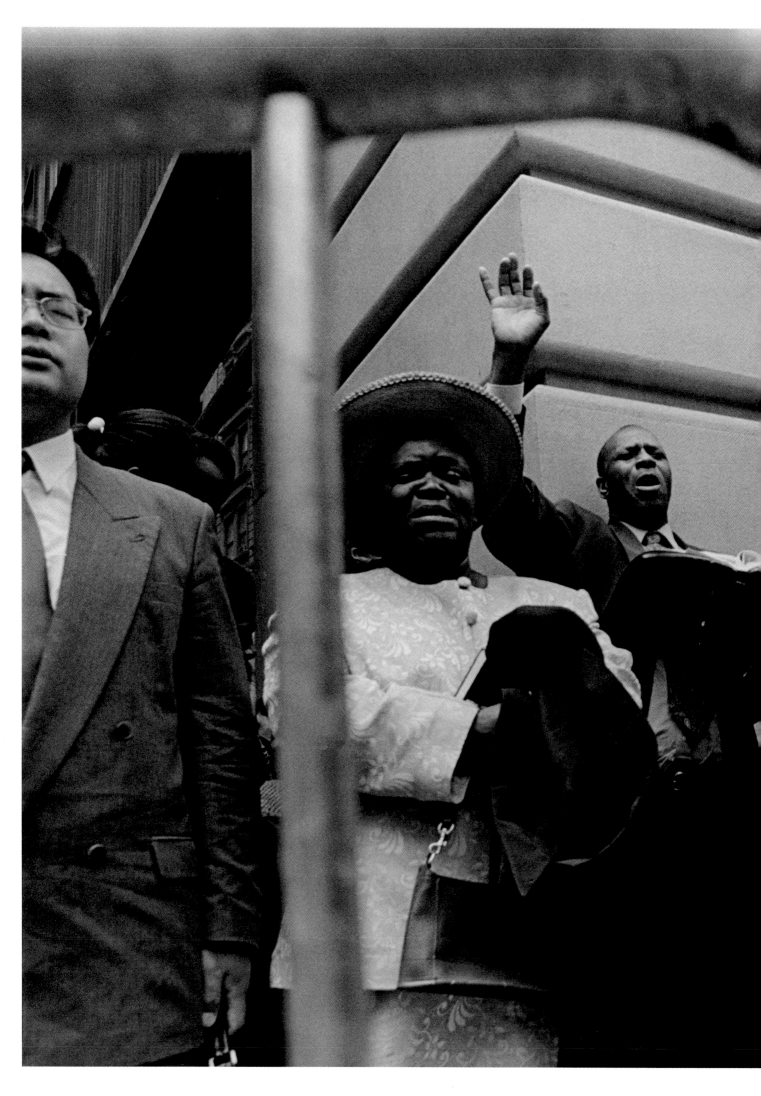

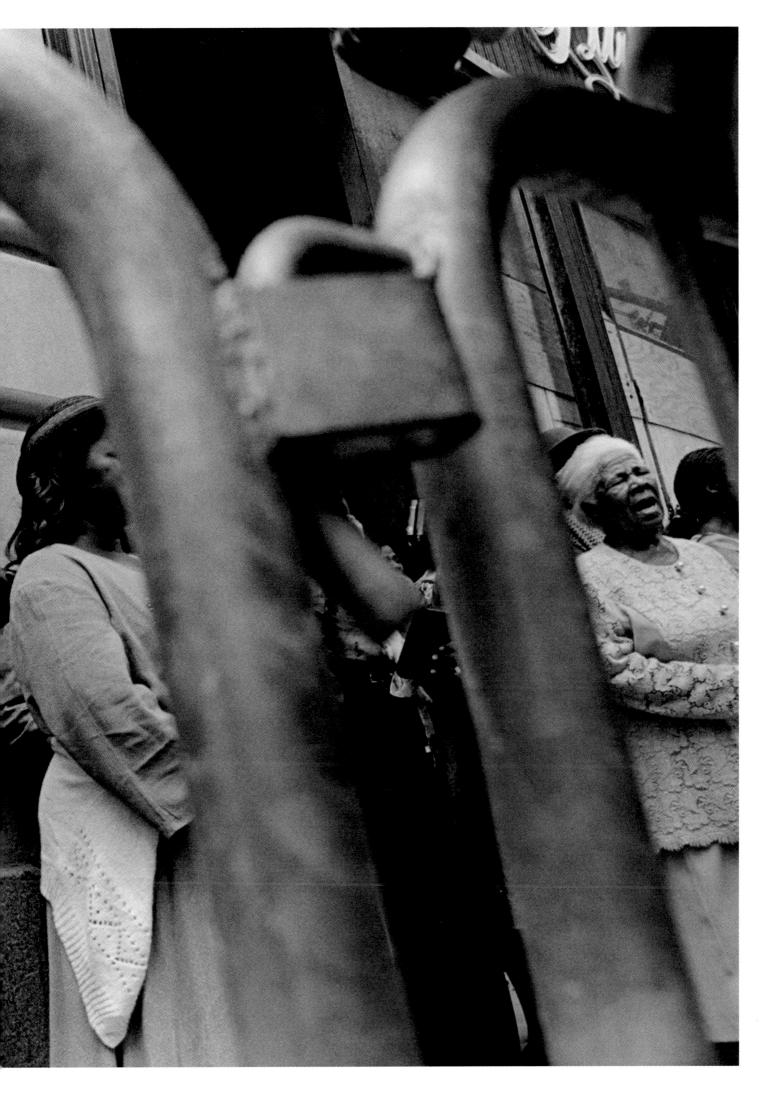

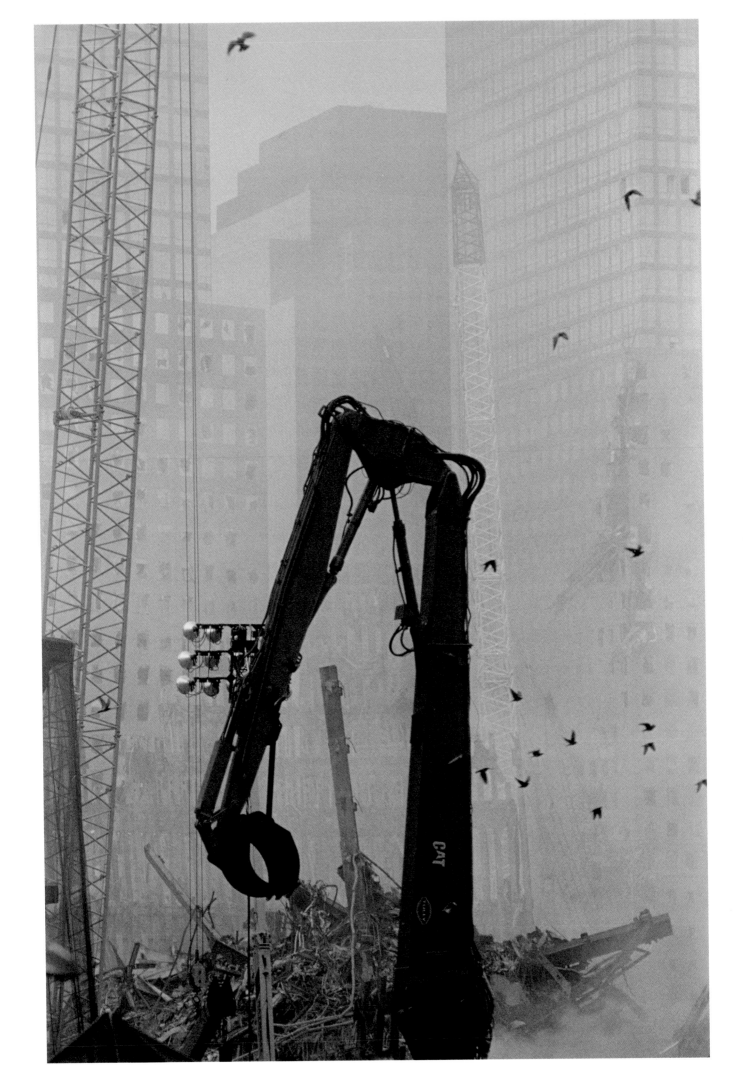

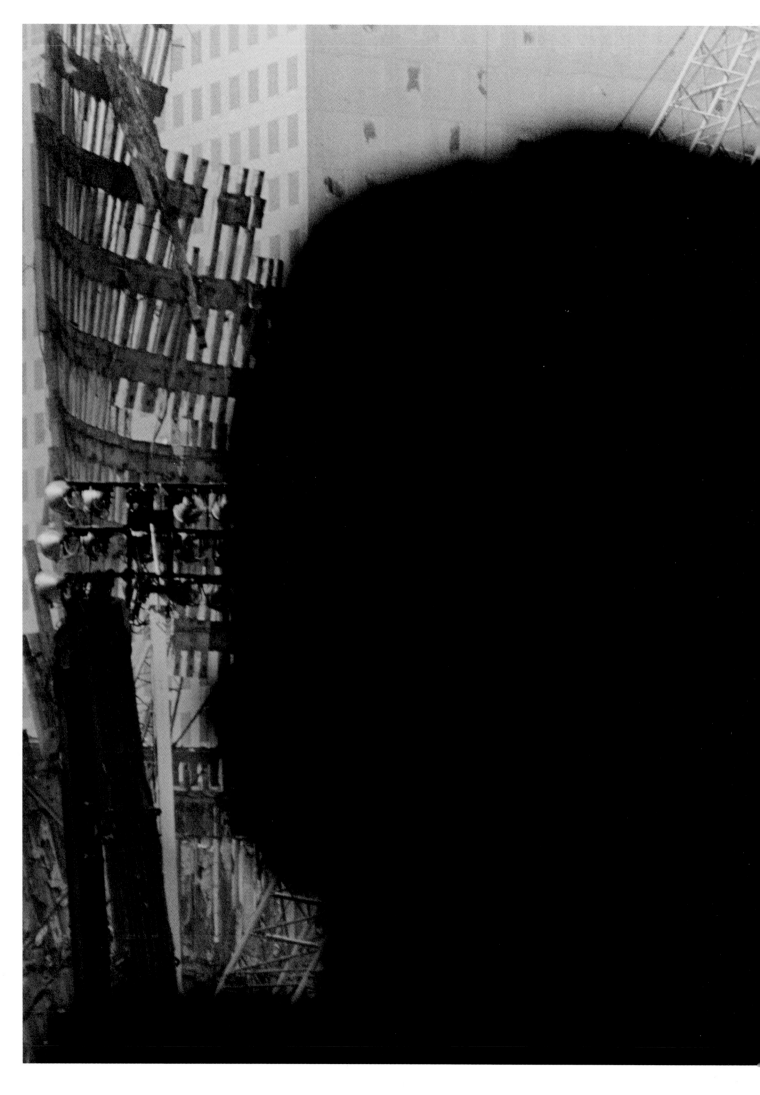

Bridges, tunnels, government buildings, airports close. The White House has been evacuated.

Fighter planes police the skies.

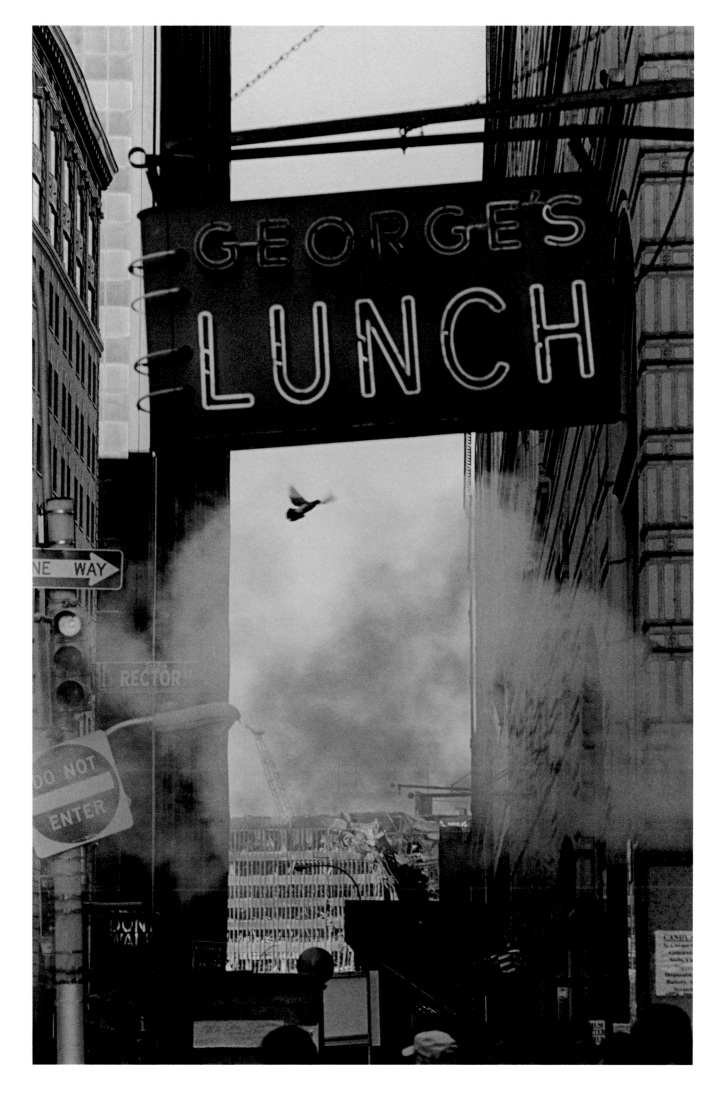

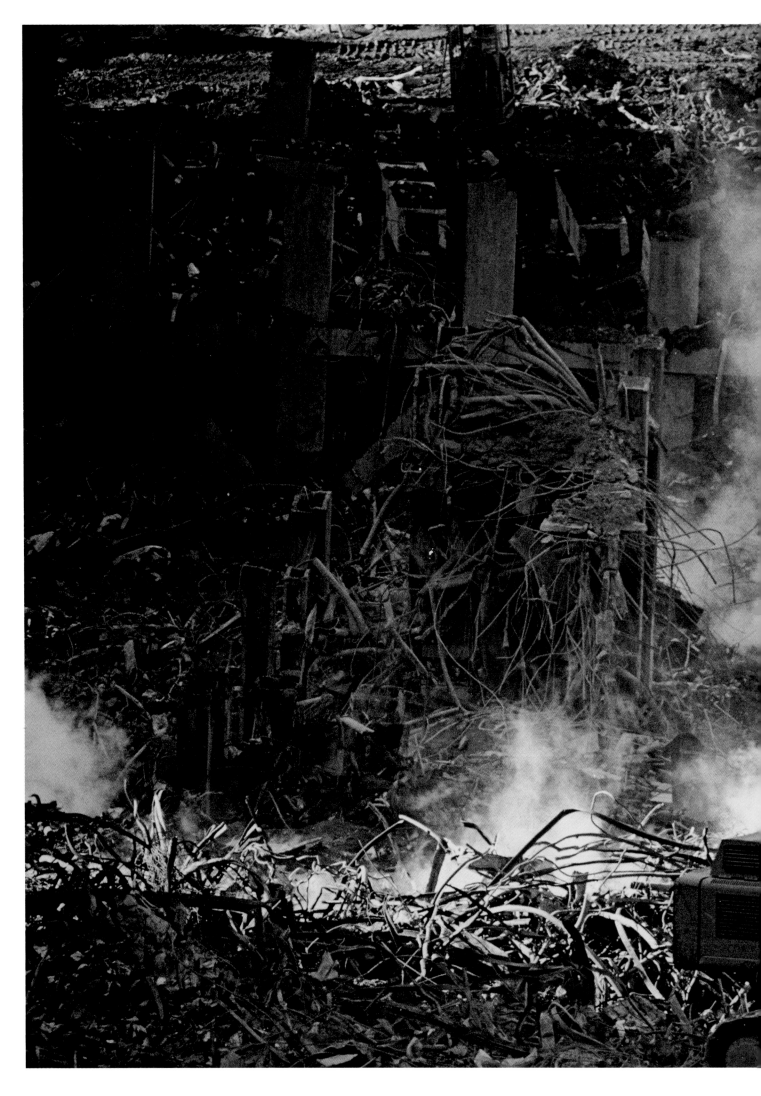

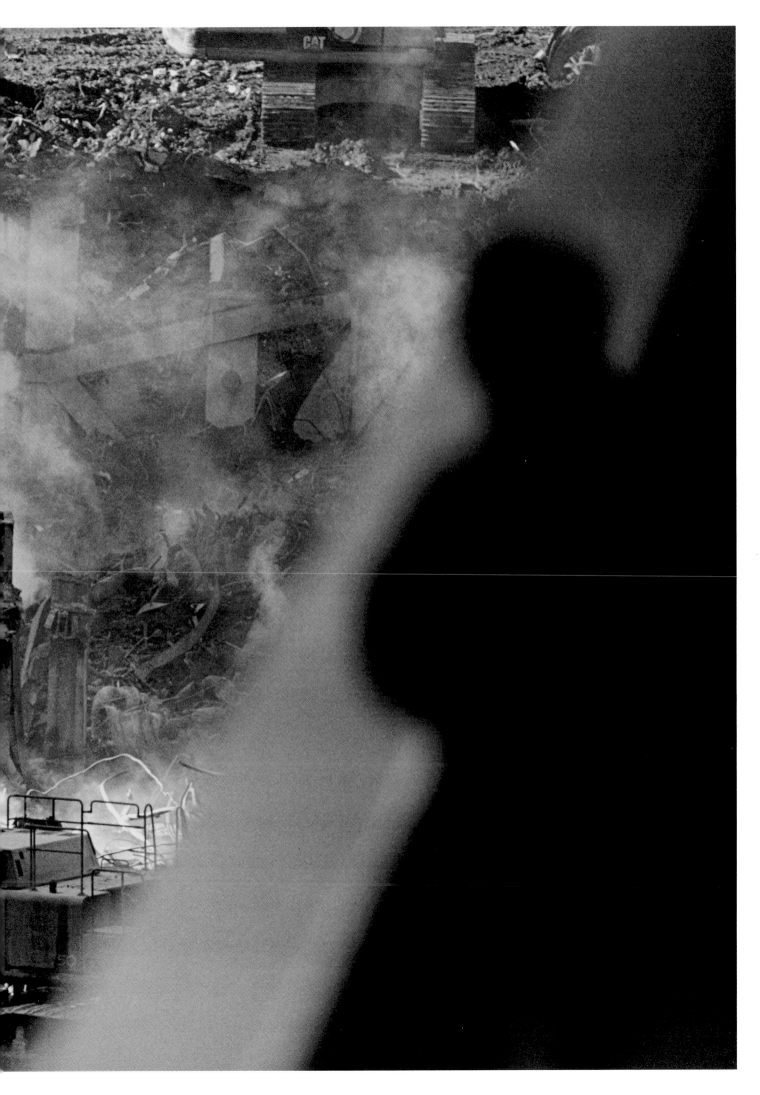

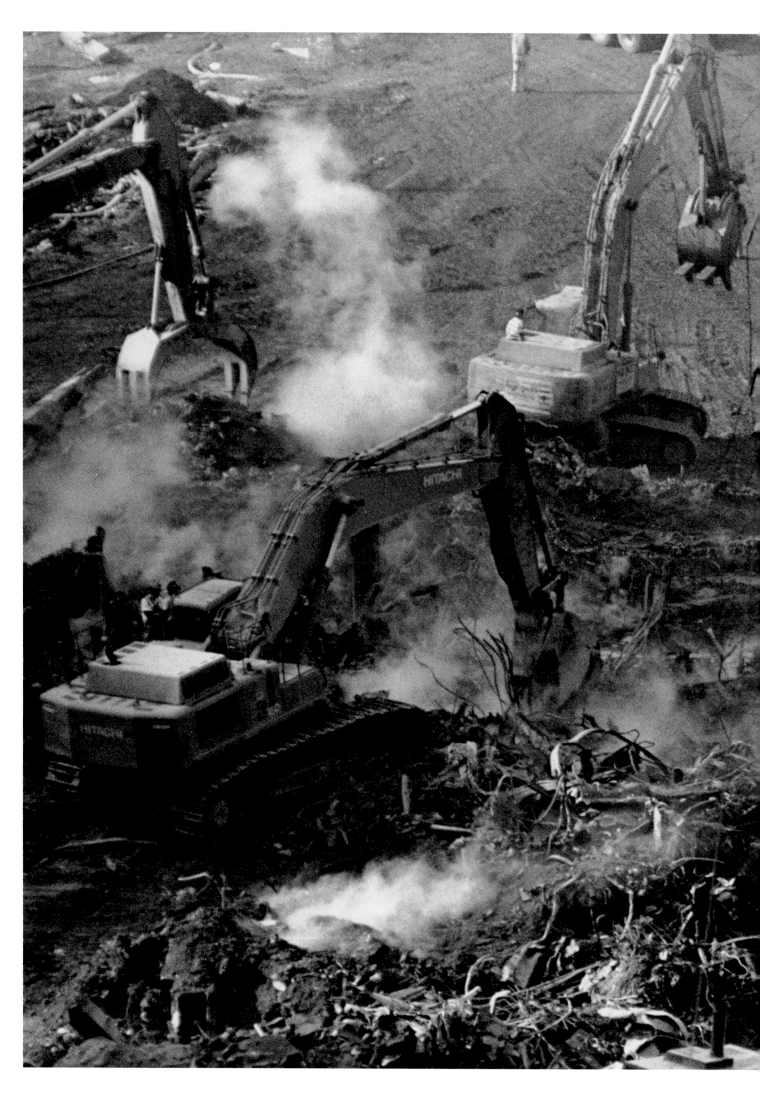

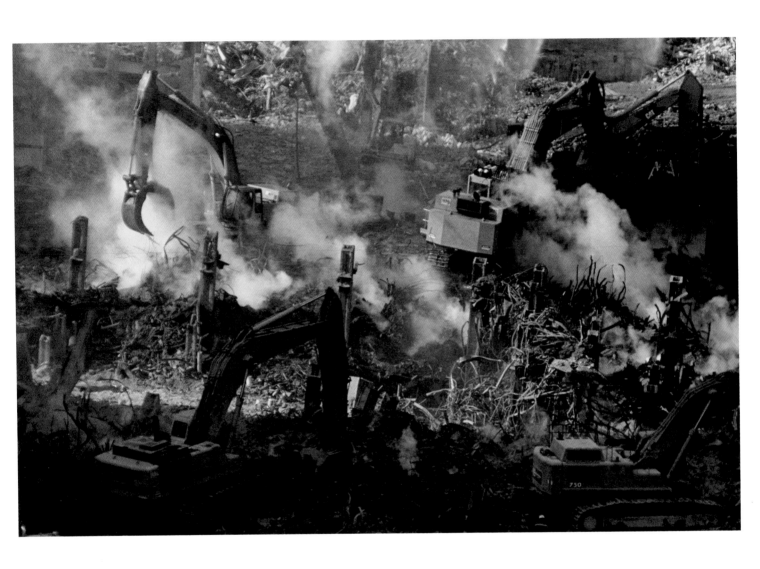

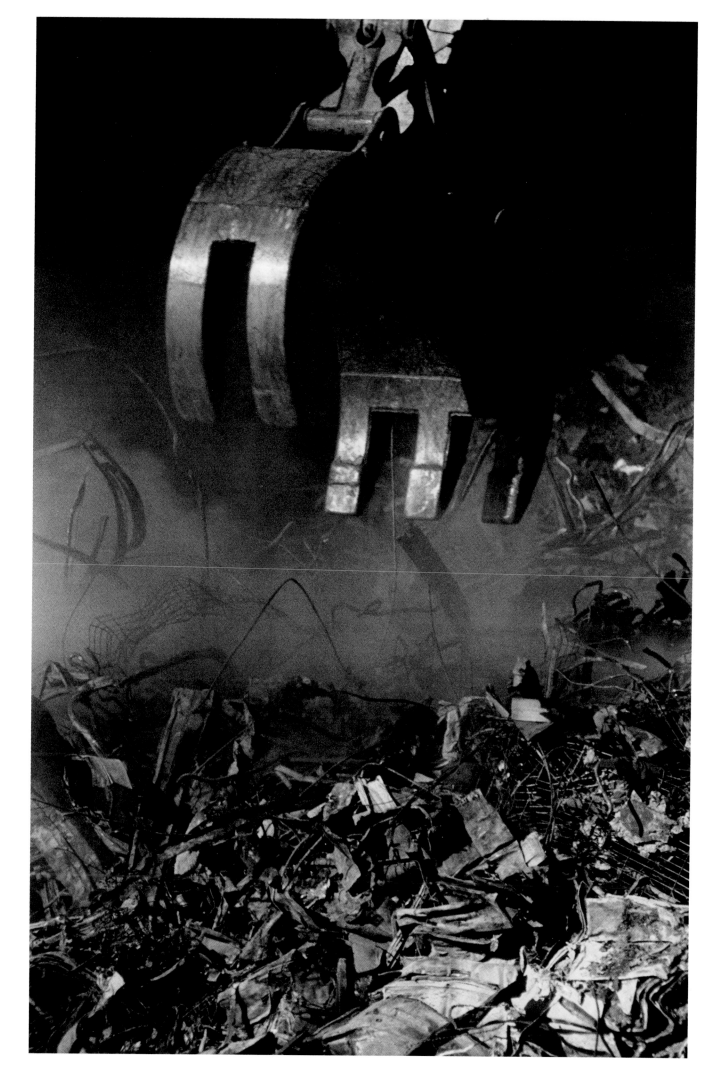

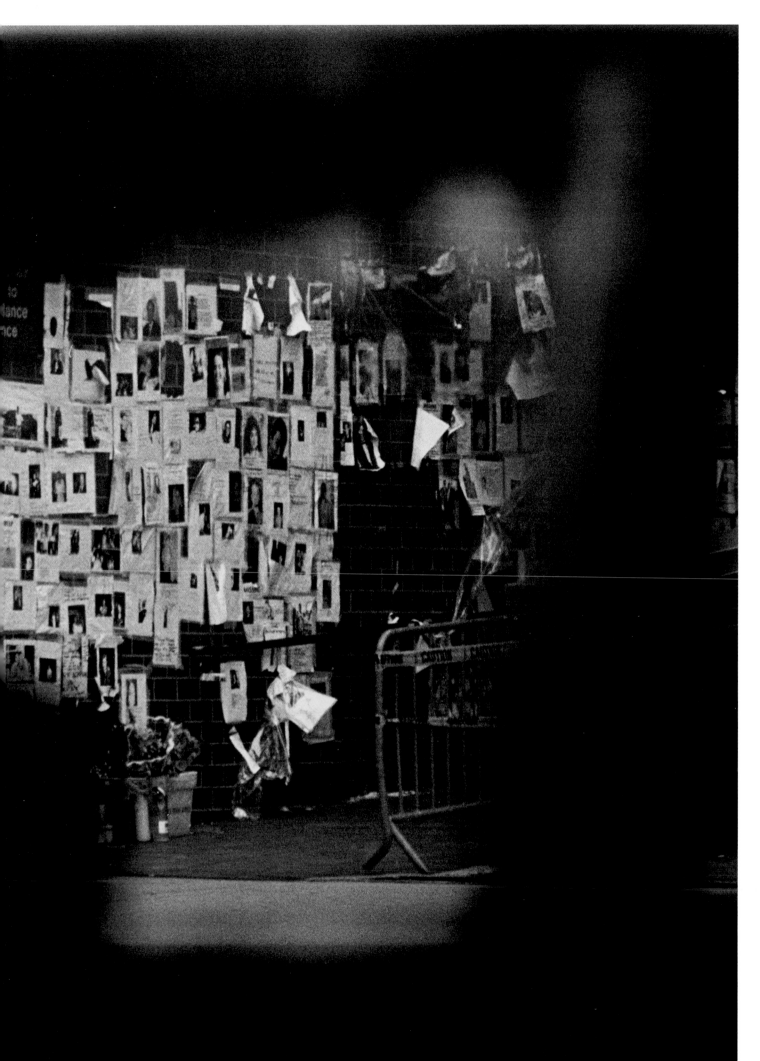

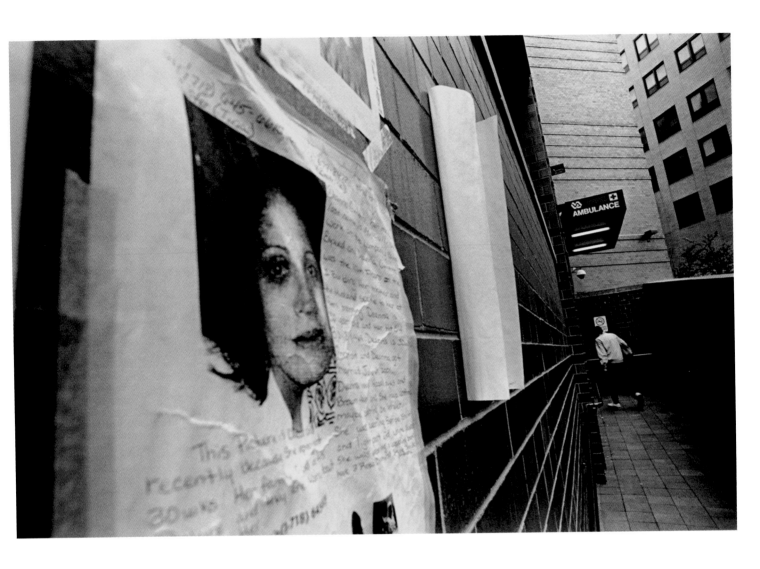

As rescue and recovery workers search the ruins,

51

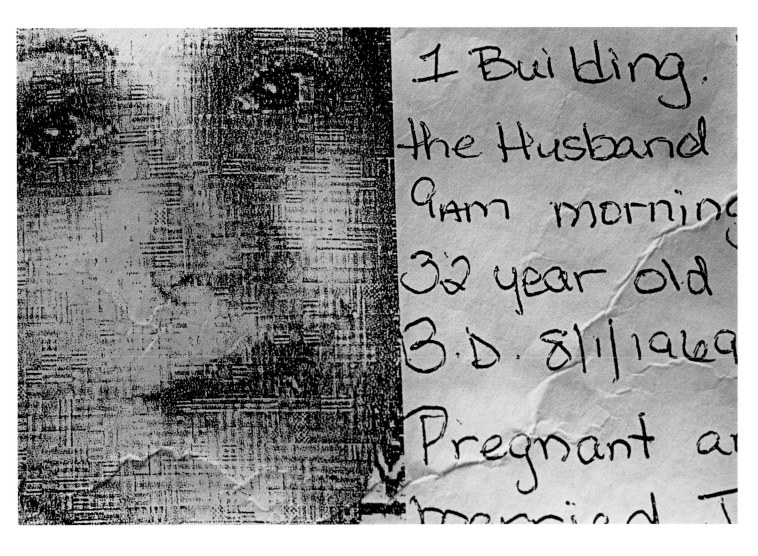

Mayor Giuliani warns that the death toll in New York could be in the thousands.

4-7974 OR 914 4

100 lbs.
DARK BRN HAIR
W/HIGHLIGHTS
DARK BRN EYES
TATTOO OF BUTTERFLY
ON LOWER BACK
HAS ON GUCCI WATCH

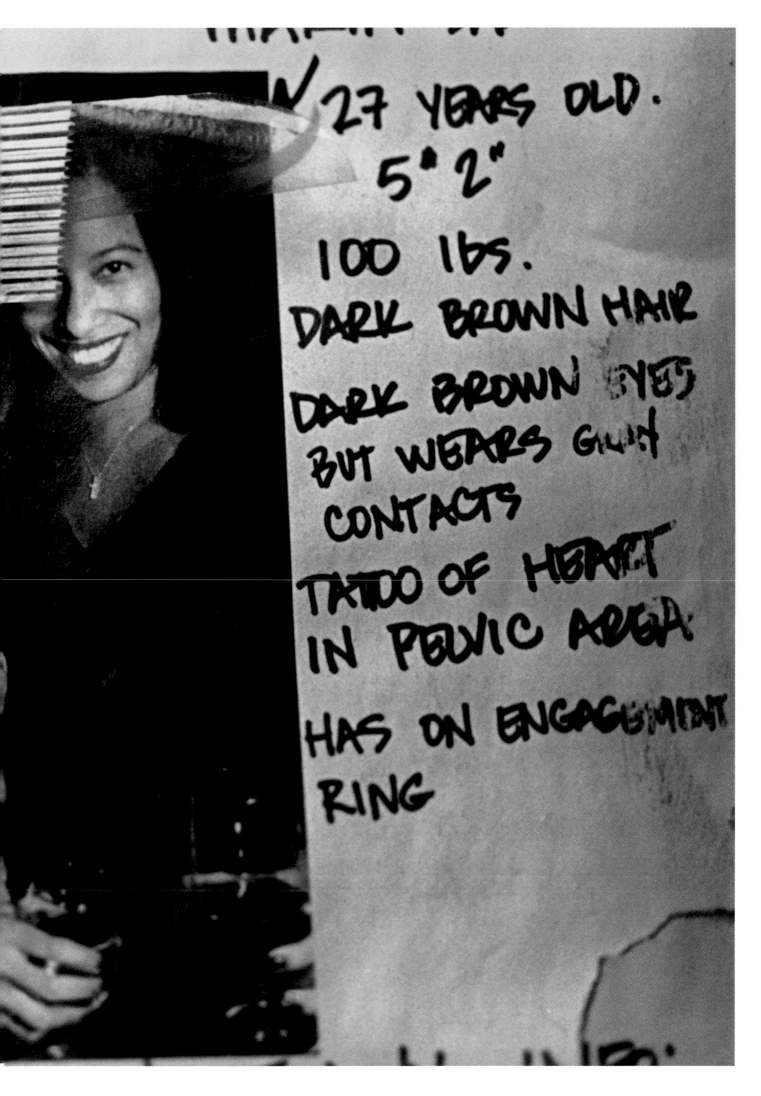

My husband is a missing
N.Y. fire fighter.

He was sent to A
New Jersey Hospital

Please check all
ER and OR Rooms
Help!

61

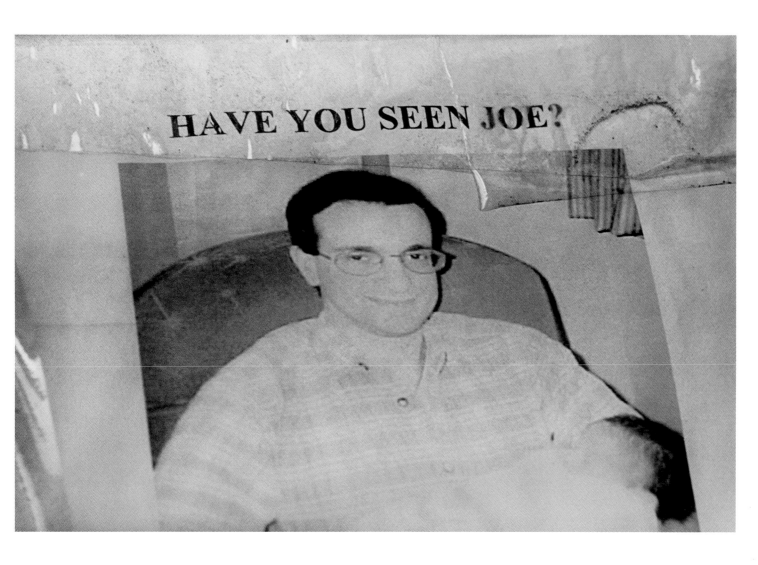

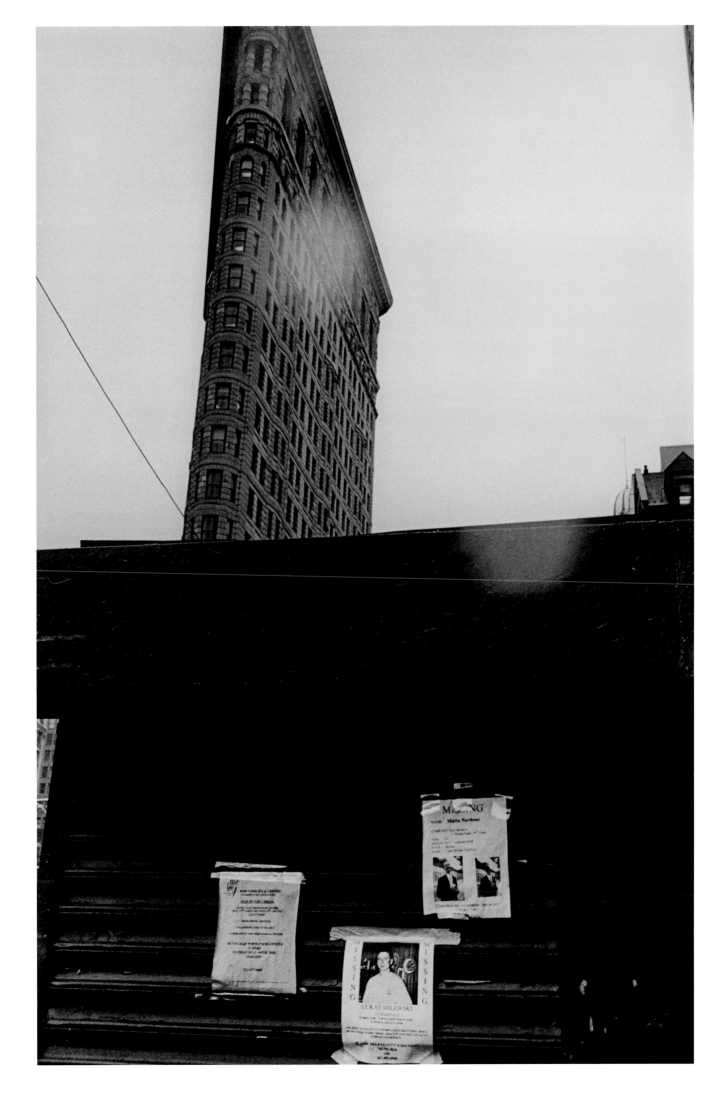

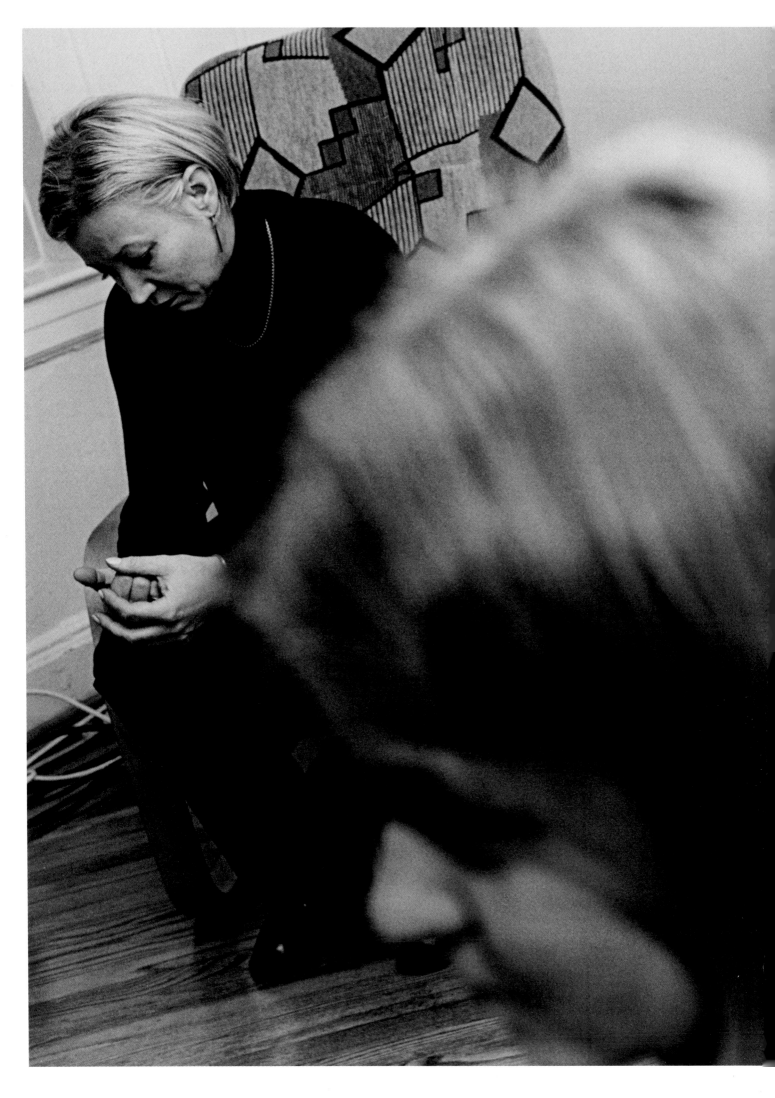

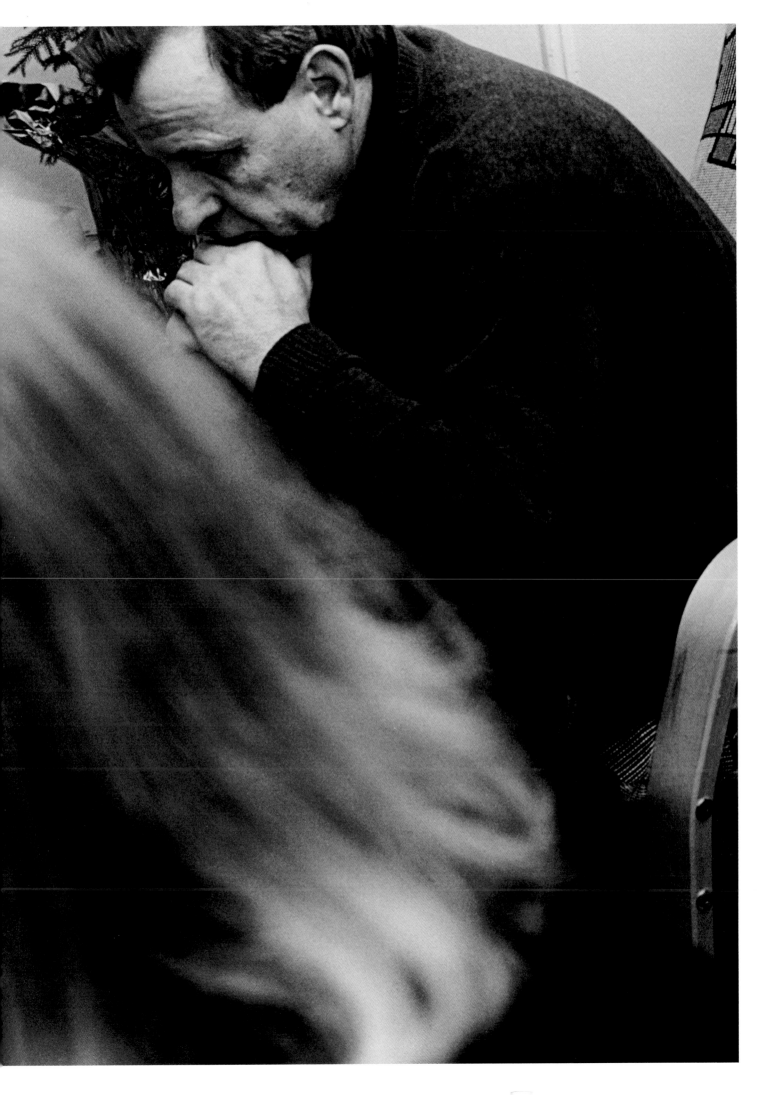

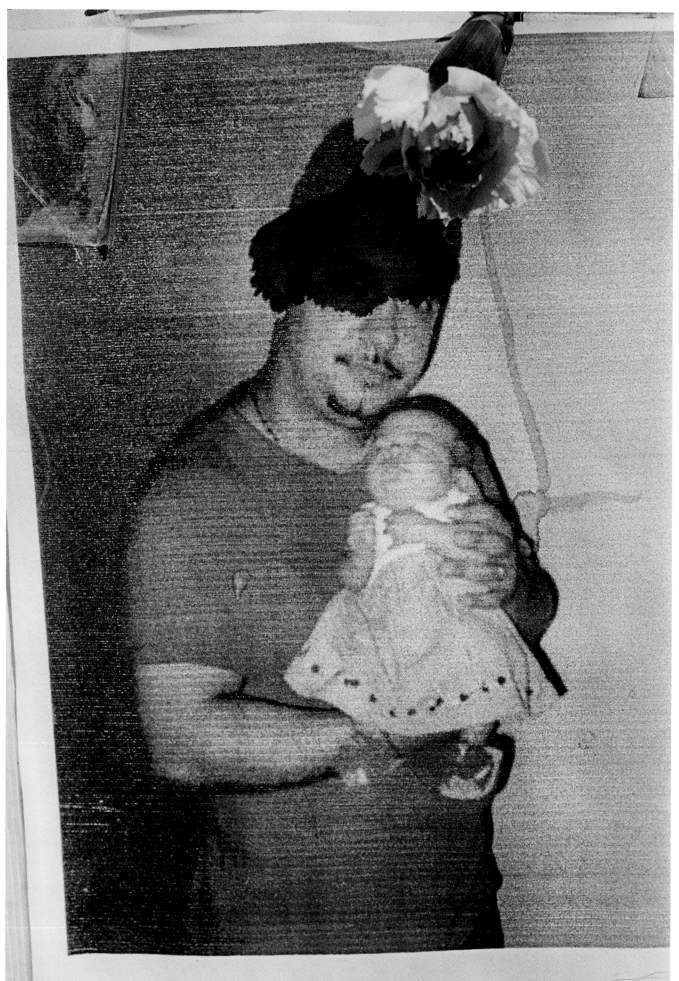

Emilio "Pete" Ortiz
Devoted Husband & Father of 6 Month

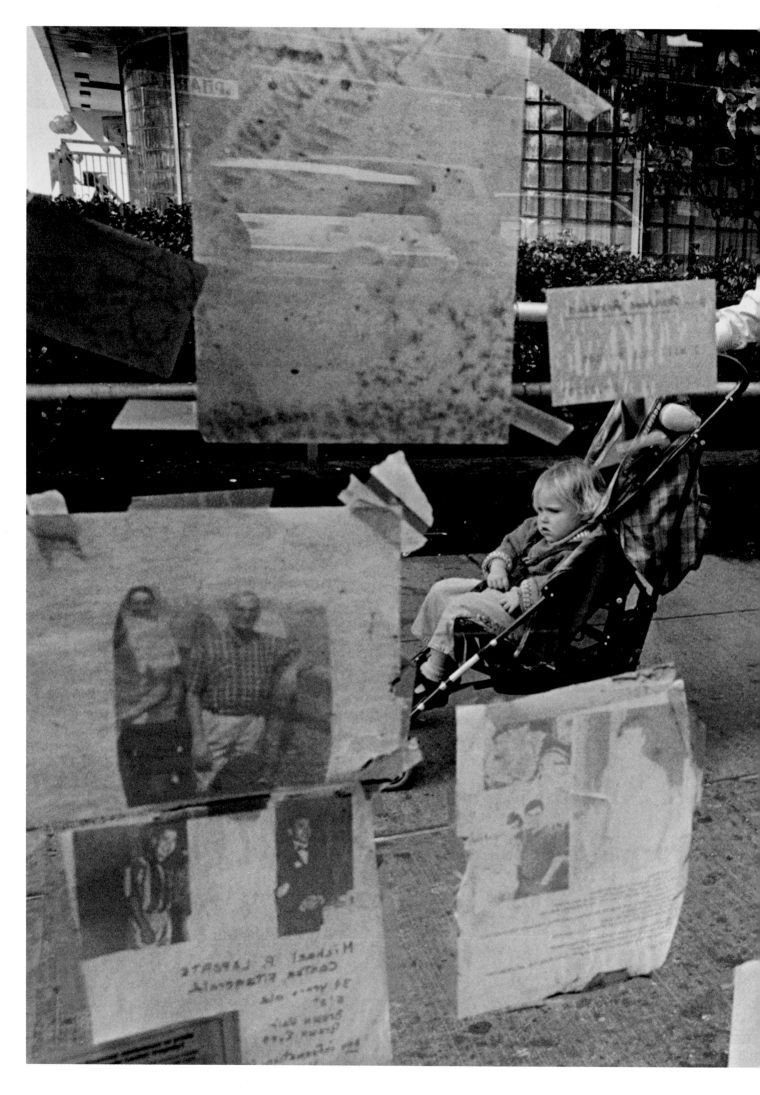

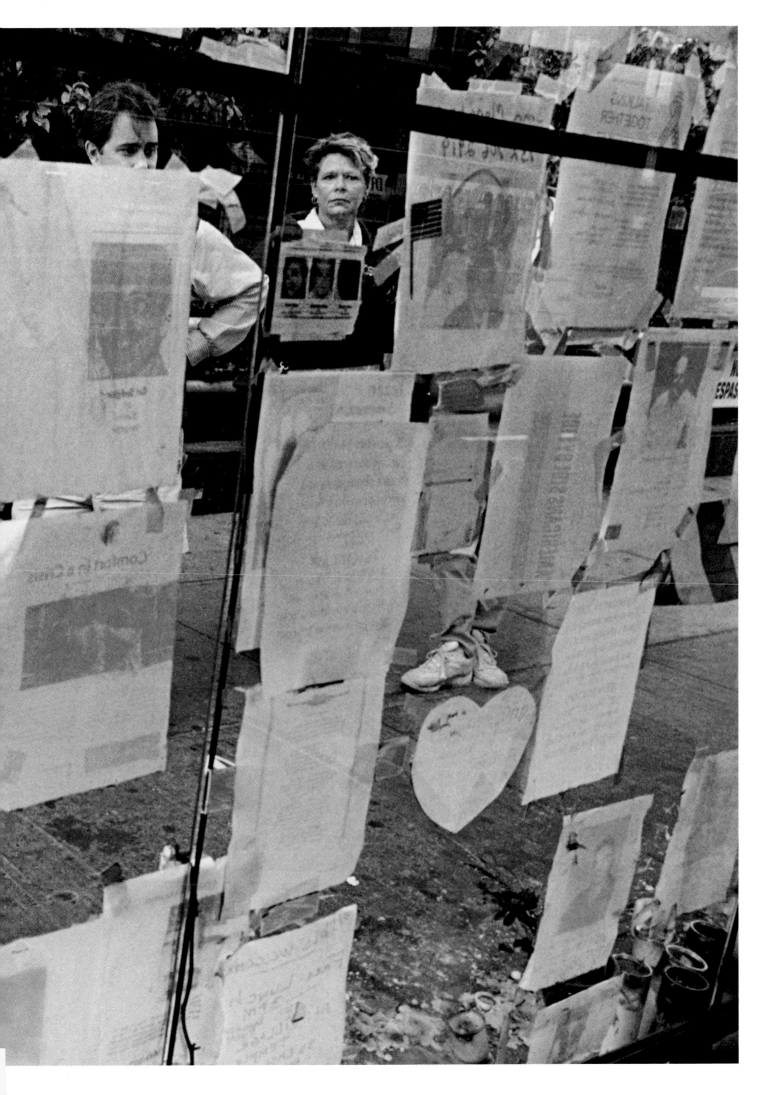

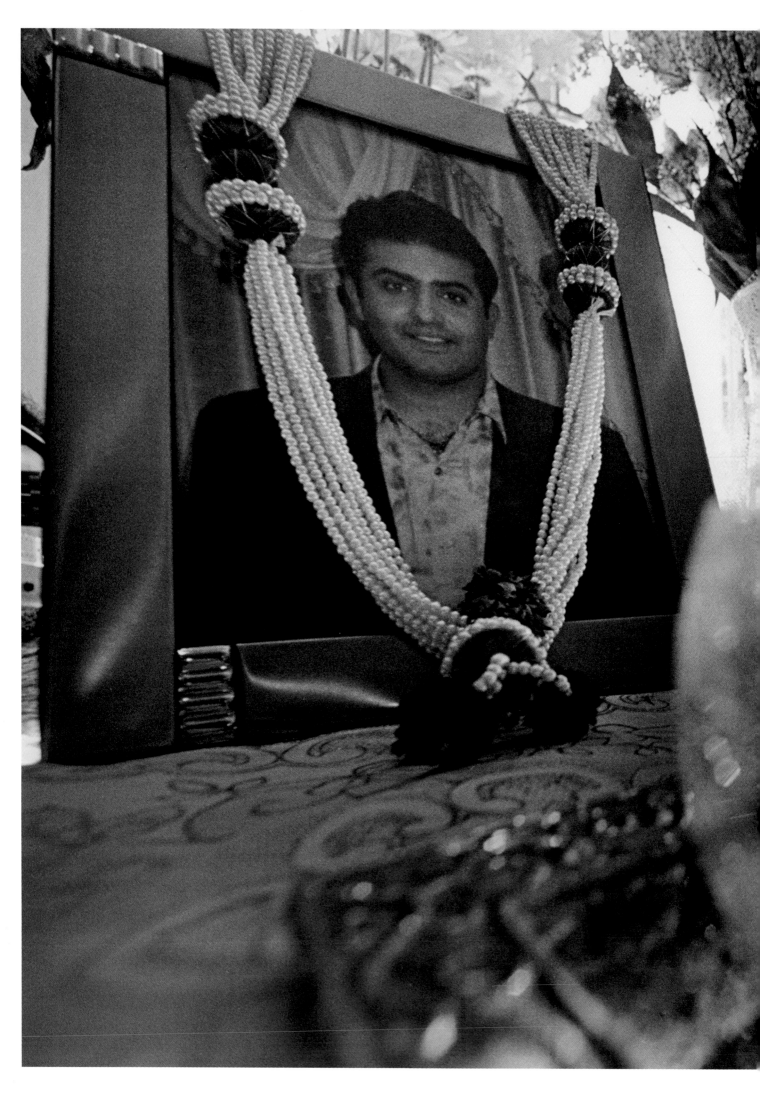

Identifying Osama bin Laden as the mastermind of the attacks,

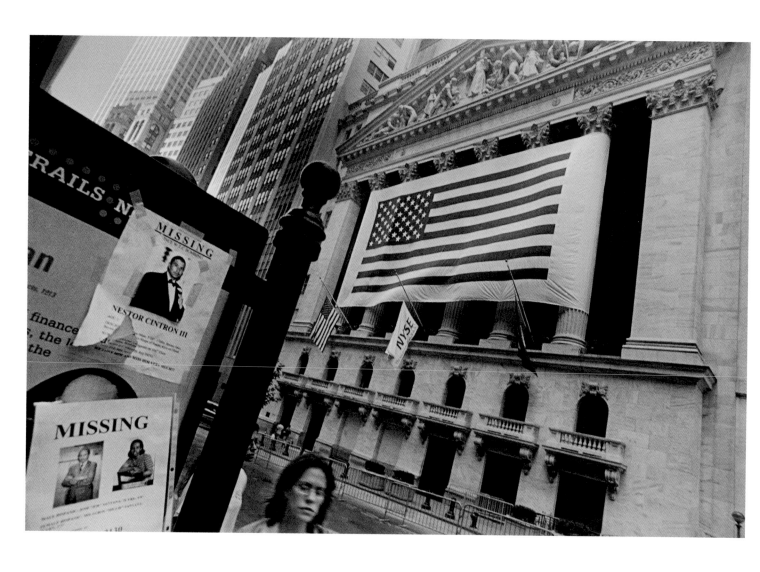

President Bush tells Americans to get ready for war.

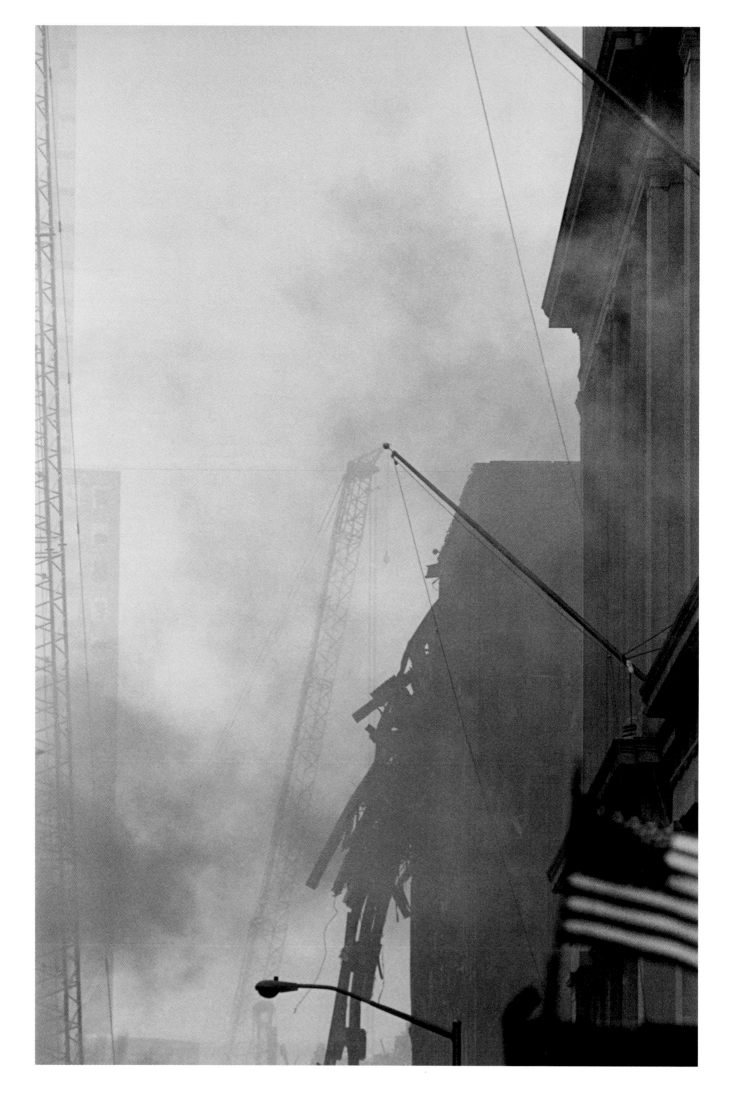

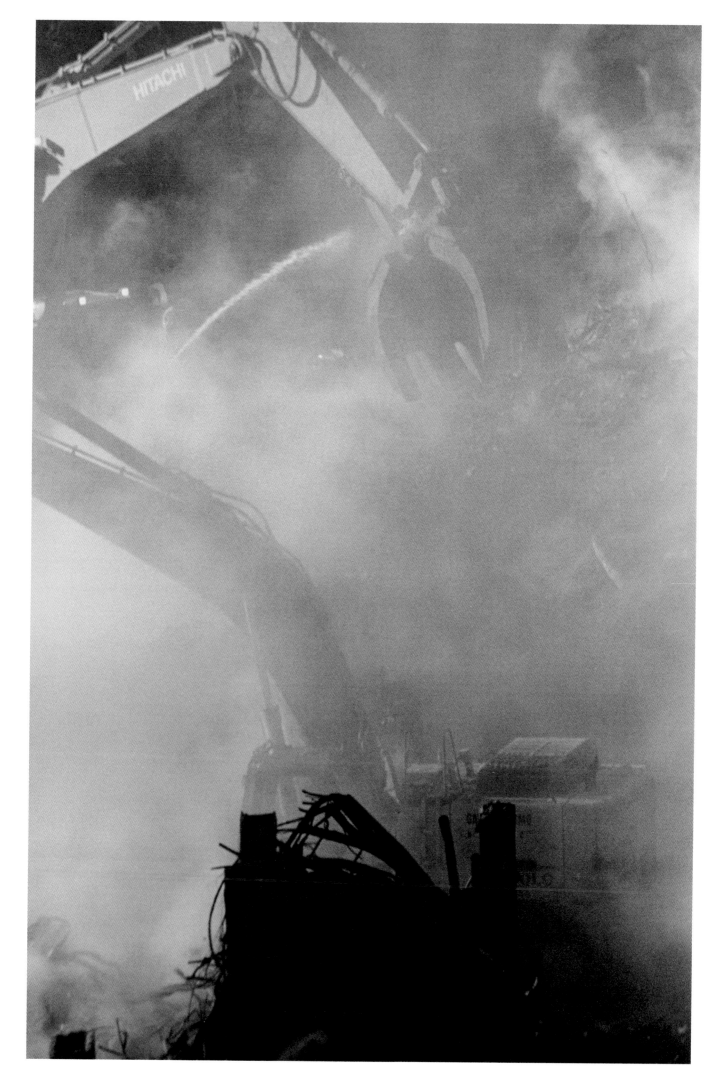

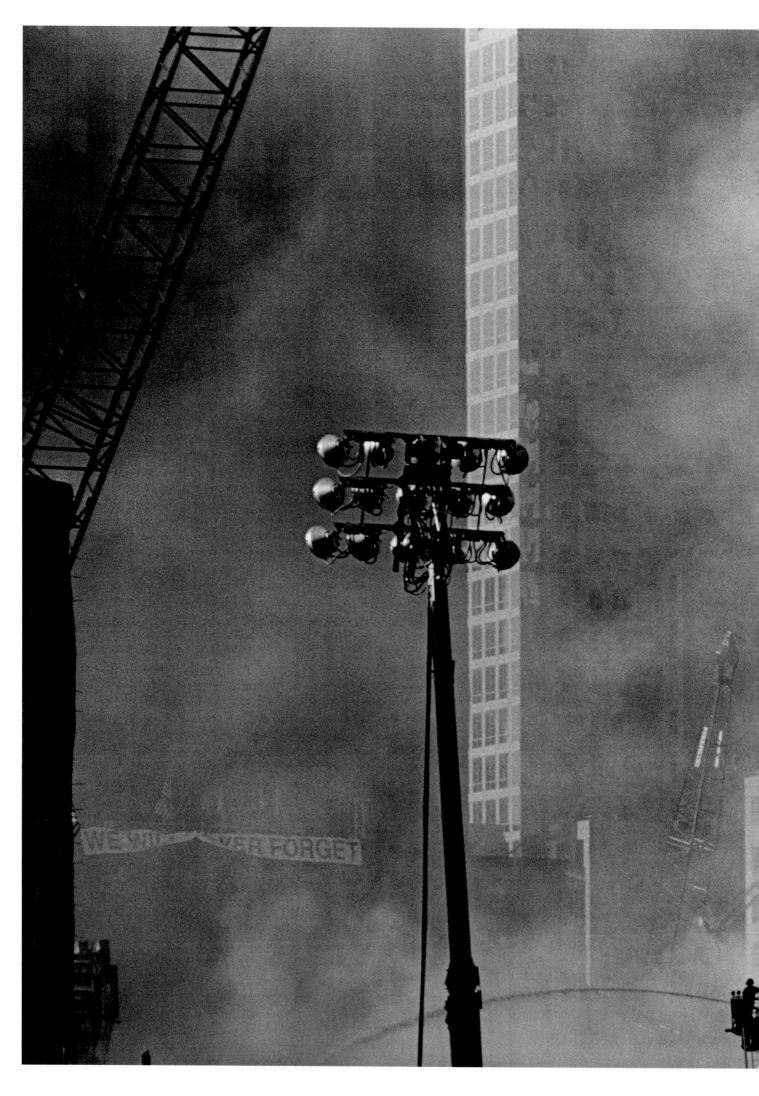

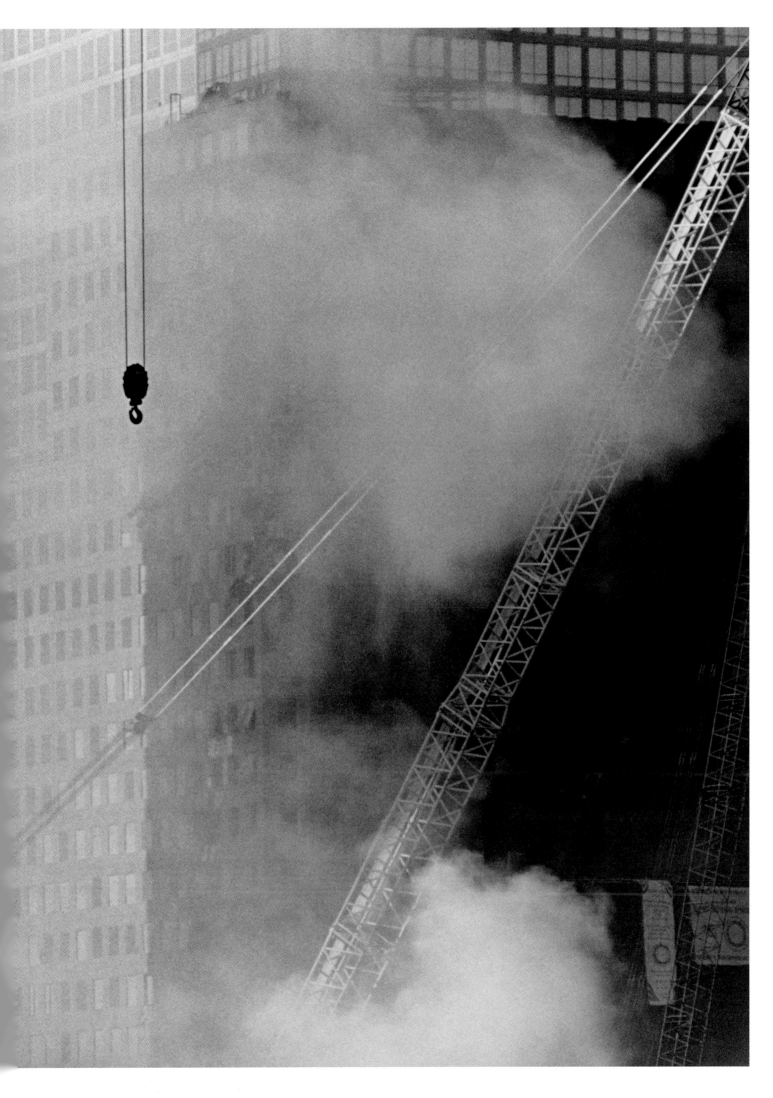

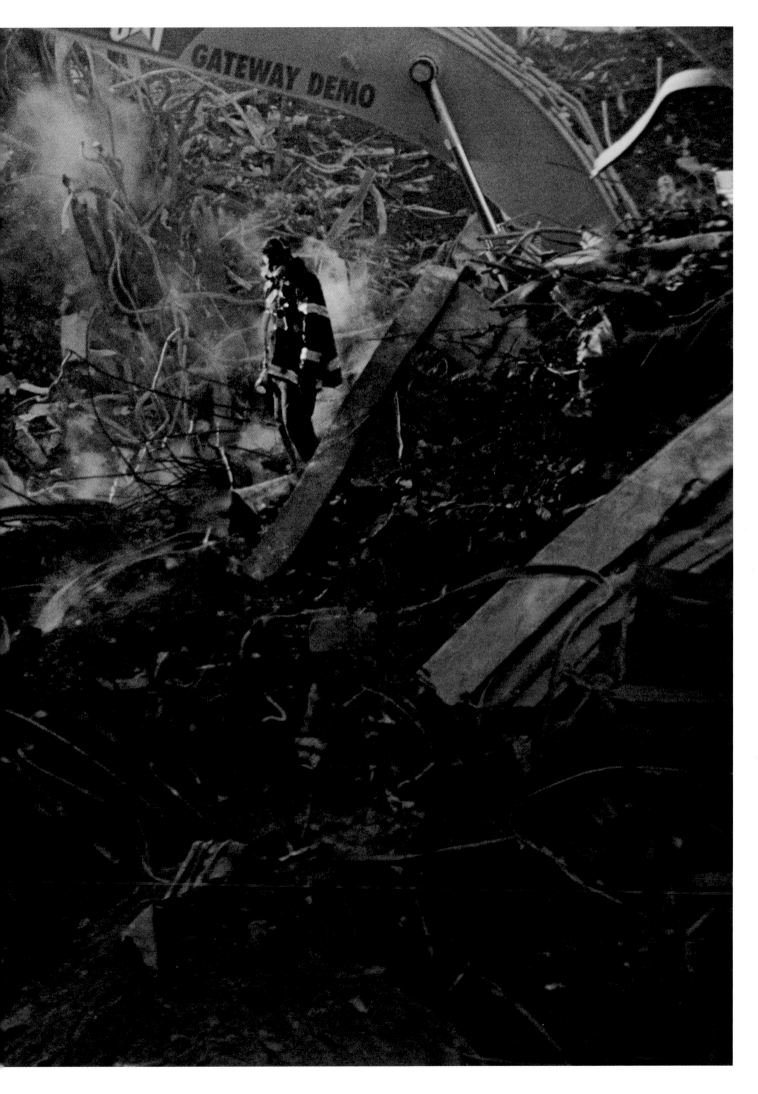

OFFICER MITCHELL COTO: We thought that by going back every day, we were going to find a pocket of people alive. Maybe they were inside of a store, sitting down, drinking coffee and waiting for us to come and open up a void so they could get out. But there was only one person recovered alive, maybe twelve hours after the first blast, and her head was stuck between two beams. She had burns.

The amount of people who showed up. . . . I mean, all these agents, these Virginia State Troopers; it brought out the best in people. And it was . . . whew. Horrible. You'd find a sneaker. And you'd think it was an empty sneaker, but there was a foot in there, a piece of bone. You'd find an arm, a piece of a face. When we found a police car, we thought somebody was in it. We were digging like crazy—nobody's there. But then, you couldn't tell the difference between a bone and a piece of rock. So we were sifting with our hands. We were trying to find evidence at the same time. We didn't want to get rid of pieces of the plane.

When we'd find firemen, everything would stop. When we'd find police officers, everything stopped. When you found one fireman, you found four firemen, because the firemen were pretty much bunched up together. Sometimes we found people around them. At one point, we found three firemen hugging each other, one on top of the other.

Nobody really wanted to talk. Everybody was interested in just working, working, working, working. I'd work for twelve hours, go up to the site for four or five hours, sleep for two hours, go back to work. The second day I tried to go up there; I couldn't because my body just gave out. But then the third day I felt guilty, so I went. And then the guilt just started kicking in. It became an everyday thing to go up there.

JOHN CARTIER: Before we left the house on our way to Bellevue, my father followed us towards the front door. He stopped me and looked me right in the eye and said, "Bring my son home. Bring him home to me no matter what."

We went through, like many families, days of waiting for answers, waiting for answers. And then one day we're like, "That's it; enough is enough. We're going to go out and *get* the answers. Because James deserves it." And my parents deserved it.

My brother, James, was a Local 3 electrician. Twenty-six years old, just starting out. He was smart, doing great in school. He was respectful, caring.

KAMILA MILEWSKA: The first few days, I didn't feel any pain. I was just angry all the time. At my parents that they wanted to leave Poland to come to United States, and my grandmother, who invited us to come here. At everyone. I was angry at myself. It was so strong a feeling, you couldn't imagine. Then I was angry for all politics, because it's twenty-first century and people still have power to do something like this. United States is biggest country in the world, and I'm not so good at politics, but I think that United States, especially past president, Bill Clinton, should have been more careful about connection between United States and these countries, especially Afghanistan.

At the beginning people I met at Family Center were shocked; they couldn't believe. But after one week, they were just crying. For example, I met some man at Family Center. He loved his wife; she was five months pregnant. And he didn't want to talk with us, just sit and that's all. I didn't hear anyone talk about Afghanistan, about bin Laden. Nothing. They just talked about their loved ones and they showed pictures. But then I met people from human-rights organization, and then they really started to talk about what George Bush should do, what Giuliani should do.

There were so many famous people in Family Center, like Giuliani, like Bill Clinton, like Muhammad Ali. I met Bill Clinton and I talked with him. I talked about my brother, Lukasz, not about politics. I think most people did the same. Giuliani came in five or six times. At the beginning, I even didn't know him, I didn't know that he's so important for New Yorkers. But for me it was different. When I saw Bill Clinton, of course I know him. I was glad he was there. And Muhammad Ali. You know, he just gave me his hand.

KAREN DOWNES SILBERMAN: Now, for the aftermath. I had mixed emotions about it. When it was my birthday—September 12th—I didn't celebrate my birthday; I celebrated life. But I still had so much guilt about the gentleman who didn't make it, the man who hugged me. He stayed behind, on the phone. He was picking up the phones and answering them, calls from my family. He was saying, "Karen's all right, she got out."

The aftermath. Mixed emotions. Feeling good, because I'm alive, wondering why God spared me. And I'm angry at a lot of people. Very angry. A lot of people lost their lives because of security saying that it was okay to go back. The first building was burning down—for God's sake, wouldn't you evacuate the second building? They're twins. They're next to one another. But I think a lot of people believed those buildings were invincible. I'm angry at a lot of other people. Why would a woman go back for her cell phone? Why were people looking out the window at this? But a lot of them went into shock. One of the women I worked with stood outside as the debris was falling. She just stood still and then started to walk away, very slowly. People got hit with debris, and died that way.

CHRISTOPHER JOHNS: That Thursday night was the first time I had to go into it as a funeral director. We had our first funeral. It was for a firefighter, Peter Carroll, and I had to go and get the body. No big deal, right? I do this all the time. I go up to the Medical Examiner's Office, and what they did was . . . it's the street between Bellevue and the Medical Examiner's Office, maybe 28th or 29th Street. It was closed off on both ends to traffic. And on both sides of the street are these huge refrigerated trailers, like tractor trailers. All you smelled was death.

So when you first pulled up, you had to sign papers. And it was a madhouse; people were out in the streets. And no matter where you walked, you were passing these *walls* of people's pictures. They were all set up in Bellevue, missing-persons posters, and I'm saying to myself, "Jesus, I can't believe they think these people are walking the streets." I got my paperwork, then I had to have a police escort to go in back where the street was. There were body bags as far as the eye could see in those trailers. What happened was, when a family was notified, they got a DM number—a DMORT number. Some of the bodies I had to pick up had five, six, seven, ten numbers. There's got to be some mistake, I thought. So when I'm going up with one name but with eight DMORT numbers, it means the body's in pieces.

I picked up Peter Carroll, and I could not believe how I felt when I left there. I was crying. I got him in the car, and we've got a police escort. Every body that we were picking up in the beginning got a police escort back. You had New York State Troopers; forget about the New York City Police Department. Of course they were great; they ran everything, but they were busy. You also had Connecticut State Troopers, Jersey State Troopers. . . . No matter where you were going, they gave that body a police escort back to the funeral home.

Here at Harmon Home . . . obviously, these bodies weren't going to be viewed. But the owner, Terrance McGinley, wanted every firefighter to rest in his dress blue uniform. Even if the firefighters were missing body parts, we dressed every one.

NORMA MARGIOTTA: I don't know how long before Tom DelPino and the fire department came here and told the children that their father had . . . you know, was gone. The image that I have of Tom, because he's a father. . . . All he did was shake. He couldn't get the words out to tell my kids that their father was dead! He just came here and cried and cried and cried. There were no words.

LT. WILLIAM RYAN: On Friday, they found the guys from Ladder 5, the company in Manhattan I used to work with, and on Monday they started burying them. I had a funeral every day, and then two on one day, and. . . . They found, what is it, five of them already? Six? Three are still unaccounted for. They haven't found their body parts or anything.

They had a service for Giammona, but they still haven't confirmed him dead. Vinnie Giammona was a lieutenant in 5, Mike Warchola was the other lieutenant. Two lieutenants rode that day. They were relieving each other, exchange of tours, and they both jumped on the rig. Mike was on his last twenty-four; he was supposed to retire the next day at nine

o'clock in the morning. At his funeral, his brother, a captain, got up and said that Frusci's father wanted to thank Mike for saving his son's life.

I was going to funerals, and going up there to the pile to dig and then going up there not to dig, and just going there. . . . Some days I would go by and I couldn't walk through there, and I'd go around the back side over to Ladder 5 and hang out with those guys. Then I didn't go for about a week, because it was too depressing. I would get off the ferry, then get on the train to Brooklyn or walk to the Brooklyn Bridge, but I wouldn't go there. I would walk on the east side, where I couldn't see it.

CHRISTOPHER JOHNS: Initially, my understanding was that bodies were being identified by their uniforms. Mostly because it was still summer, the firefighters wore shorts, and their names were embroidered on them. And of course, if here's a body and it's missing a leg, and there's a leg ten feet away. . . .Well, what had happened was, it was the change of tour for the fire department. You had the old tour leaving, the new tour coming in. But sometimes people were throwing on uniforms, not necessarily their own. Some people were identified by their faces, tattoos, jewelry, things of that nature.

About a week after September 11th, the Medical Examiner's office made up a special form that the families had to sign. It not only gave funeral homes the authority to get the body; we had to sit and tell these family members, "Your husband is not whole. What do you want us to do when and if they find the rest of him?" And their options are: the city will call us and we'll get the body part, or, eventually—I don't know when—they'll have a mass cremation and then give some of these ashes to every family member. Nobody wants that; everybody wants the body part. So what we have to do is, we get the body part, cremate it, and if they want it buried with the body, the remains are buried at the foot of the grave. We can't open the grave to put the body part inside the casket.

OFFICER MITCHELL COTO: A lot of guys were mad because in the beginning, when we were digging with our hands, it felt like some people were just digging to find airplane parts and trying to salvage evidence. We were like, "Listen, we're here to grab people and save lives. What the fuck are you doing over there by yourself? Come on, let's do it!" Because we had bucket brigades, two hundred cops on one line. A bucket goes up, a bucket comes down, a bucket goes up, a bucket comes down. In the beginning, that's all we had. But when we saw two weeks go by and we only moved about an inch of dirt, we were thinking, "Hey, we're going to be here forever. Eventually, they're going to have to bring the big machines in."

It was hard for us to see it happen, but the mayor was right. Although he didn't want to have a riot on his hands, because God forbid anyone should say, "Listen, we're not searching anymore; now we just want to recover bodies." I think that's one of the reasons why people kept calling it "rescue/recovery."

Giuliani did a pretty good job. I don't say he was out there with a shovel, but as a mayor, he kept his head. The governor sent the state troopers right down and gave us a lot of support. And then we had our president who sent us money. But this guy doesn't have mercy! When he was the governor of Texas, everybody who was on death row got it. But he's the only one I've seen so far who said, "Listen, I'll hunt you down wherever you go."

RITA LASAR: We went out to have some lunch, and when we got back, the phone rang. It was my son's best friend, Danny, who lives next door. He said, "Can I come over?" And we said, "Of course." When he came up, he said, "Did you watch President Bush at the National Cathedral give his speech?" We said, "No, we were out." And he said to me, "He mentioned your brother." And we said, "What are you talking about?" He said, "Well, he mentioned the heroism of a young man who could have escaped, and stayed instead with his friend in a wheelchair." We looked at each other, my son Raphael and I, and said, "Gee, I wonder how many people did that?" I mean, we didn't think he had singled Abe out.

On September 11th, my brother's friend, Ed Beyea, who was a quadriplegic, couldn't get out, and my brother, Abe Zelmanowitz, refused to leave him. My sister-in-law had gotten

through on the cell phone and they were screaming, "Leave! Go! Leave! Go!" and Abe hung up. Before he hung up, he said, "I'm waiting for the firemen; they're coming soon." He was on the twenty-seventh floor, so there is no doubt he could have saved himself.

After Danny told us what President Bush had said, I realized that my country was going to use my brother's death as justification for the deaths of other innocents, and that we were gearing up to go to war. And I was devastated. So I wrote a letter to the *New York Times* in which I described briefly my brother's act and the president's citing him, and then I said, "And I pray in my name and my brother's name that this country, that has been so deeply hurt, not unleash forces that it won't be in our power to call back."

KAMILA MILEWSKA: It was about ten days or eleven after September 11th. My father called me on my cell phone, and he was screaming, "Kamila, Lukasz is alive! Lukasz is alive! Just come back home! He's alive!" And I started crying, I started screaming. . . . I was just screaming and crying and laughing—everything. So people looked at me like I was crazy. Then I came back home, and my parents told me that my aunt in Germany found my brother on Internet list. My father was with our neighbor, because he had Internet. . . . It was the name of my brother. It was written, "Lukasz Milewski," in Polish letters. The first one was a Polish letter, so I knew that my brother wrote this. It was time that they found him . . . I remember . . . 9:50. . . . It was 21st September or 19th September, and that he's okay. Other people was "injured" or "hurt," and my brother it was written "okay." I came back to Family Center to tell everybody about this. . . . One of my friends just asked me, because I told her, "My brother is alive! My brother is alive!" She looked at me, like . . . she said, "Where did you find this?" I said, "On Internet." She just started crying, because she knew about this. She knew it was not true.

PAUL KRIEG: The Friday after we'd gone back to work, the week that the Stock Exchange reopened, I had gotten up, felt great, took the dogs out. And by the time I came back, the buildings had started coming down in my head, again and again and again and again, to the point where . . . I was in the shower, and I just remember . . . it kept coming down faster and louder and harder, to the point where it physically knocked me down to my hands and knees, and I was throwing up bile in the shower. That was the first day that I called in sick. At that point I started calling every therapist I could find to get an appointment, just to stop it. They all didn't really want for me to have too much treatment; they wanted me to heal on my own. And pretty much just the way they said, it took another two or three weeks. Since then, I've been back down to the area. I've seen it, I've been around it, I've been able to cope.

Still, losing my job was very tough. That was the terrible thing about all this, that it started getting into your head. It wasn't just the damage that was done by loss of income, fear for your life; it started eating away at your self-worth as well.

STEVE SPAVONE: I fought in Nicaragua with the Contras; I was involved with search-and-destroy missions. There were five other Americans with me. Four of them were ex-Marines in Special Forces and two of us were recruited out of Pecos, New Mexico, a survival-training area. I had a lot of experience with weapons; it was just something that came second nature to me. When you're fighting someone for a purpose, when you're fighting in a war, at least you know why you're dying. But for someone who knows they're going home at four o'clock, who's got to pick up his kids from school, how can someone like that who's burning or waiting to die not ask, "Why is this happening to me? What did I do so wrong?" The thing is, none of the people in those buildings did anything wrong. Of course, the people who did it were monsters, but, you know, it's unfortunate, because so many American people . . . even in my own family. . . . I called my aunt up to tell her I was all right and I tried to speak to her about the issue. She said to me, "Well, they did this because they hate Americans." And I said, "They didn't do it because they hate Americans. They don't hate us, they don't *know* the American people. They did this because of our government, our Middle East policy." "No they didn't," she said. "They did it because they hate freedom and democracy." What imbecile in their right mind would hate freedom, in any form?

It's obvious to me, and to anyone who follows policy or anyone who's educated that it's the fault of our government's policy in Israel. I mean, if you looked at the newspapers today, it said that Bush is demanding that Arafat stop these terrorists. But is Bush trying to stop the Israelis from using American-made attack helicopters, blowing up their cities and towns? Tell me who the terrorist is, the person who throws rocks at a tank, or the person who has the tank and bulldozes the house over and blows up a village? Someone throwing a rock or someone shooting missiles from a battleship out at sea or attack helicopters flying into a village against nothing but people throwing rocks? Who is spreading more terror?

KAMILA MILEWSKA: My brother was only twenty-one years old, and he wasn't any firefighter or policeman, but in some way he died for his country, for freedom. Most of the firefighters, most of the policemen, they knew that they can die in World Trade Center, but my brother, he didn't know. He just went to work like some other day. He even couldn't imagine that this day would be the last day of his life. That's why I think he is hero. The day before, he didn't feel. . . . It was not flu, but he just didn't feel well. And he didn't want to call that he can't come, because he was very serious about his job, even though it was not so important job. He worked in a restaurant, in Cantor Fitzgerald, and he tried to do everything the best he could.

I really don't know where he was when the plane crashed. I can say he was on 103rd floor, but I'm really not sure. Maybe he would try to get out from the building. Or maybe they sent him to go downstairs. At the beginning, I really wanted them to find my brother, but now. . . . We had already funeral in Poland. And what now can they find?

MICHAEL HENDERSON: It was probably a week or a week and a half after September 11th that we were contacted by the City of New York's Department of Design and Construction saying that they would be putting the scrap, the steel out for bid. As part of the cleanup effort, they were looking for qualified marine terminals to take the scrap away by barge. They asked our company, Metal Management, if we would bid on it, and of course, we did. We subsequently were successful bidding several of the lots. At one point, we were handling 1,500 tons a day.

What struck us all—guys like Warren Jennings and myself, who have spent basically all our adult life in the scrap business—we'd never seen steel this heavy, this huge, this massive. It was just unbelievable. But for all of us, from management right down to the guys cutting up the steel, normally when we have a big job, it's something to get excited over, because it's work, and work is what keeps us all in jobs. But in this particular case, you couldn't get excited about it. We all knew people that died at the Trade Center, or we all knew people who knew people who died there.

WARREN JENNINGS: The framing and the rebar, the lighter-gauge material all went to Fresh Kills Landfill out in Staten Island, so we were handling the heavy, heavy structural. Mike Henderson started formulating a game plan of how to handle the volume of steel that this project was going to be pushing out, in order to clear the site and free it of all these huge structures and impeding overhangs and unsafe positions, so the city could put the rescuers and firefighters in there to start doing their jobs.

When we first got started, we didn't think that we could even come close to handling the volume. But we knew the city had to move it off-site; we even thought that maybe some of it would be pushed off at sea. But day after day, the same material, a never-ending stream of twisted, banged, dented. . . . Every day it just kept coming and coming and coming. And then we started to realize . . . now we're reassembling the buildings themselves with what the pieces were, where they were. We started naming the trees, the outer shell; then we had the inner structures. We just ended up, boy . . . it's just another piece, another piece and another piece.

OFFICER MITCHELL COTO: We were all waiting for the second wave. The second wave was the anthrax. From what they're speculating, it wasn't even foreign; it was domestic. My mail stood there for a week; I wasn't paying any bills. And then when I started to open the mail, I had two pairs of rubber gloves and a gas mask on, sitting outside in the front with the wind

blowing. And everybody on the block knows I'm a cop. So when I saw a lady coming out with a mask on her face, and with those dishwashing gloves—I guess she's thinking, "Hey, if this guy is wearing a chemical suit to open his mail, do you think I'm going to do this with my hands? You're crazy!"

So that's what I did. I did that for a month, two months. But then you say, "Oh, shit. Did I step on it and bring it in the house?" Listen, anthrax, nobody . . . they never told you what the symptoms were until later on. You thought you were having an asthma attack or pneumonia; meanwhile, the anthrax was absorbed so much into your lungs, you couldn't breathe. But I was more worried, I'm *still* worried about having asbestos damage. I was actually ordered back into Manhattan that night, the 11th, to Chelsea Piers, where they had a triage set up. I had to get decontaminated for asbestos. And what about the mercury? Or what about the lead poisoning? I had to get a blood test done because I wasn't sure. We were hearing stories that there was a high mercury level, and cops that were down there. . . . Even the cough. Everybody's got the cough.

KAMILA MILEWSKA: You know, it was the first time I was really proud of United States. It was the first time I felt that in some way I am one of you, that I am New Yorker. When some people start to talk about poor children in Afghanistan, I was angry, because I saw on TV these poor children with guns, with hate to people from United States. But I really was happy that they went to Afghanistan and tried to do something. The same way that I am happy that they catch this man, this American man, John Walker Lindh. I surf on the Internet a lot; now it's my hobby. When I started to surf on Internet, I put in my brother's name, and I could see so many websites about my brother. But I was reading about John Walker, and I think that he is a traitor.

RITA LASAR: Because of the letter I wrote to the *New York Times*, people started asking me to speak at peace rallies and to write articles, and I did, because I was impotent to affect our foreign policy. On October 7th, I was to go on at Union Square Park at a peace rally when somebody came up and said, "We've started bombing Afghanistan." And I was . . . sad is not the word. Speaking out hadn't changed anything. Then I got a call from Global Exchange, asking me would I like to go to Afghanistan with a group of people who had lost family members on September 11th. I felt blessed, and I said, "Of course."

JOHN CARTIER: I think about our president going into war, and people say, "Well, they're killing people over there." I say, "Why don't they just open the draft so I can get over there and help them?" Because I'm ready. I already tried to go, but they won't take me. It's not that I'm too old; they just said that because of what's gone on in my family, I'm not mentally stable. You know what? When you talk about what happened, you're almost talking like a mad person. Not even a mad person, but you're talking like somebody who is disorganized. . . . Picture the Mad Professor with his glasses on his forehead, and his hair is all messed up, with papers all over the place. But you know what? He's methodical. . . . And that's what I said, "I'm not mentally unstable, I'm methodical."

Let's not beat around the bush. We're killing people. They killed us, we're killing them, but we're just killing them better.

PAUL KRIEG: Everybody likes to say, "We shouldn't retaliate," but I don't believe that these people respect that. They tried to blow up the towers once; we forgave them. The second time they did blow the towers up. In most situations, yes, you should try reasoning with someone, but all they want to do is destroy us. So if anything, I think we should have hit harder and faster.

As far as the prisoners go, they killed a lot of innocent people and they scared the crap out of everybody, and they changed everybody's lives. In their culture, if they had caught us, everybody would be dead or would be missing limbs and tortured beyond belief. So I don't have any feelings for those people at all. I've got more rage against the people who would want to protect those folks.

Lt. William Ryan: I walked over to where we set up that command post, at the pedestrian bridge at Liberty and West, and I just stood there. I couldn't move. But then I realized . . . that's when it all came back to me. I started shaking. And this guy's looking at me as though I was insane. So I went behind some trailers and cried, because you know, firemen aren't allowed to cry in public.

I tried to walk up north, to where there'd been another command post, and ran into some guys I knew. It was pouring rain out; I was soaked. I'd been standing out in the rain for like an hour. Anyway, I went into this tent where a bunch of firemen were, guys who were veterans of the first recovery groups. When they would find bodies, they would go dig them out. So there were twenty guys in there. I walked in. . . . They just nodded their heads; I nodded back. I knew two or three of them, but we didn't say a word to each other; we just stood there. The radio broke the silence, like that day, when the "Mayday! Mayday!" broke the silence. "We need a couple of firemen; we think we found someone." So they took off with their little shovels, up into the pile. I wanted to go with them, but I didn't want someone to say something to me about being up there without the right equipment on, so I watched from the tent. I could see them, going probably ten stories up. It was a Port Authority cop, so the Port Authority guys went up and carried him down.

Christopher Johns: A lot of people wanted to have wakes with empty caskets. Now, before this, you could never bring an empty casket into a Catholic church. It couldn't happen. The cardinal had to give special permission, but he left it up to the pastors of the parishes to decide. So we were going in with caskets. But the thing you could not do, which you could never do, is you could not bury an empty casket. The only time you could bury an empty casket is in the Jewish faith. The rabbis, you can bury their books. But another thing is, you have to have a death certificate to collect life insurance. Before September 11th, a person could be declared missing, but to be declared dead, to get a death certificate, you had to wait three years. So the city, in its infinite wisdom, really, started issuing death certificates, but they still wouldn't give you burial permits without a body. So as I said, we were going to church and to a cemetery with an empty casket, and if we couldn't bury it, the casket would be placed at the grave, and we would still have services. Children would think their parent was in that casket. People would leave, and then we would take the casket back to the funeral home.

Kamila Milewska: In some way, I felt that when we have funeral for my brother in Poland, it will be the end, I will be able to start living my life again. So when we started to make funeral, I wanted everything to be perfect. After, my friends told me it was the most amazing, most beautiful funeral in the world. My brother's favorite color was blue, so the coffin was blue. It was one thousand flowers, white with blue. Roses. Not everything, but it was mostly roses. It was like three main flowers—from me, from my parents, and from my brother's girlfriend. It was a picture of my brother, behind—no, not behind, in front of . . . in front of coffin we had a picture of my brother. My brother's friends were singing in church some songs. It was beautiful music, "Ave Maria" that they played on violin. And in our town, Suwalki, each hour there was a song for my brother, each hour this day, which was 9 November.

During funeral, it was first time I just gave up. I felt so depressed, like a small child. All during the funeral I just asked my father, "Daddy, when can it be over?" I didn't want to go to the church, I didn't want to go to the cemetery, I didn't want. . . . I tried to be strong since September, I tried to be strong for really two months. So during funeral, I just wanted to express my feelings. I was angry when somebody told me, "Stop crying; think about your parents." I said I couldn't. I couldn't! My aunt from Germany, she told me that it was not typical crying. My screaming, it was something really strong from inside me. But my grandmother in Poland, she said, "Just let her cry. Let her cry. It will help her." But my father all the time just talked to me, "Stop crying, please; your brother is watching you. You have angel in heaven."

We had to take security, because there were so many people from television, and we didn't want to make show for my brother's funeral. In Poland, sometimes people take pictures

during funeral. Even my grandmother wanted to make some picture, but my mother and father said no, we didn't want any picture.

We buried the coffin. Inside it was ashes from Ground Zero Giuliani gave all the families. It was letters from me and my parents. It was teddy bear. It was letters from my brother's girlfriend. It was his favorite CD, T-shirt. Everything.

ARJAN MIRPURI: The ashes from Ground Zero, not yet we haven't taken them. This is thousands of people, the remains of two buildings. Our religion has some alternate. Our family will burn some kind of fire, and those ashes are considered his ashes. When a person's body is there, then we put on the clothing, but since the body's not there, we have to do special prayers and put the ashes from fire into the River Ganges.

MARIAN FONTANA: I actually didn't want to have the service for Dave until his body was found, but as time passed it seemed harder to explain to my son. We decided to have a service on the first day it felt appropriate, October 17th, which was Dave's birthday. I chose to have a coffin because I knew that my son would be able to understand it a little more. So when Aidan asked me if Dave was in there, I said yes. I felt it wasn't quite a lie, because his spirit was there. I've tried to be as honest as possible with him throughout the experience.

The priest who did his service . . . that day was his birthday, too. He's an amazing man; to me he kind of lives the Word. I know that the general rule of the Vatican is to not allow funerals without a body, but most priests have been very lax with that rule based on the unprecedented circumstances of the 11th. But I do know of one, a monsignor out in Staten Island who refused to let the coffin into the church. One of the chief's brothers, who's a monsignor, tried to call him to say something, but he wouldn't change his mind.

After they found Dave's body, we buried him at Greenwood Cemetery, where we can walk around and take pictures. We love that cemetery. I kind of divided his ashes up into. . . . The funeral director looked at me like I had ten heads, but I have him in five different urns. And then there's the urn that Mayor Giuliani sent to everybody. It's in a box by the television. Most of Dave's ashes are buried, but I'm going to sprinkle some in Prospect Park, where he had proposed to me, on September 11th, our anniversary. And on the first warm day, I'll sprinkle some at Jones Beach, where he was a lifeguard for thirteen years. And I'm going to do Ireland in August. Ireland was my husband's favorite place. We found this little, amazing town. It was probably one of the best days of my life that I spent there. We walked through these fields, and it was beautiful, and the cliffs. . . . I swam. Dave thought I was crazy. It was June and it was freezing; it made Maine feel like bathwater. . . . So I'm going to sprinkle some there. He has family in Ireland, so I'll go to this hill behind their house that he loved climbing. It's a place that I knew he wanted to be, where he was happiest. . . .

When they found him, I was like, "Okay, this is it." But then I postponed it, because I placed him in five different urns, sprinkling here and sprinkling there. I don't know why I'm doing it that way. I guess I don't want to say good-bye.

CHRISTOPHER JOHNS: There was another firefighter. He had two children, eight and ten. A boy and a girl. I think the boy was the older. People were lined up out to the street, down the corner, and all the way down Forest Avenue. That's how many people. . . . And I'm not even talking about just firefighters. Joe Blow civilians wanted to come and pay their respects. You know, in embalming school, they always talk to you about children, about misconceptions that people have about keeping the children away from death. You'd be surprised how the kids' minds work. So the kids were here, and everybody, including the mayor, kept saying, "Your Daddy was a hero, your Daddy was a hero, your daddy is a hero, is a hero, is a hero." And the day of the funeral, the kid says to his mother, "Why did my Daddy have to be a hero?"

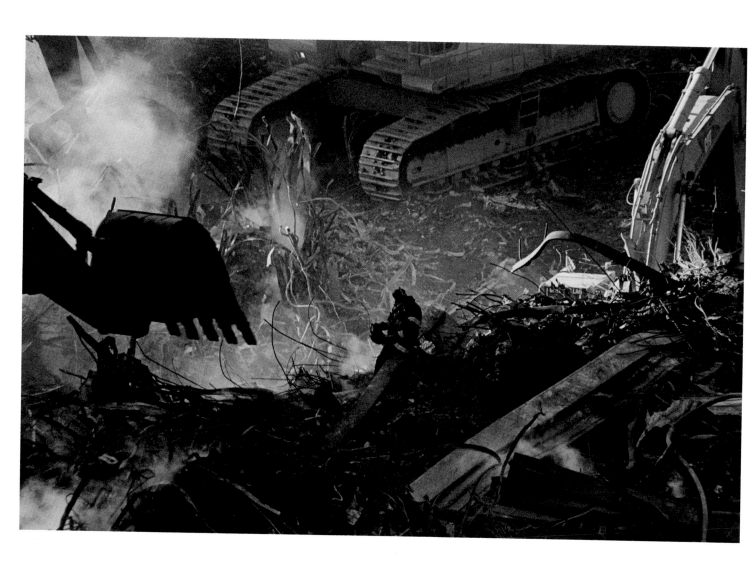

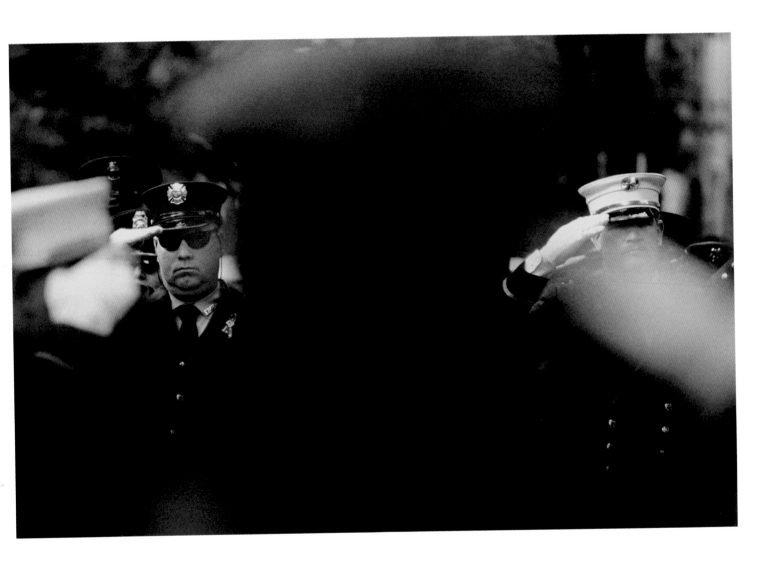

It is confirmed that 343 firefighters, 23 New York City

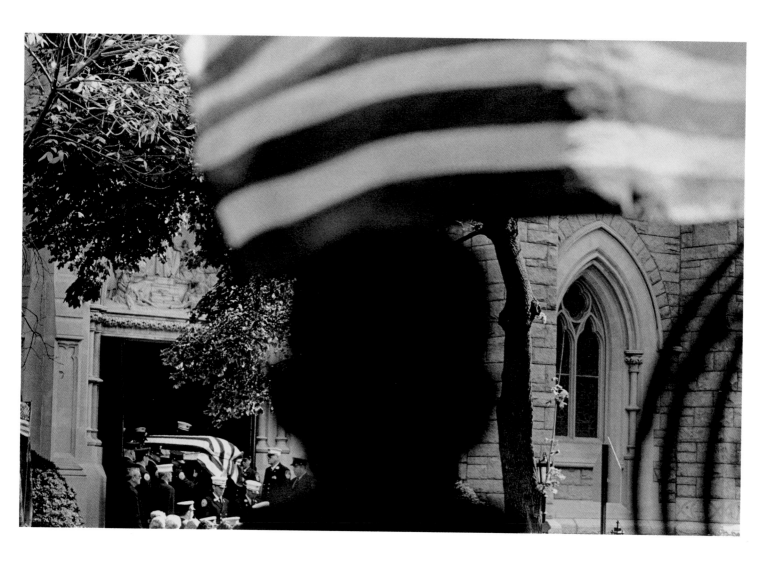

police officers, and 37 Port Authority cops have died in the line of duty.

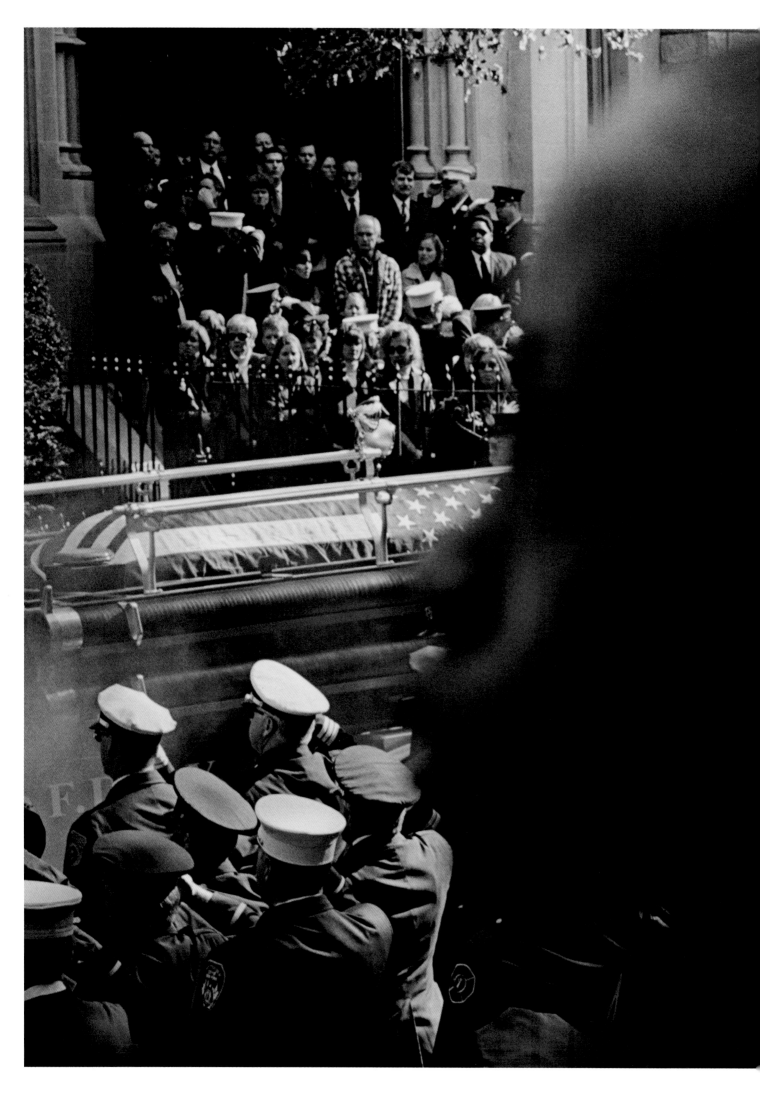

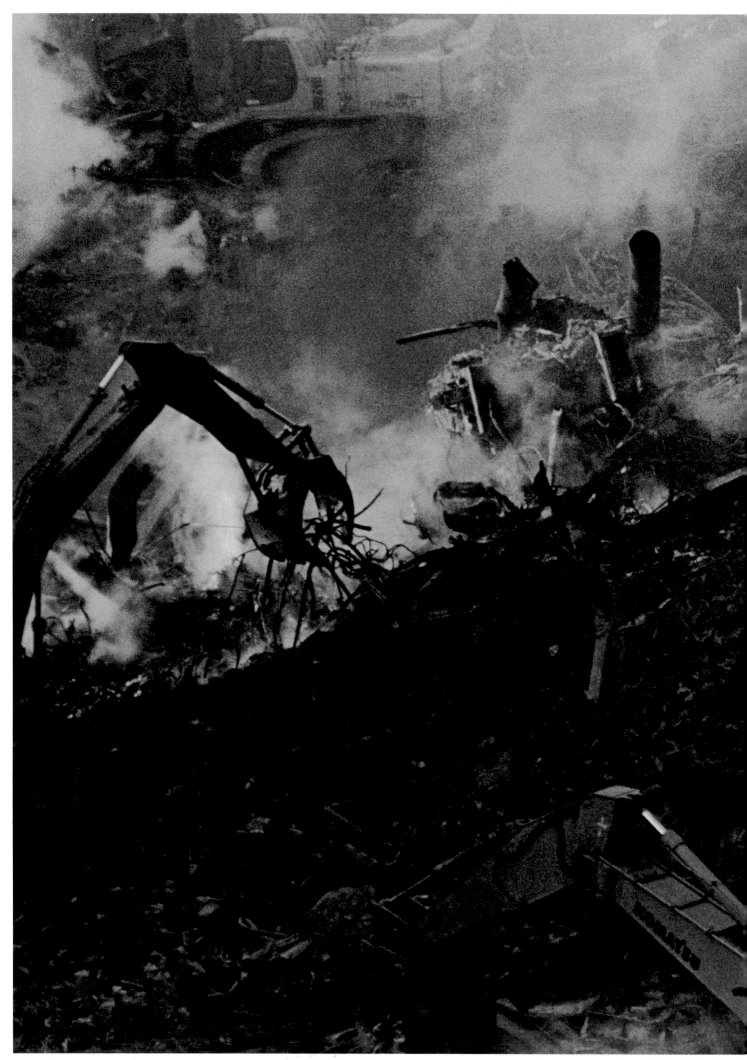

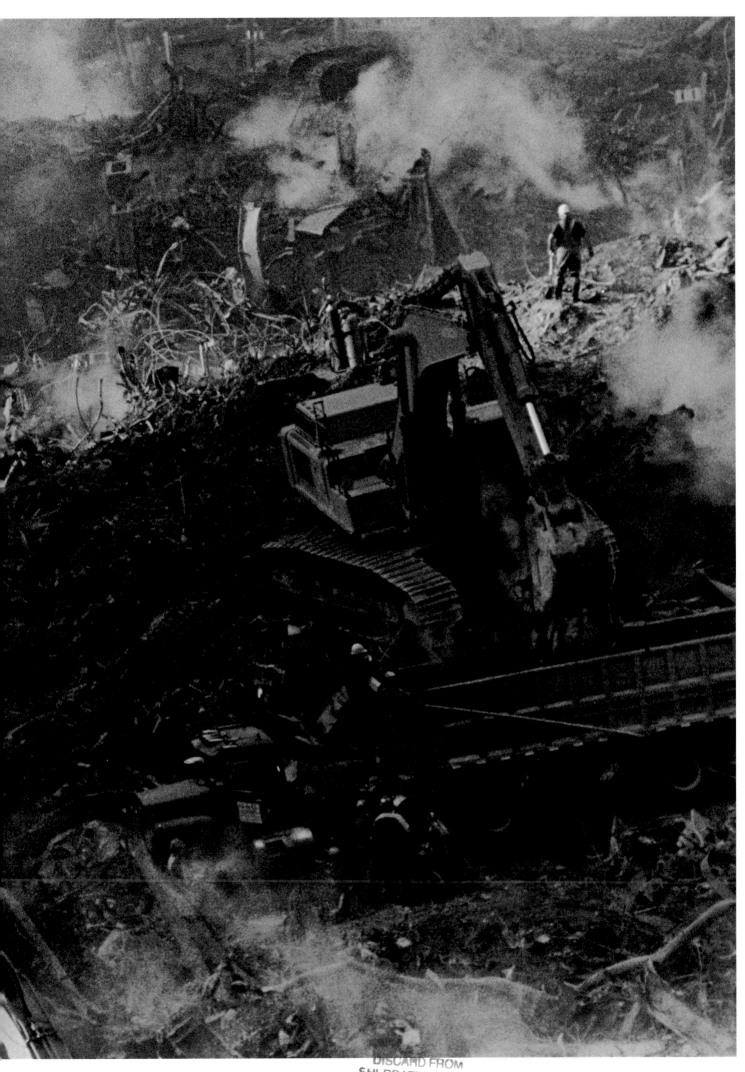

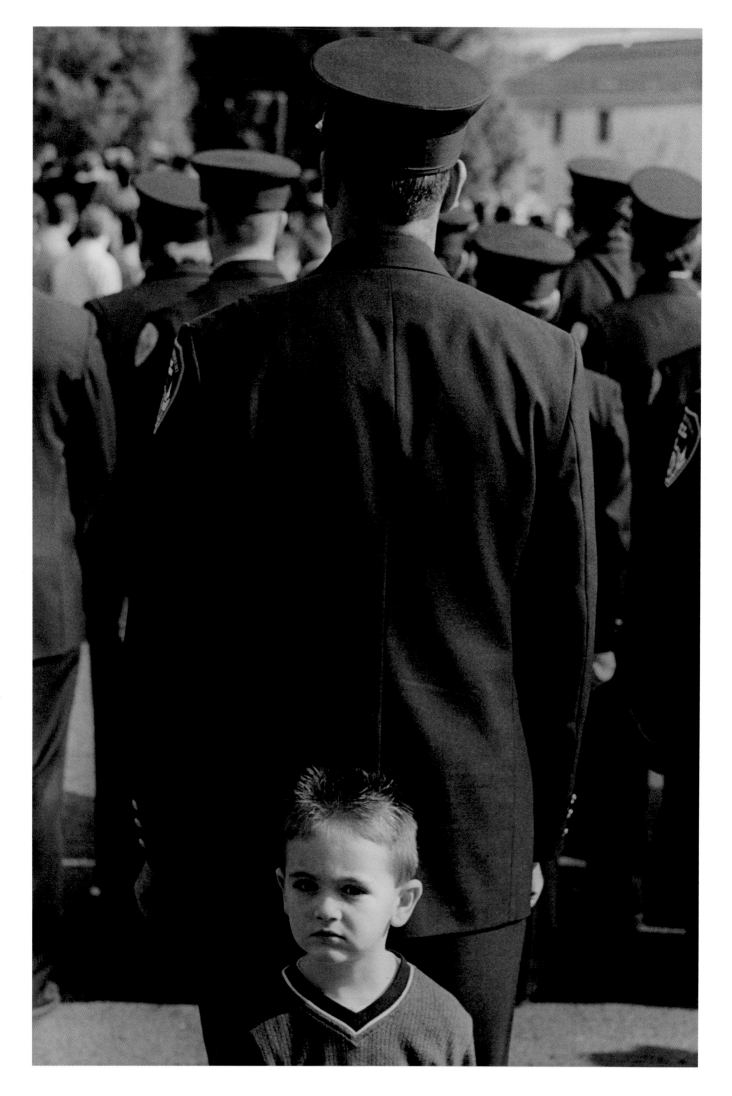

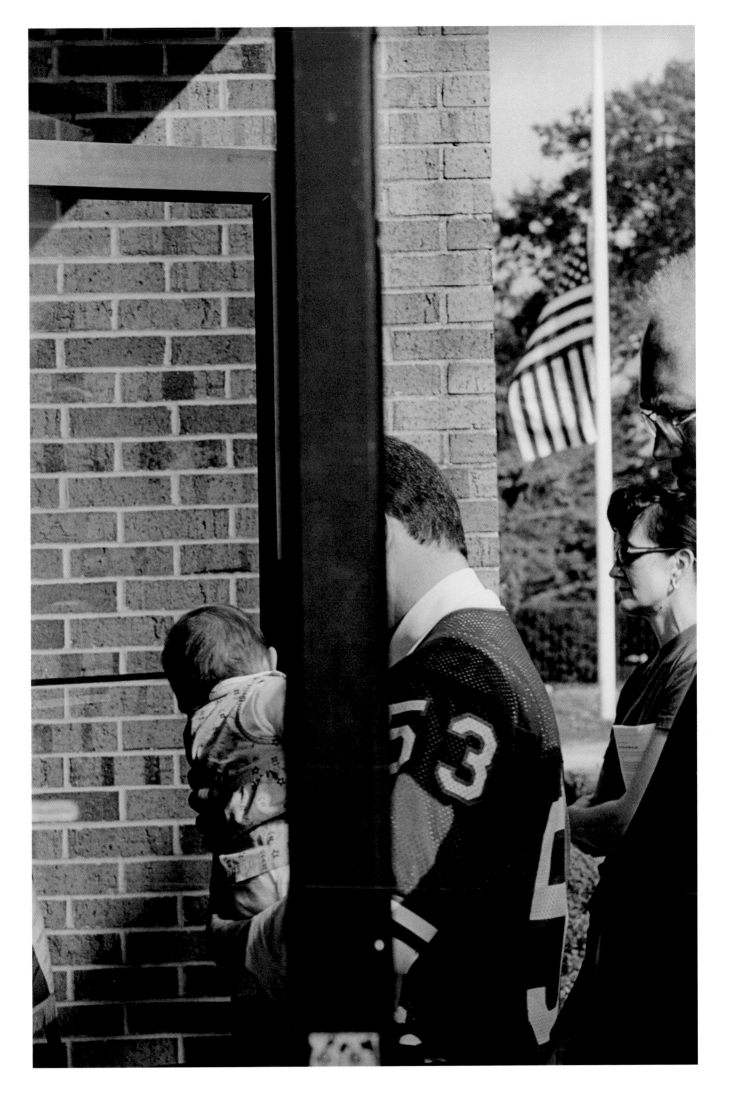

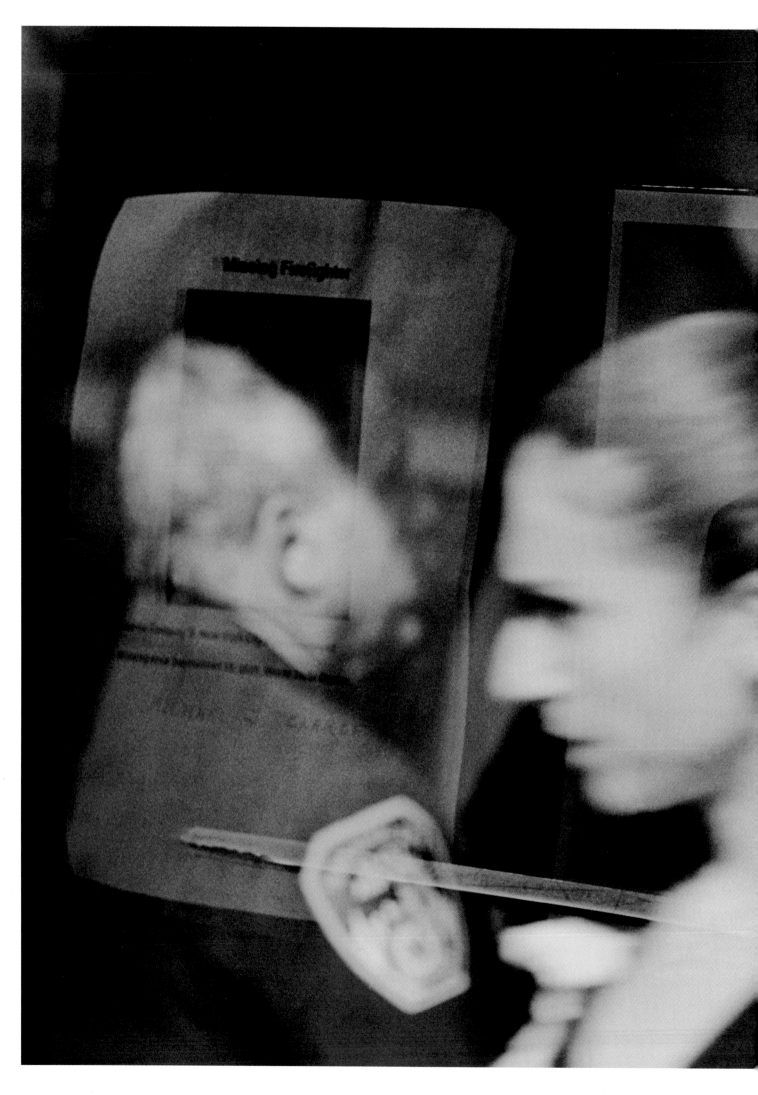

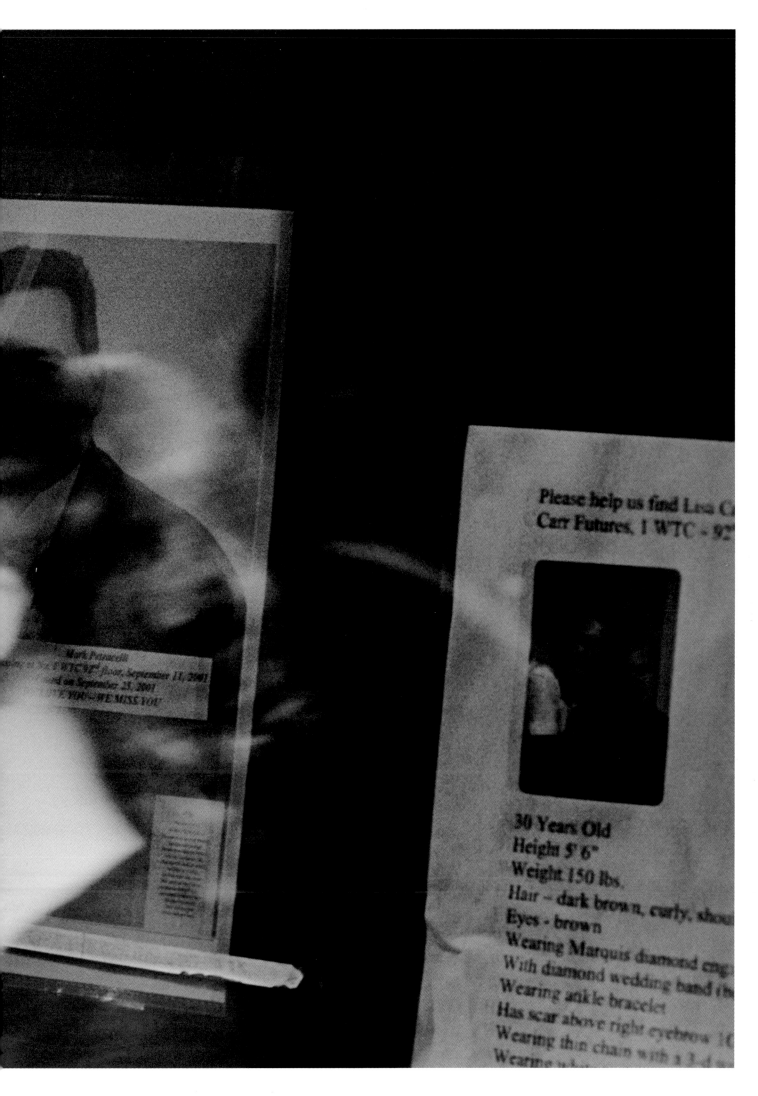

Mark Petrocelli
...ing ... the 1 WTC 92nd floor, September 11, 2001
...d on September 25, 2001
... YOU — WE MISS YOU

Please help us find Lisa C...
Carr Futures, 1 WTC – 92...

30 Years Old
Height 5' 6"
Weight 150 lbs.
Hair – dark brown, curly, shou...
Eyes - brown
Wearing Marquis diamond eng...
With diamond wedding band (b...
Wearing ankle bracelet
Has scar above right eyebrow (...
Wearing thin chain with a 3-d...
Wearing...

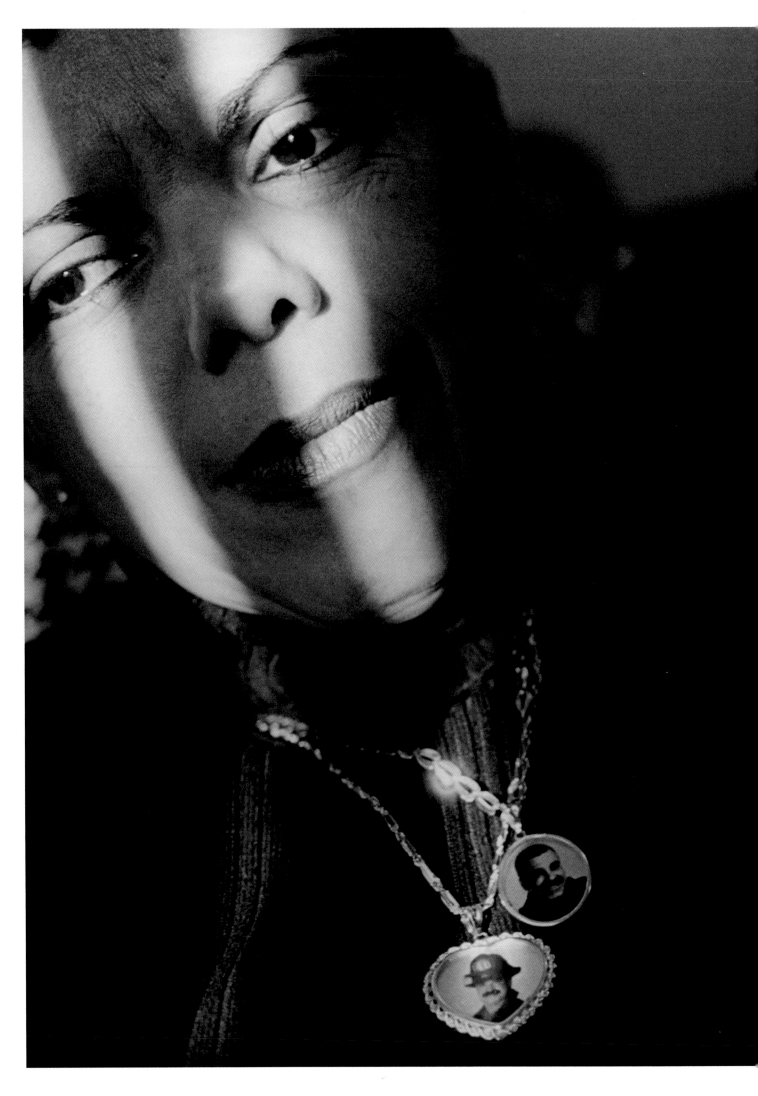

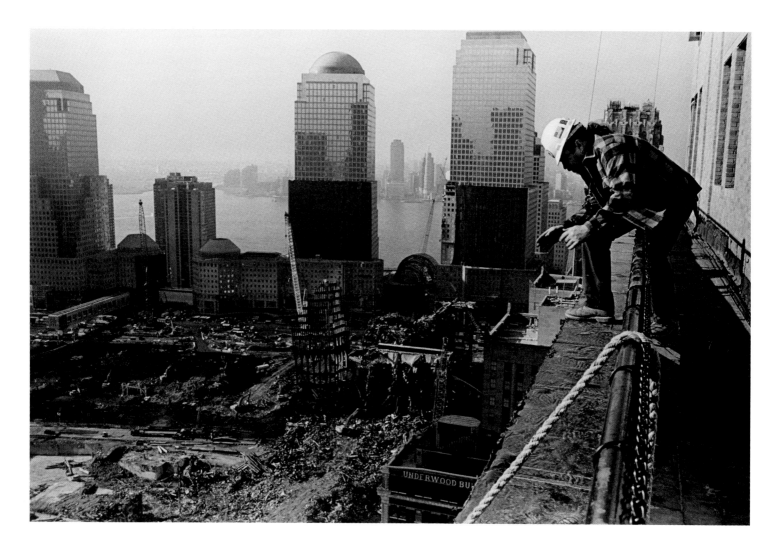

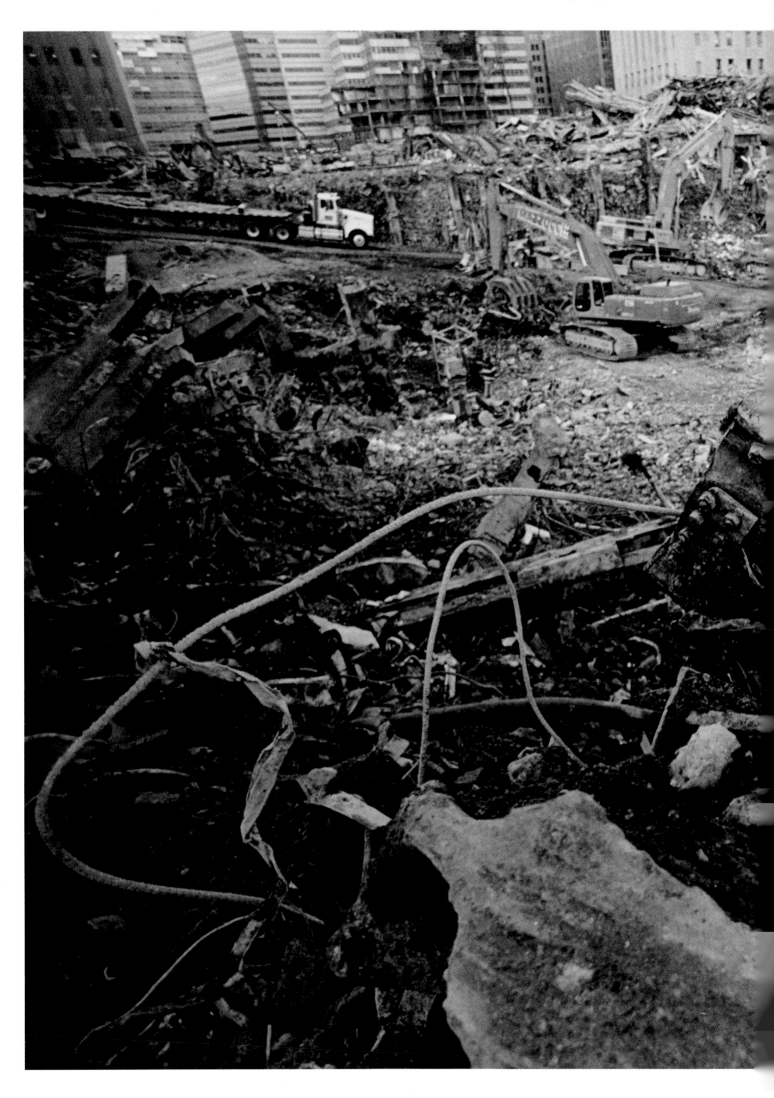

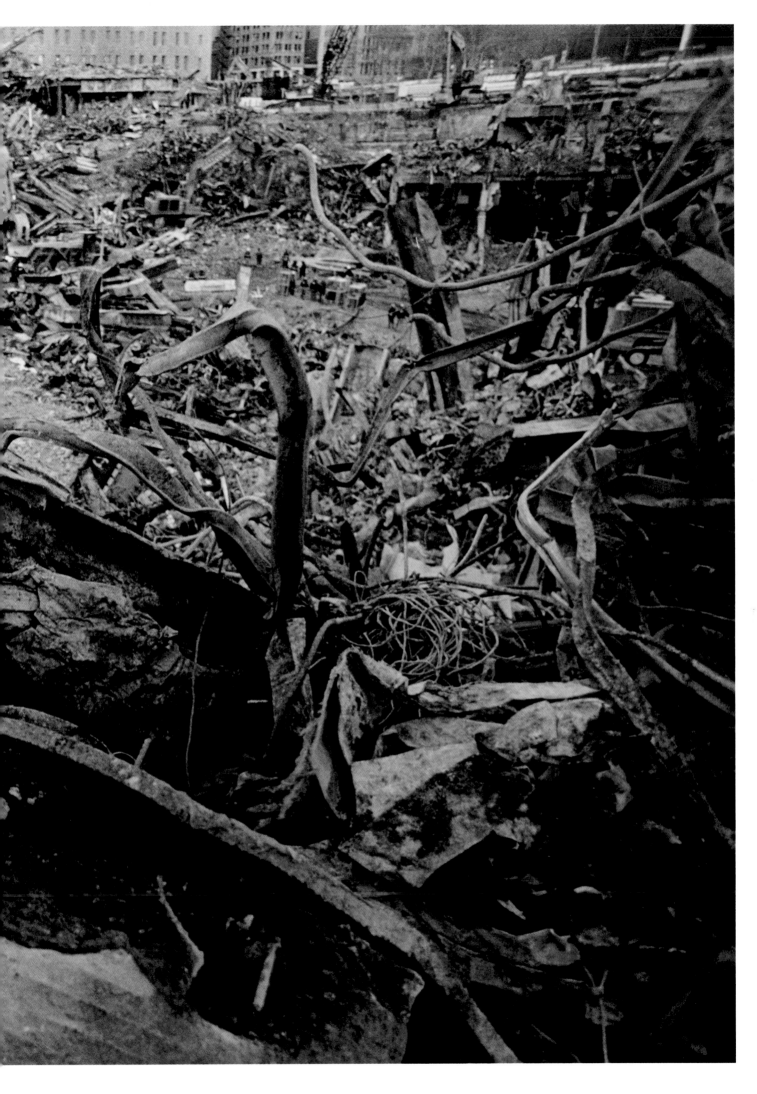

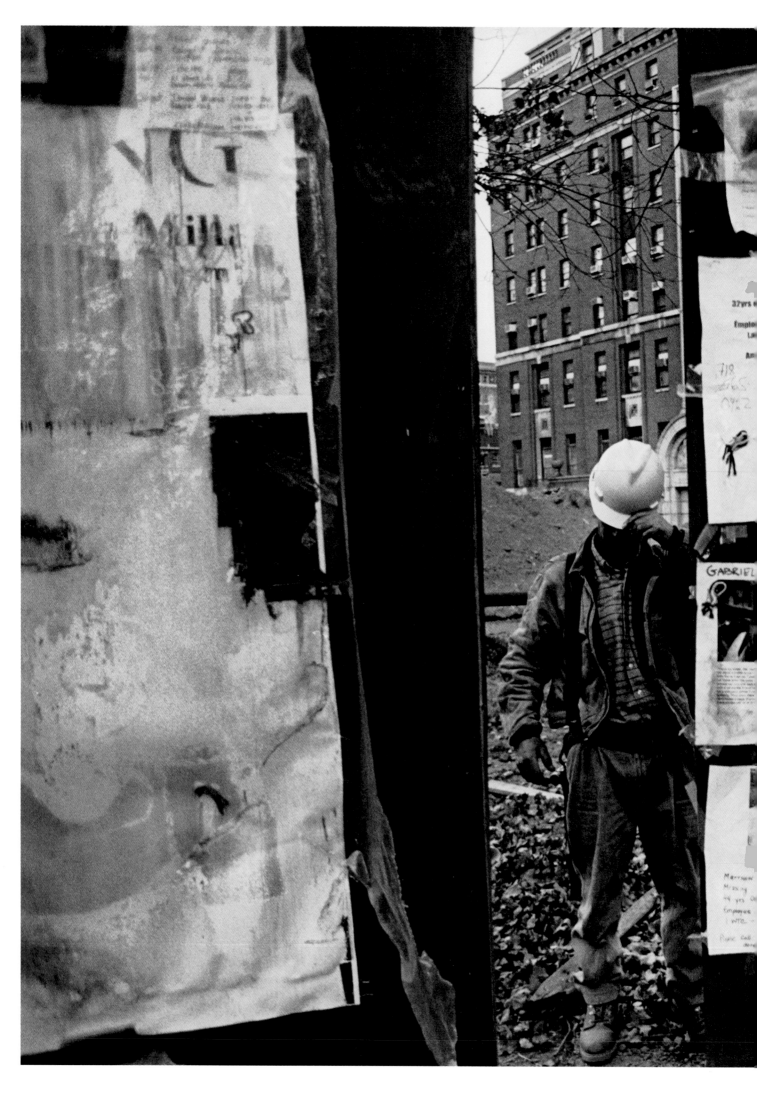

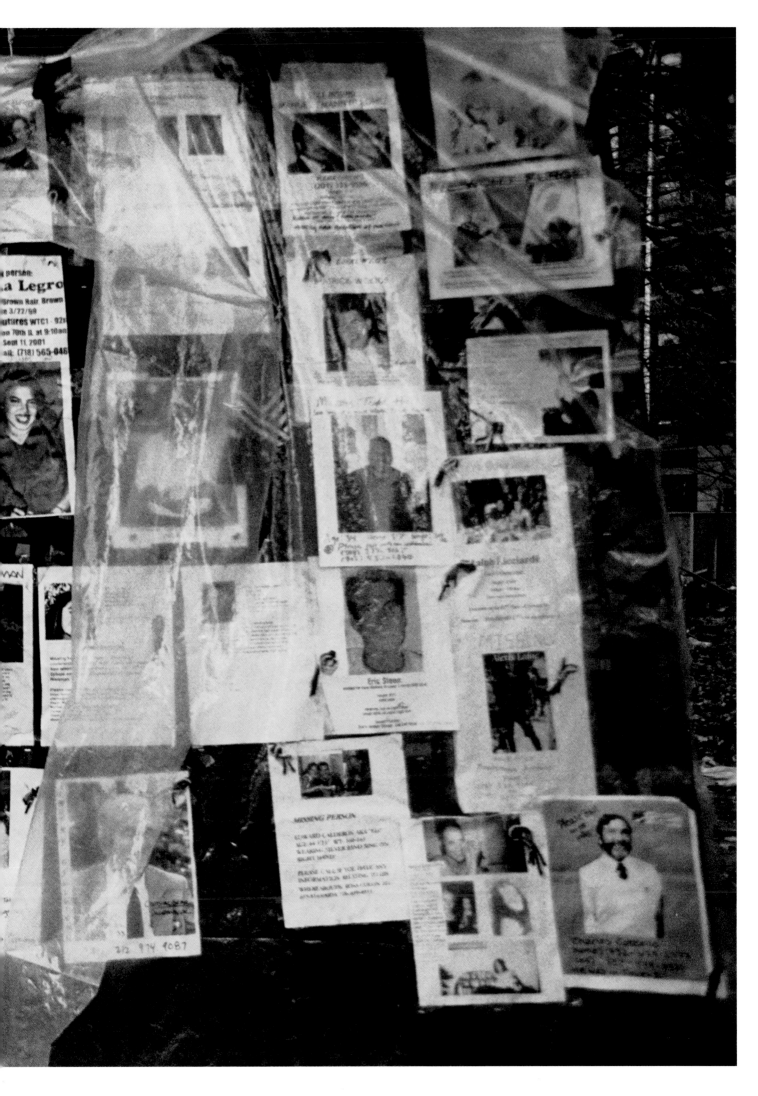

John P. Skala

Missing

Port Authority Police Officer
and Paramedic

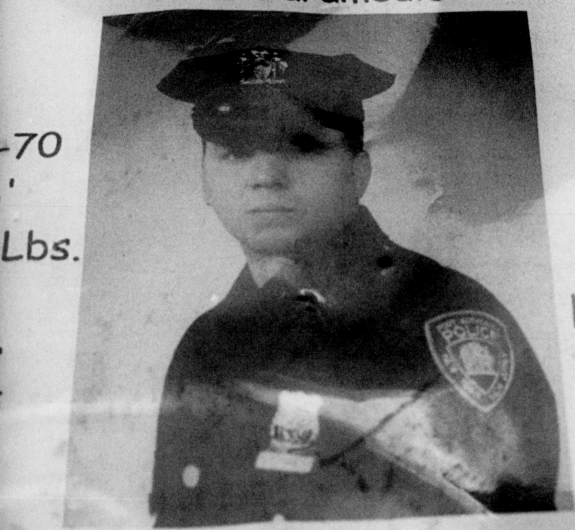

0-70

6'

Lbs.

Last
unif
his p

Lincoln Tunnel. The only one of his

Loving Brother, son, and friend

has the courage of a lion who k

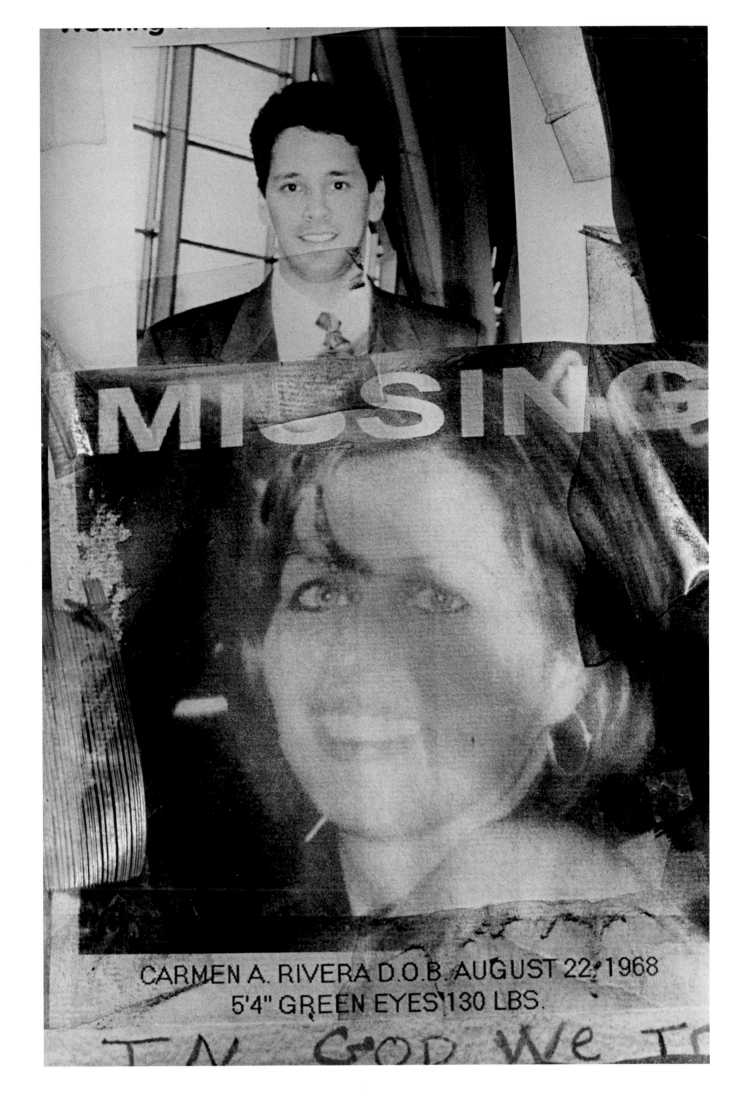

CARMEN A. RIVERA D.O.B. AUGUST 22, 1968
5'4" GREEN EYES 130 LBS.

HERO

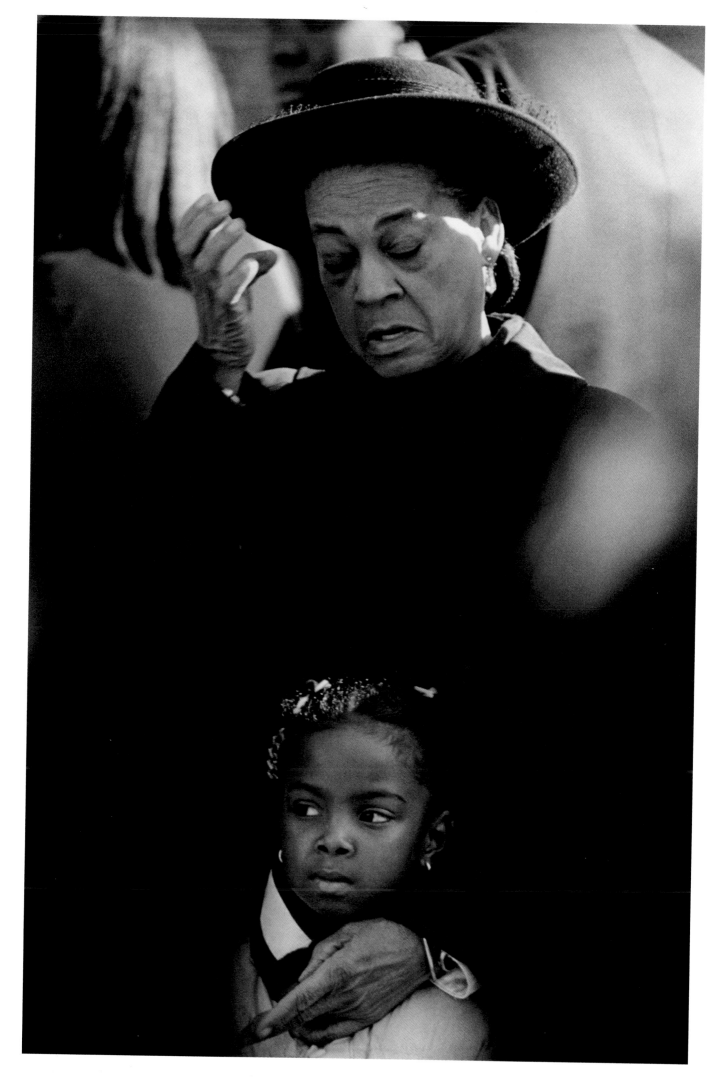

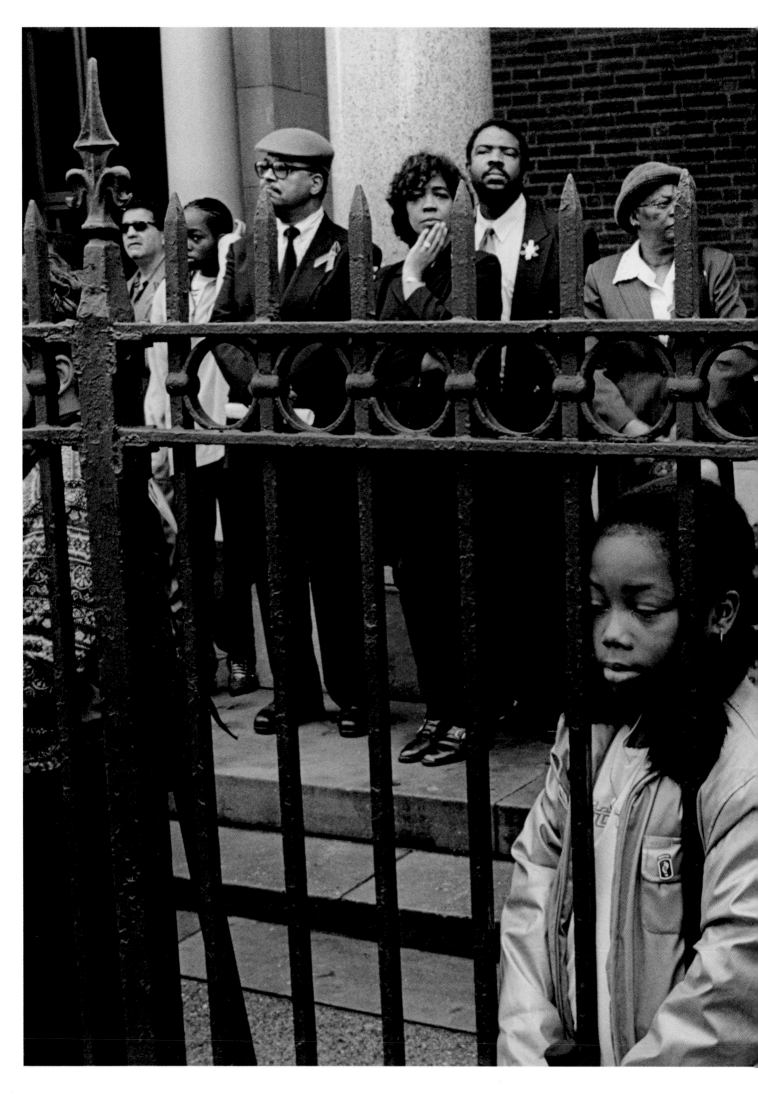

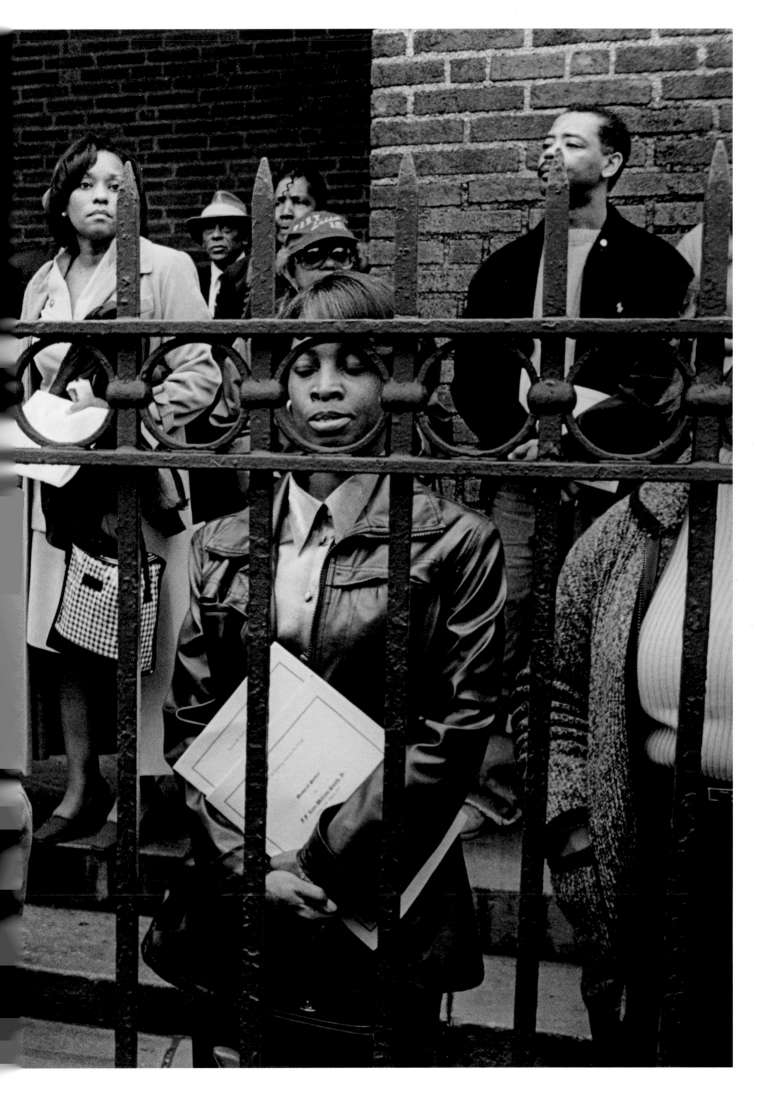

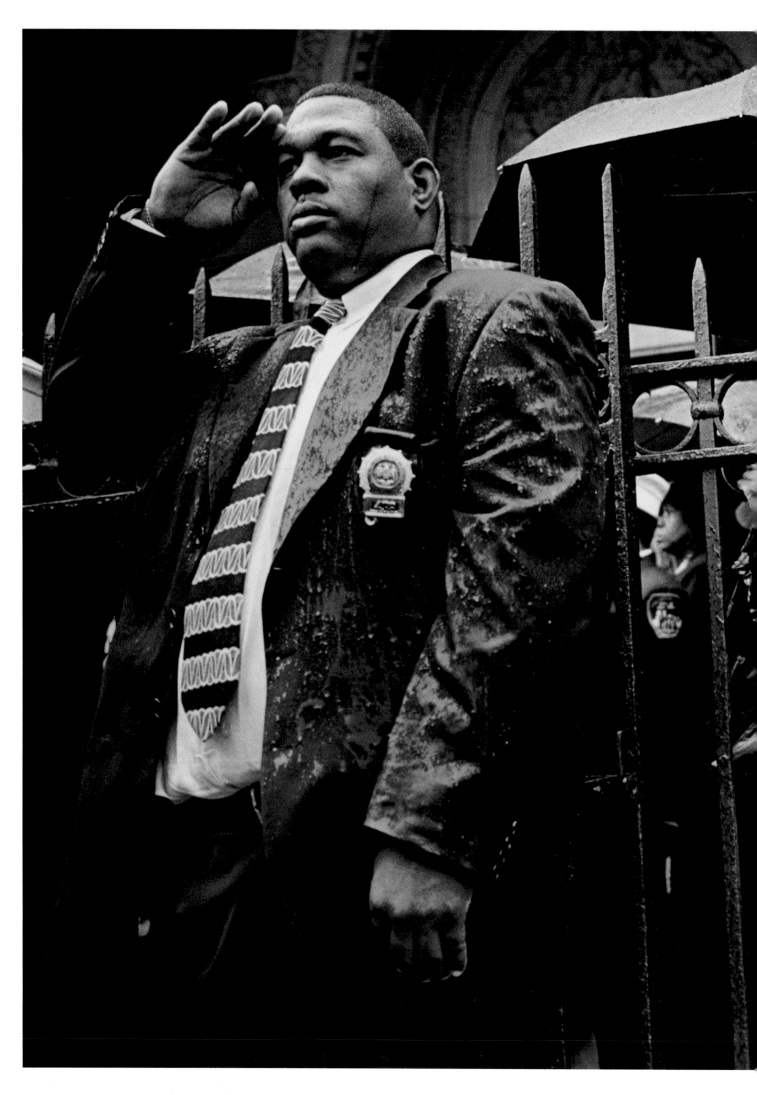

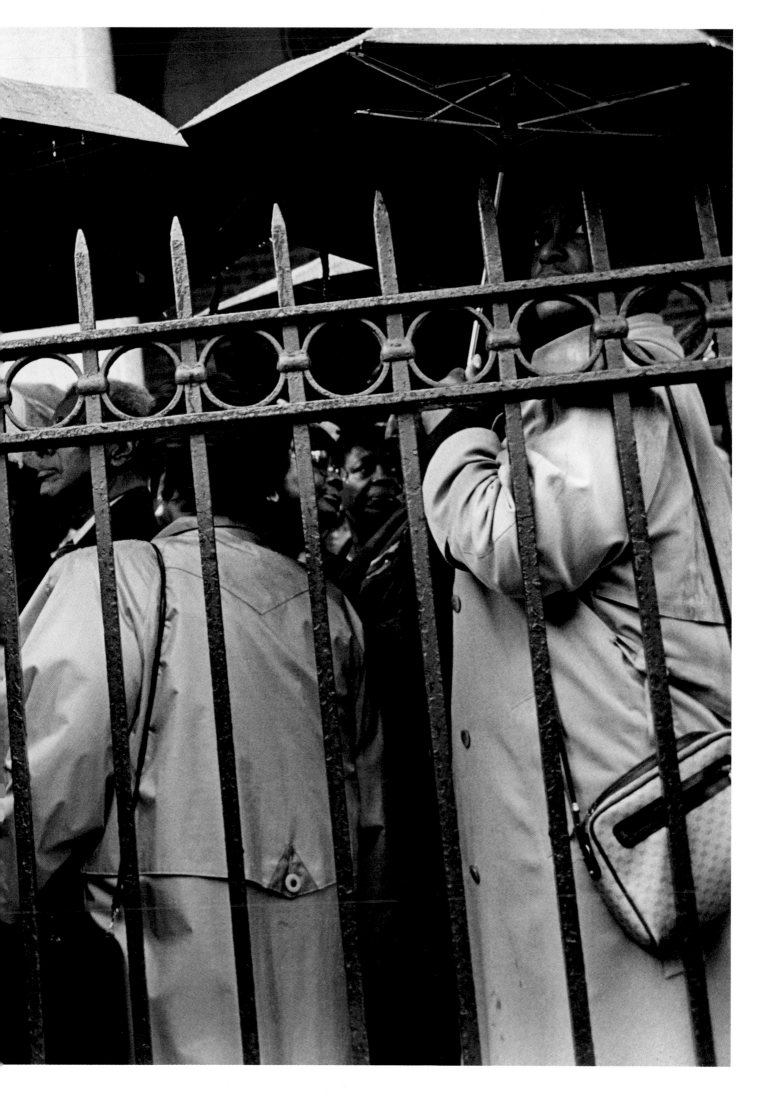

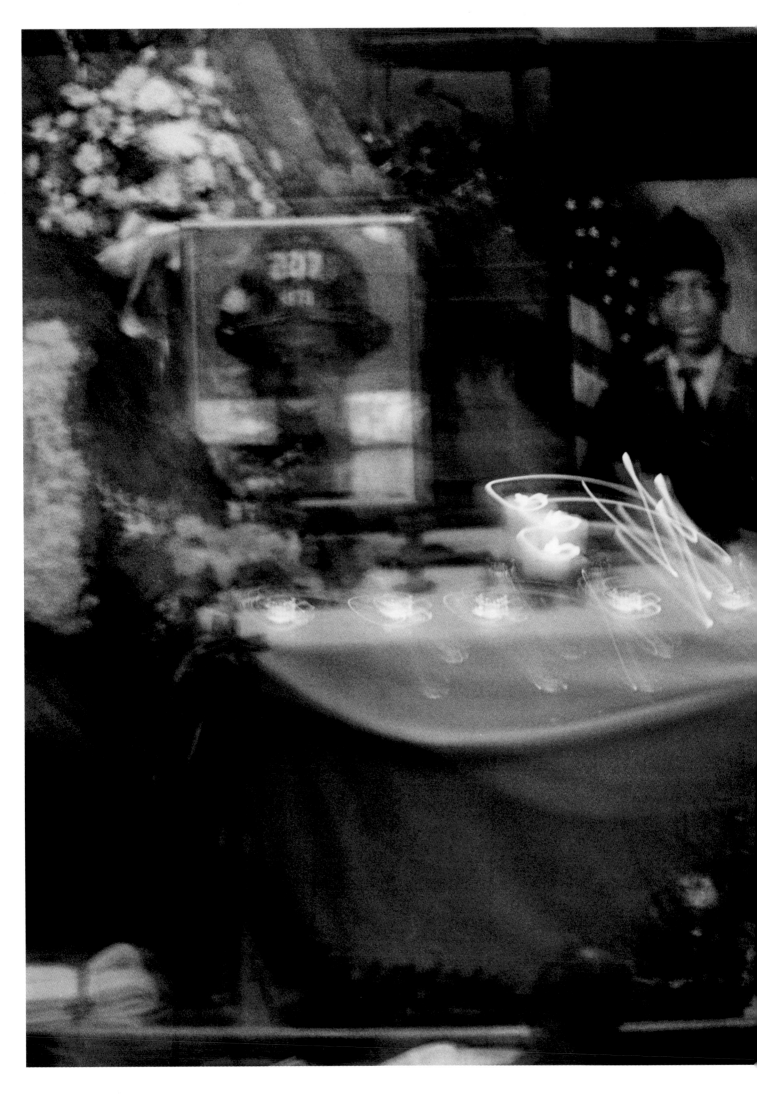

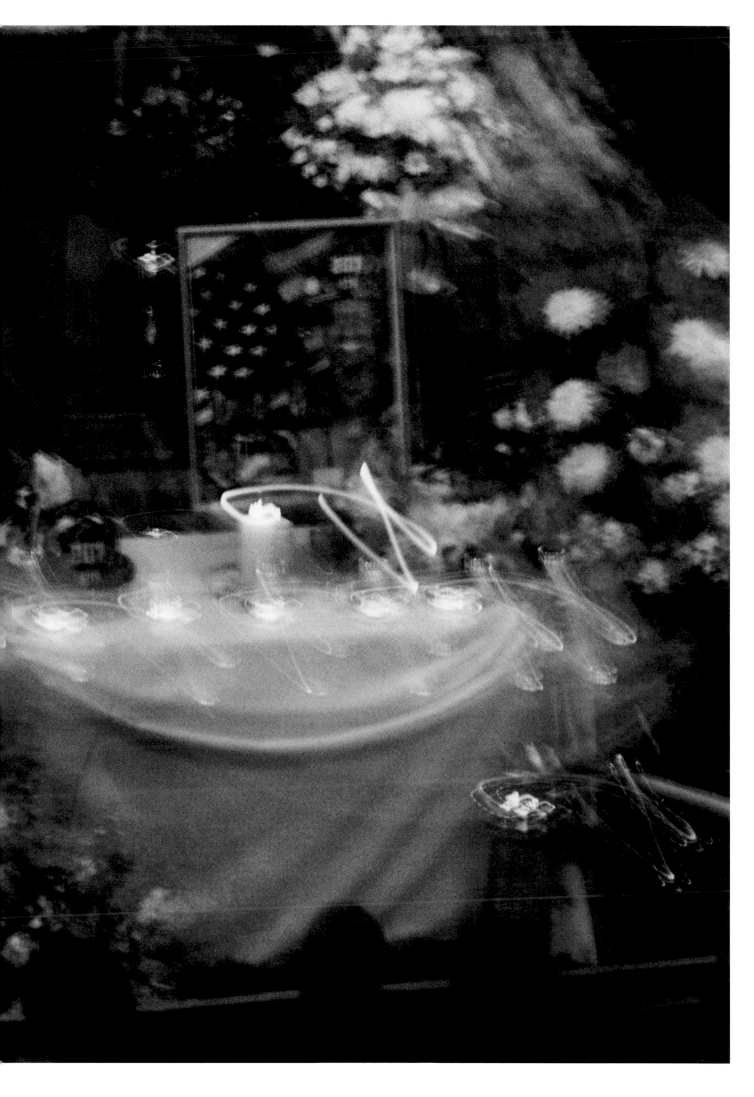

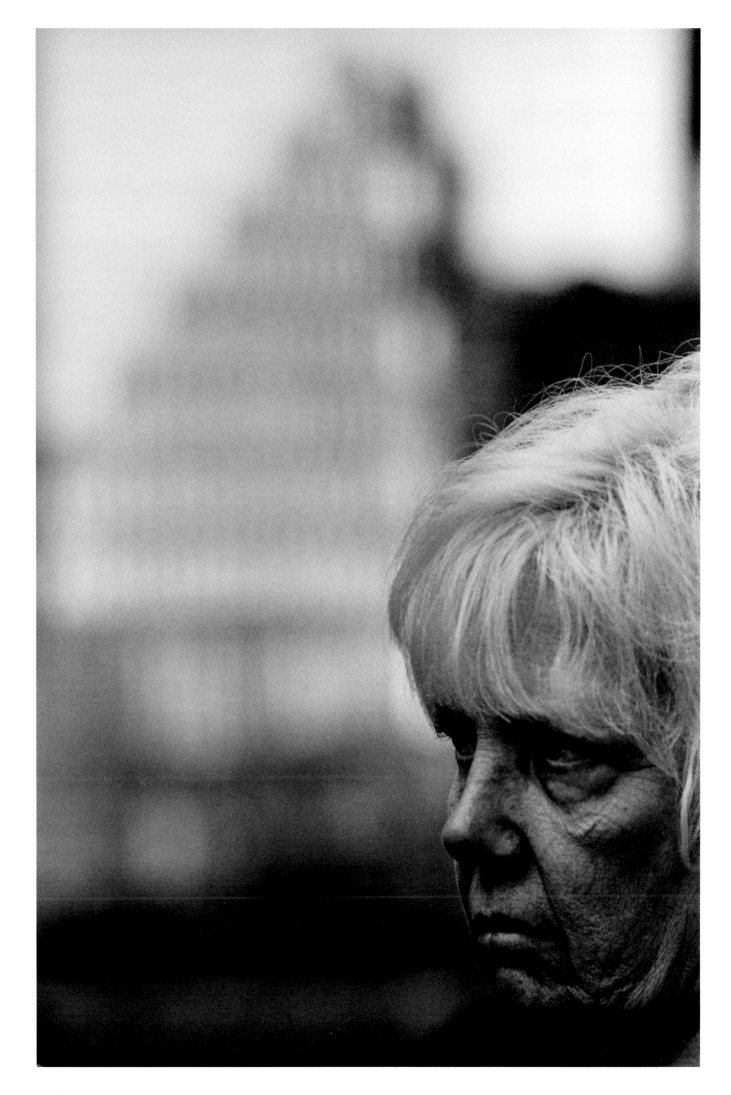

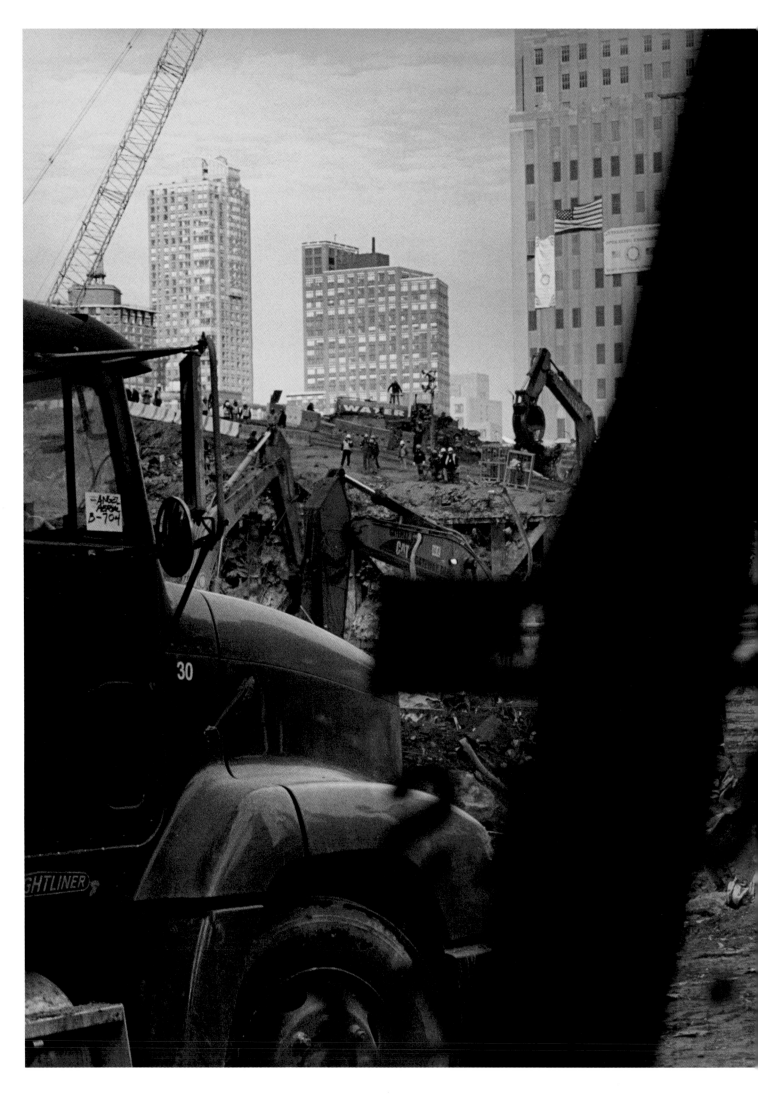

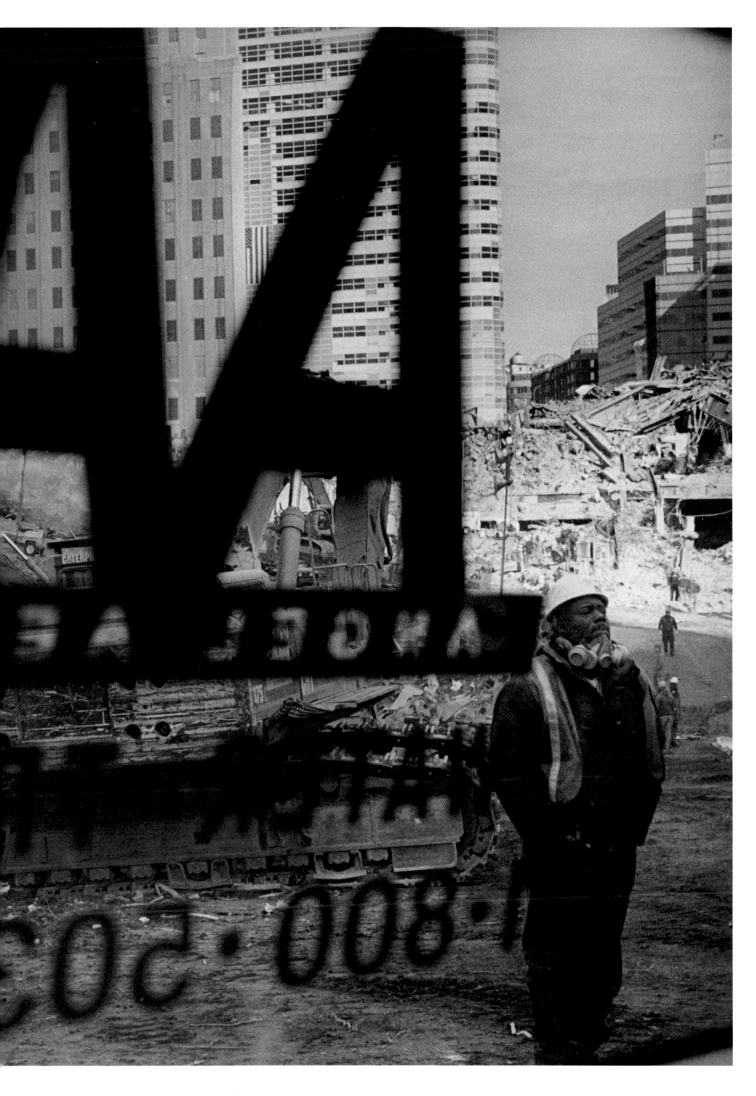

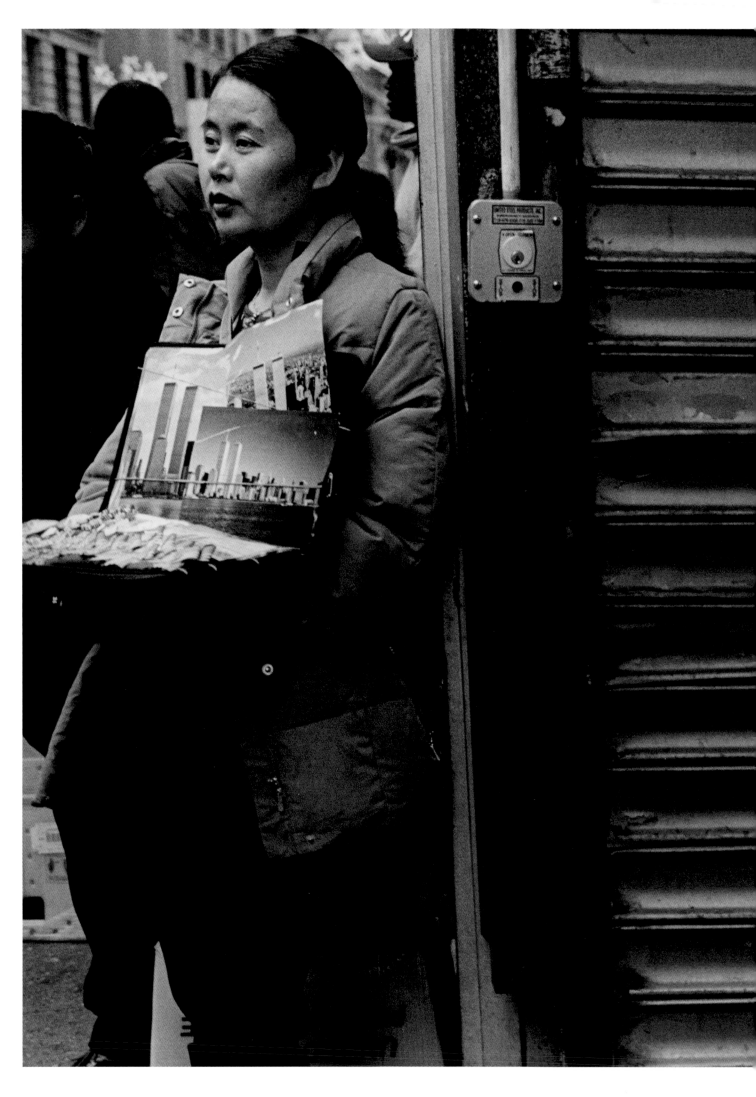

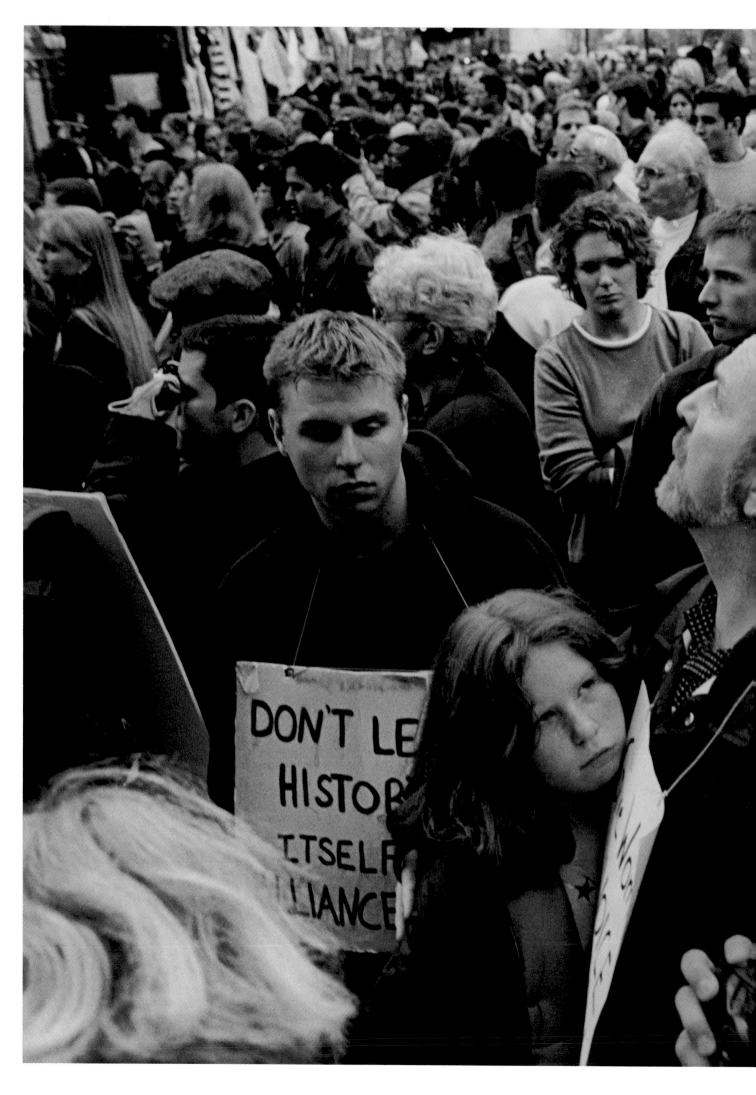

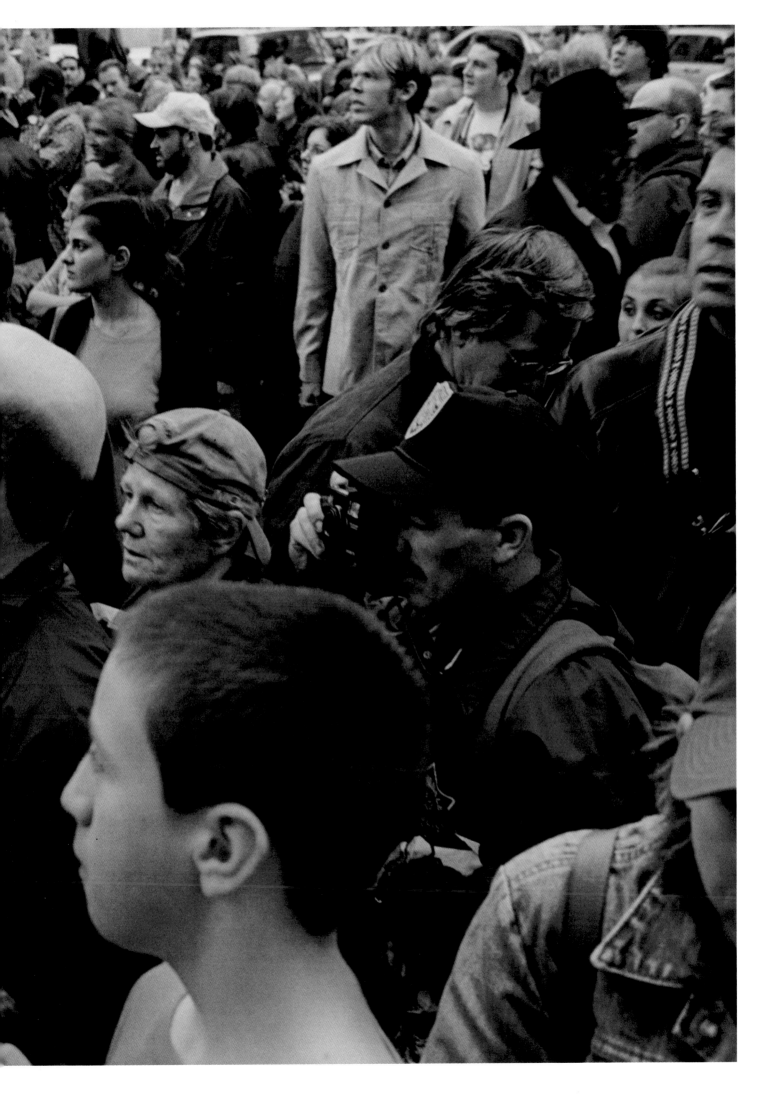

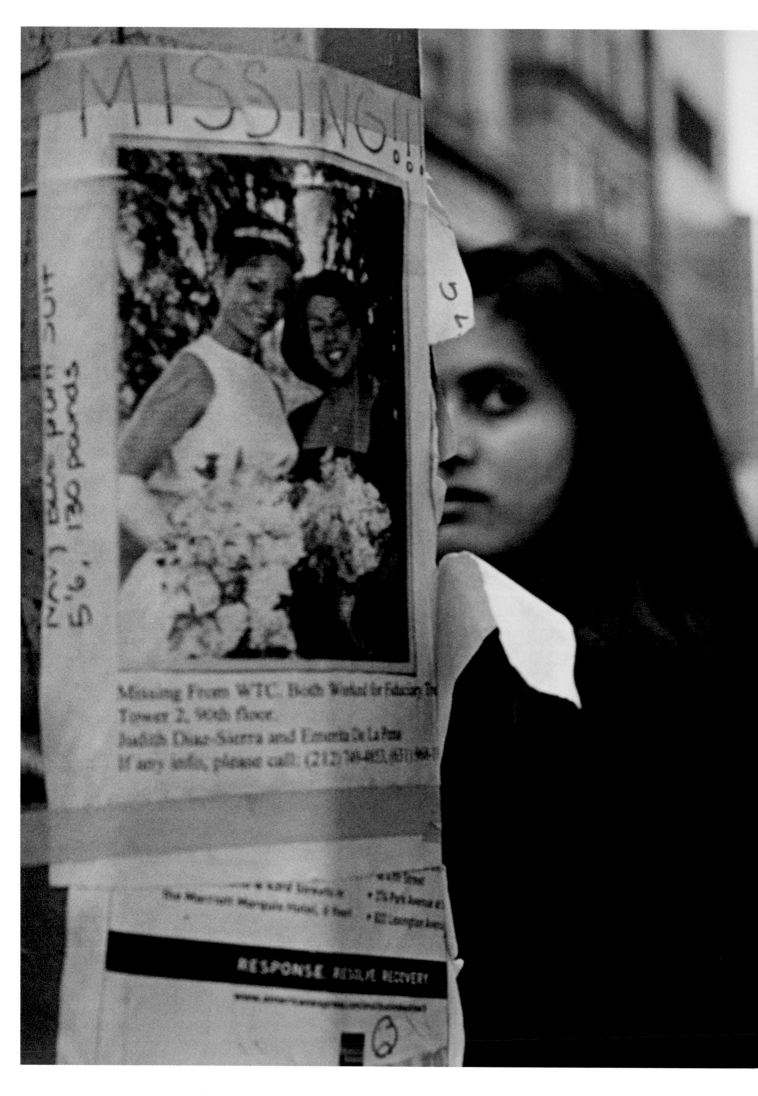

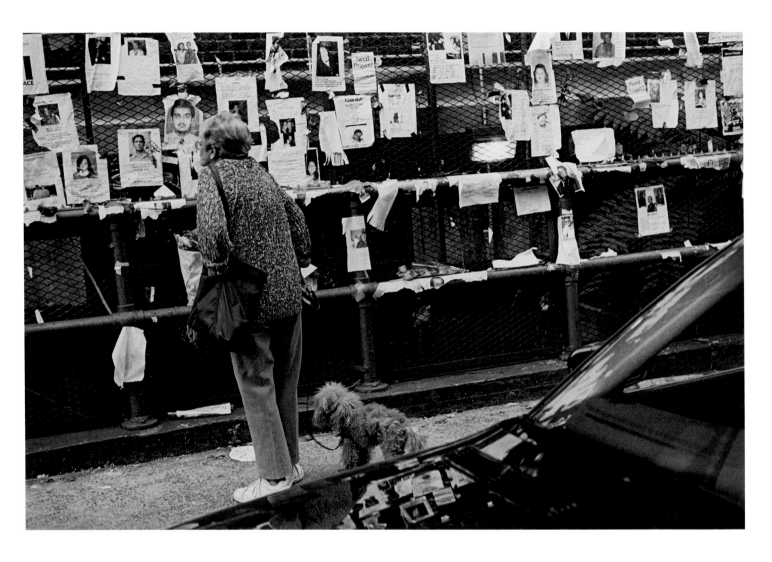

In Afghanistan, as allied forces move

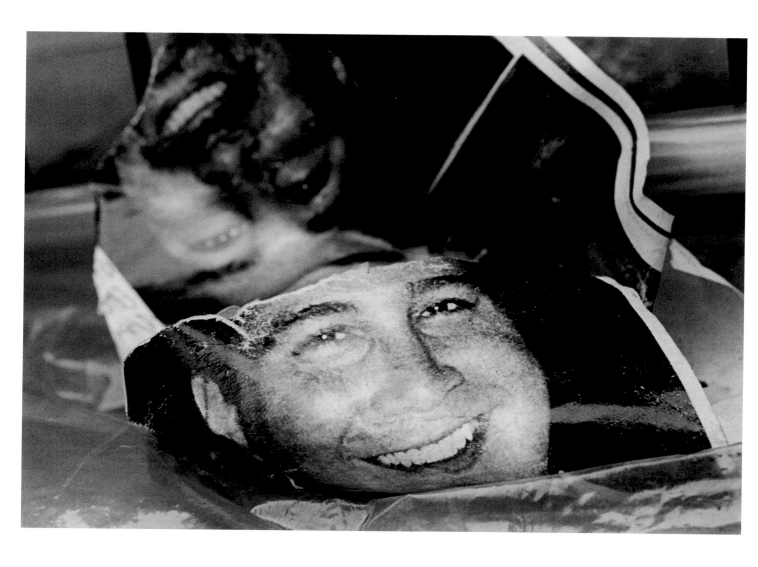

against the Taliban, there are reports of increasing numbers of civilian casualties.

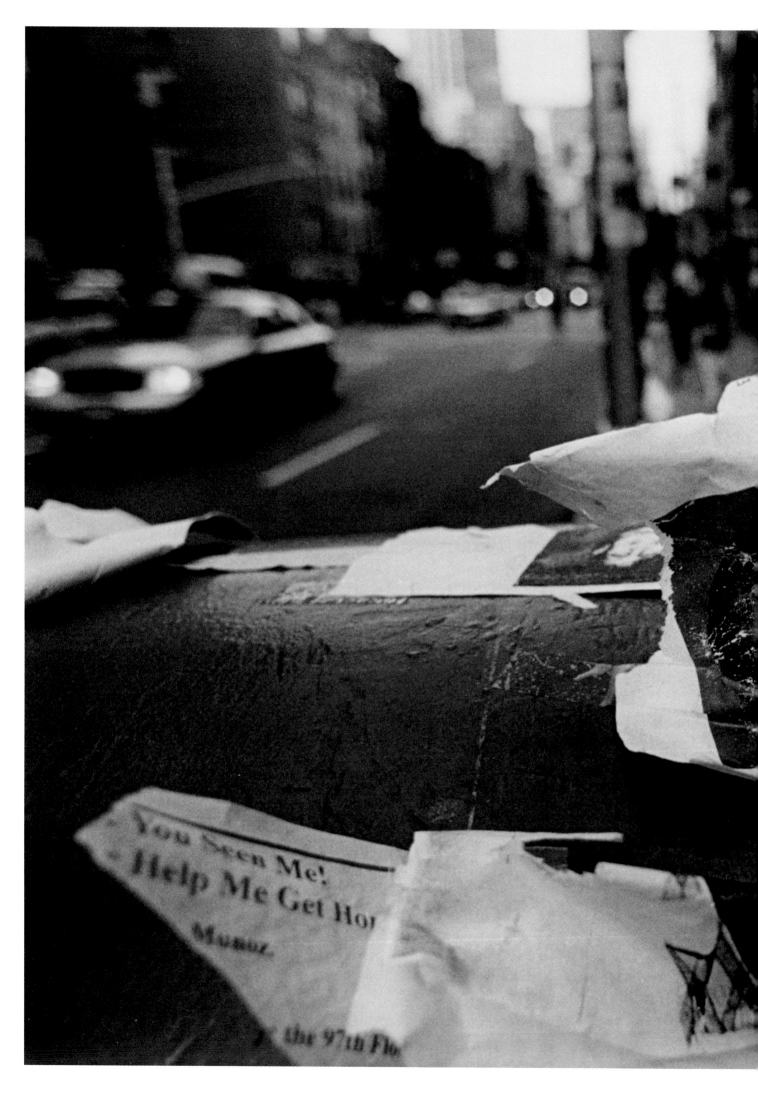

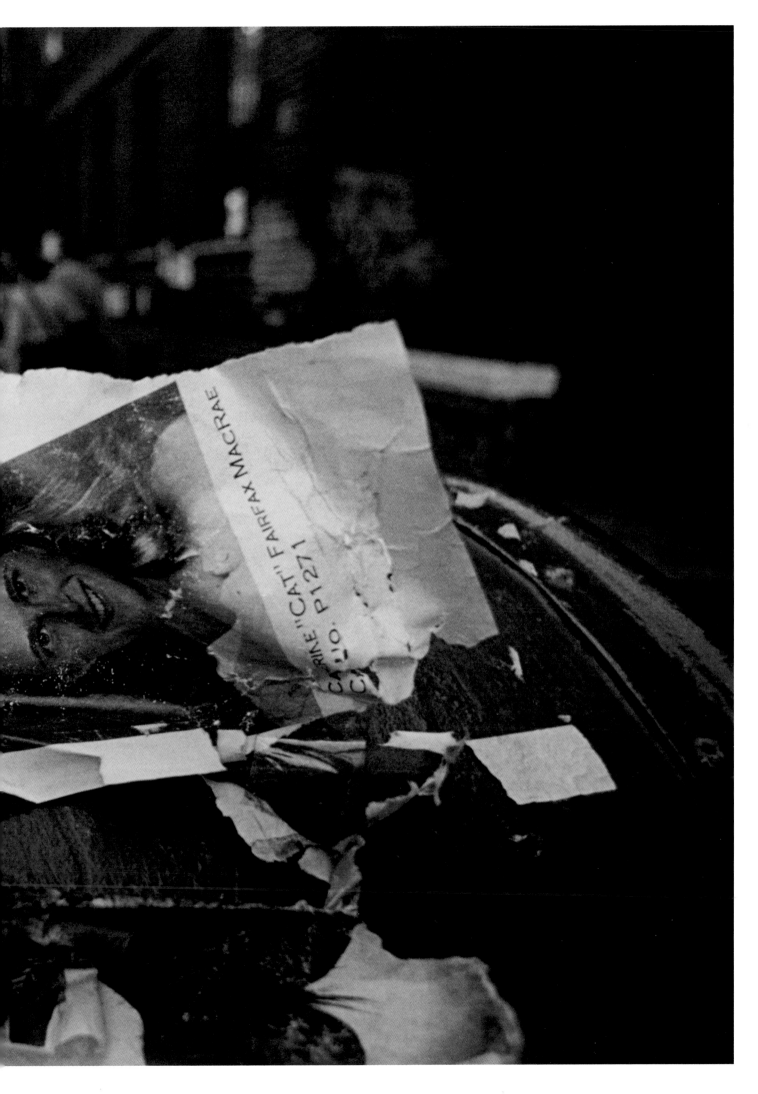

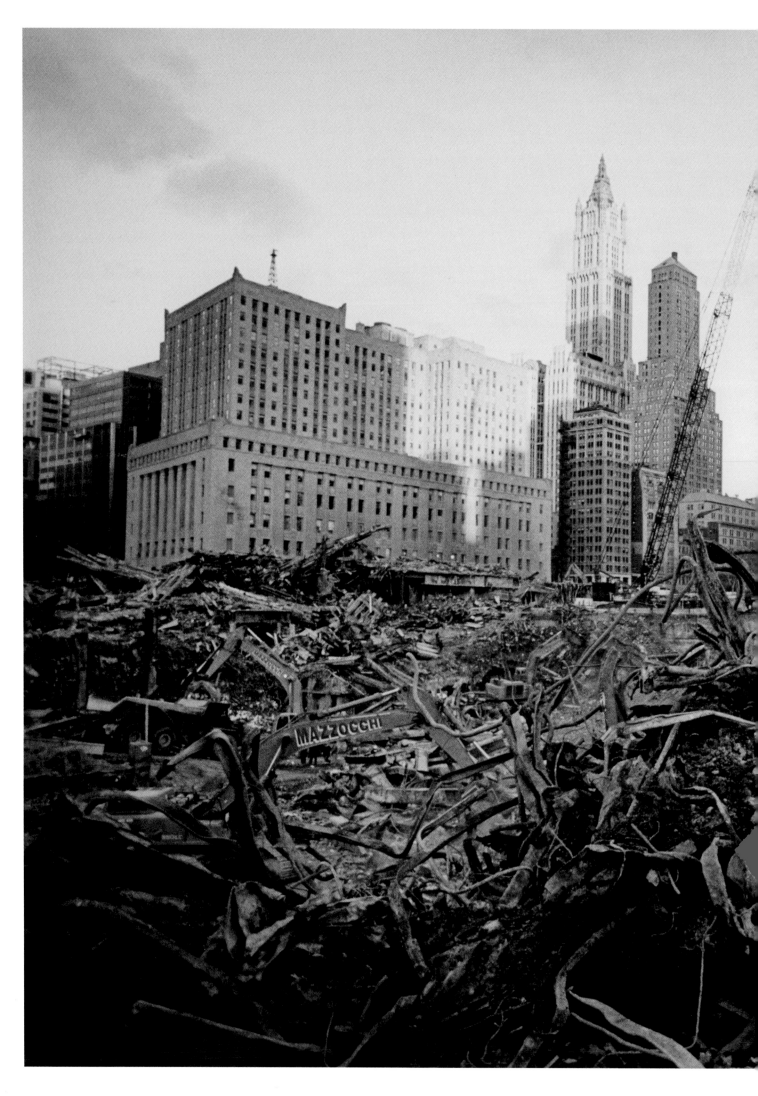

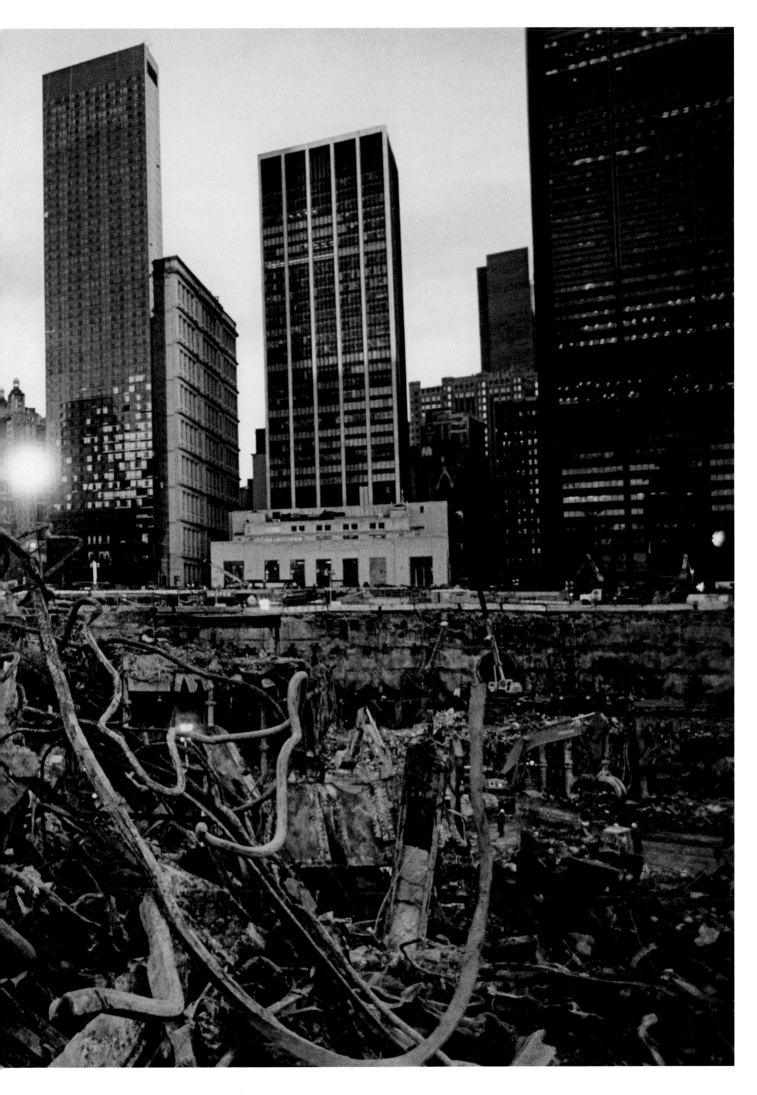

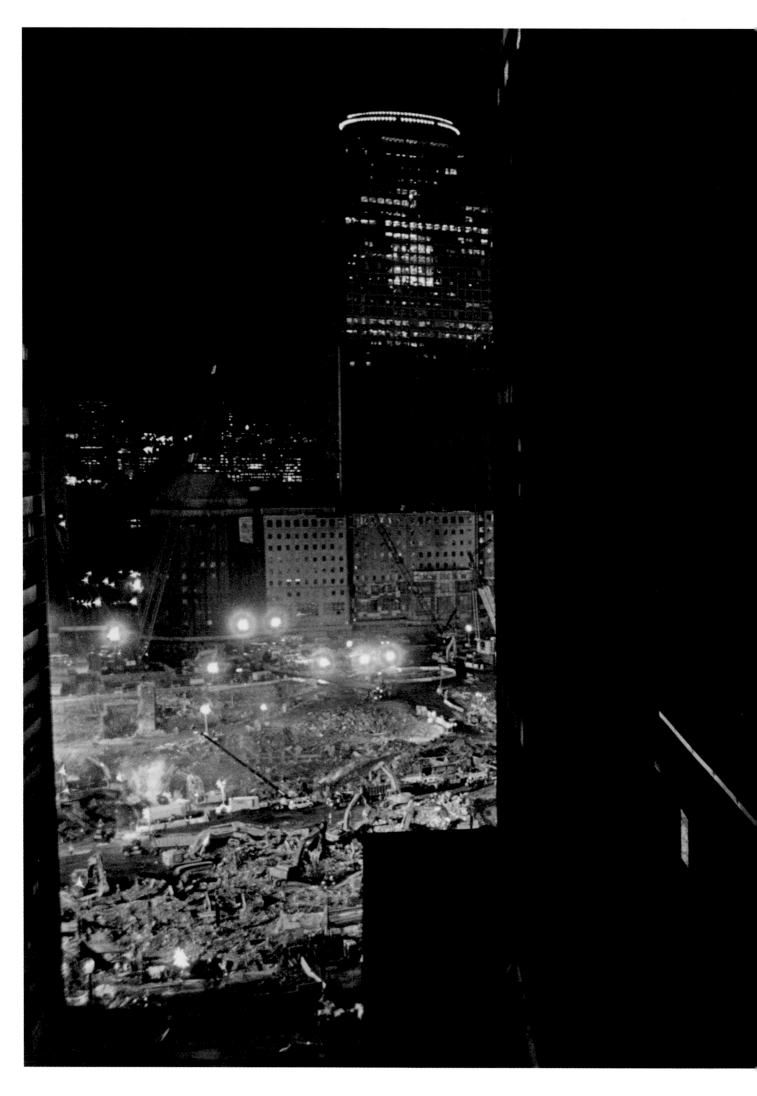

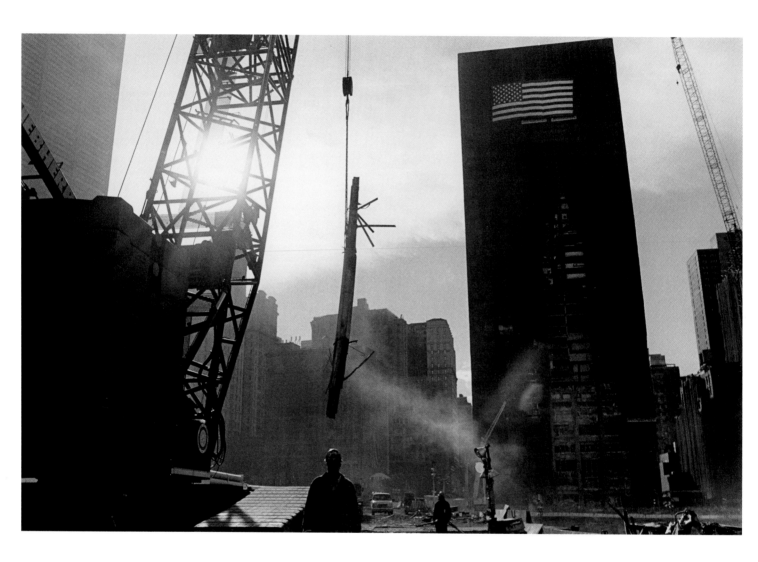

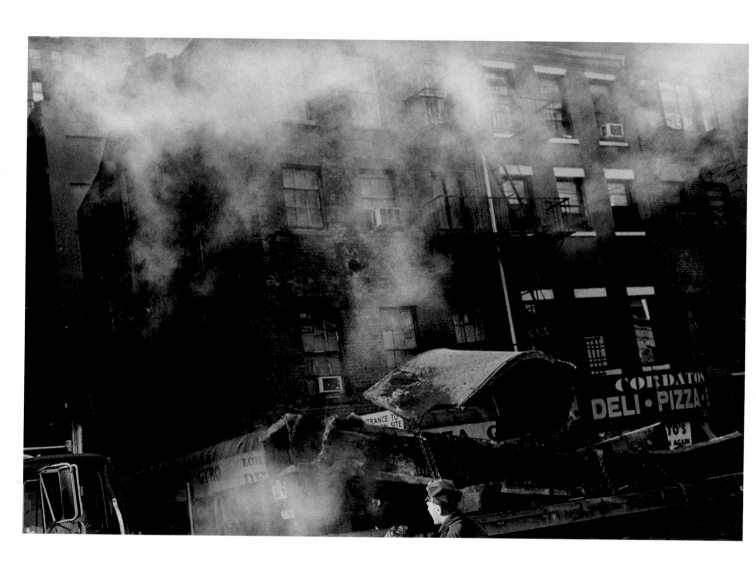

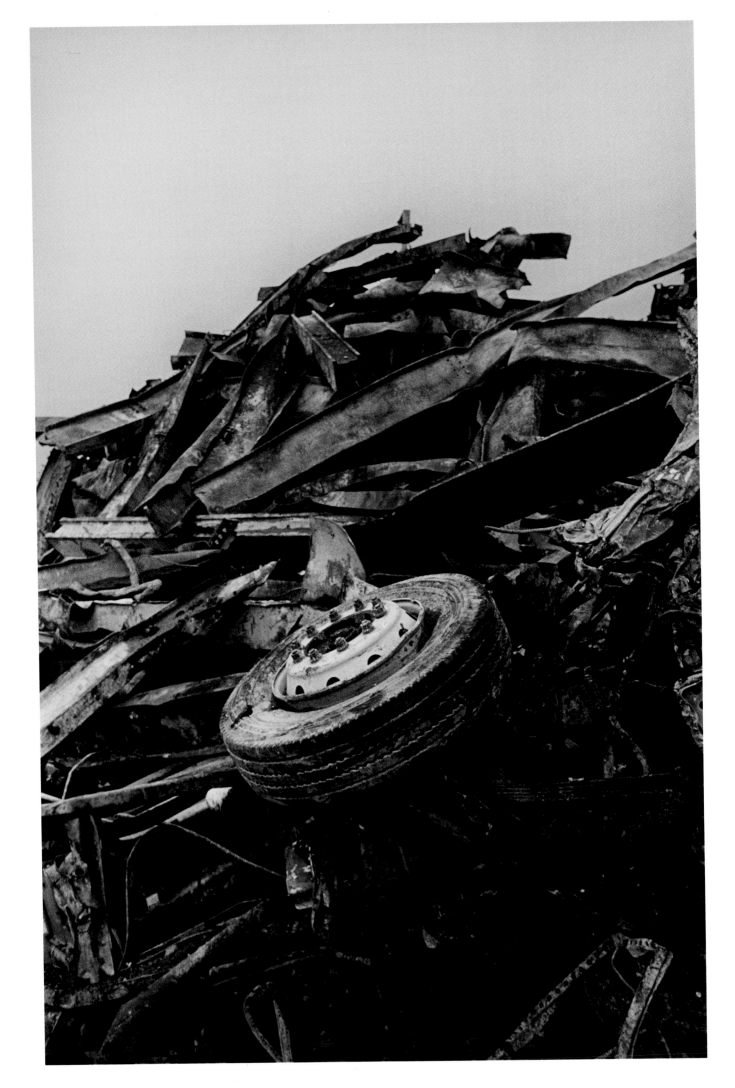

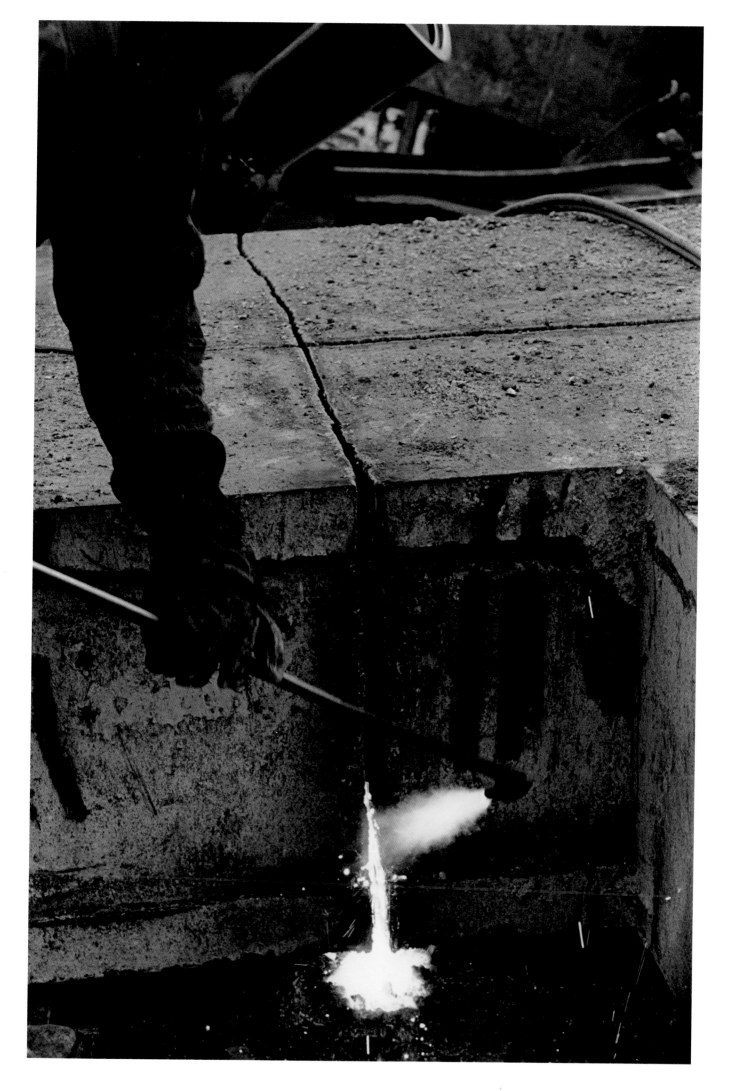

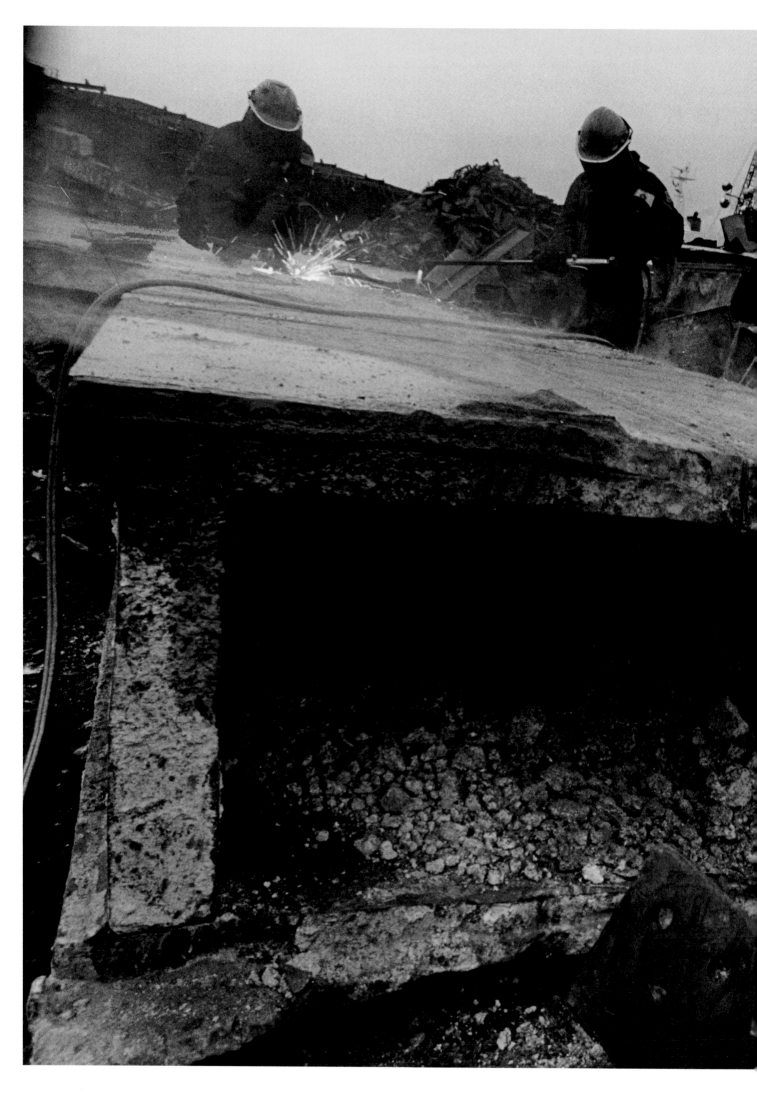

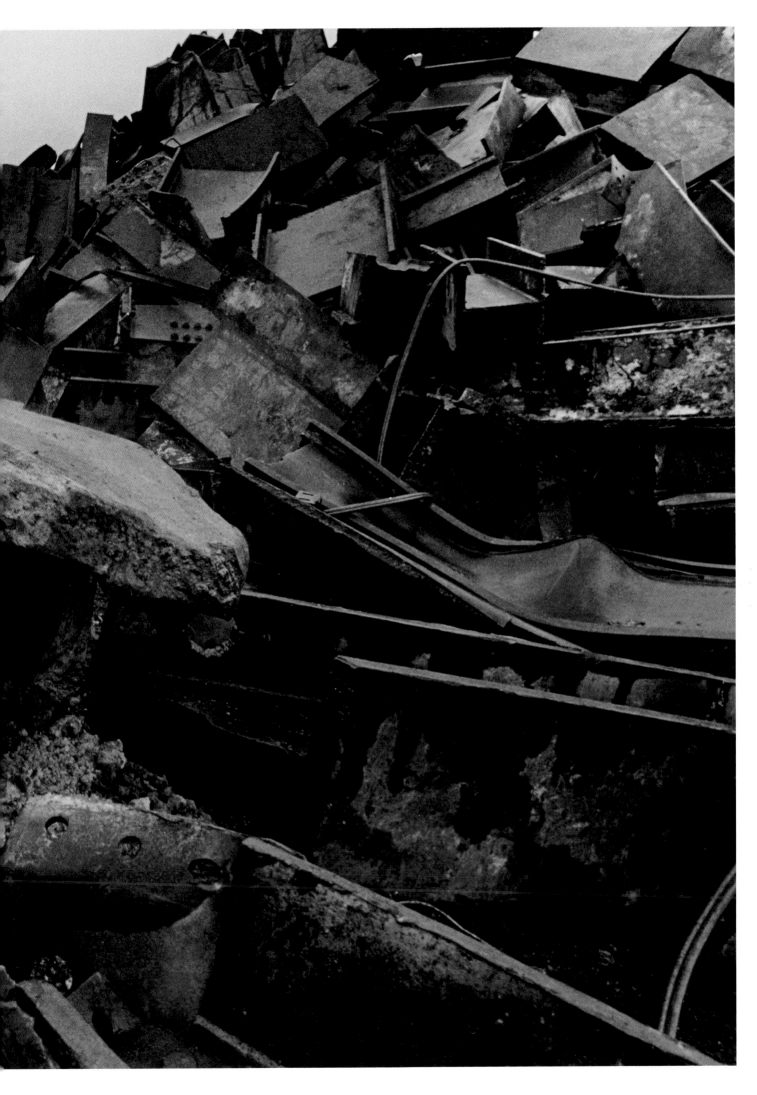

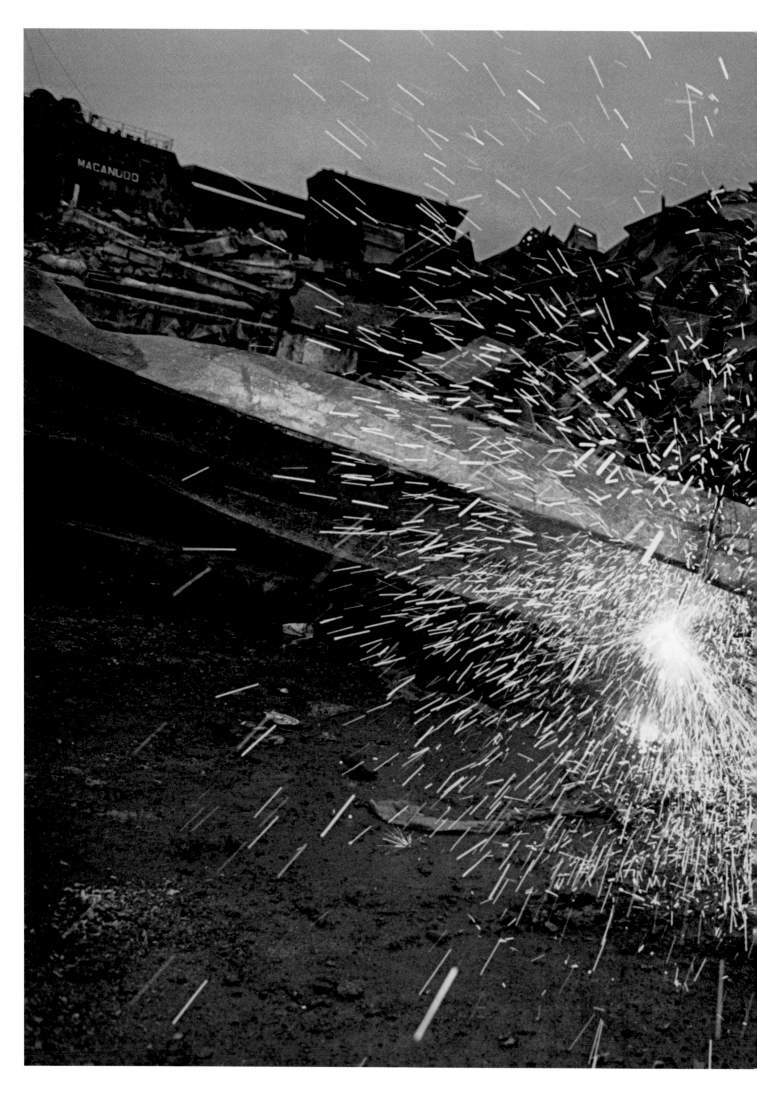

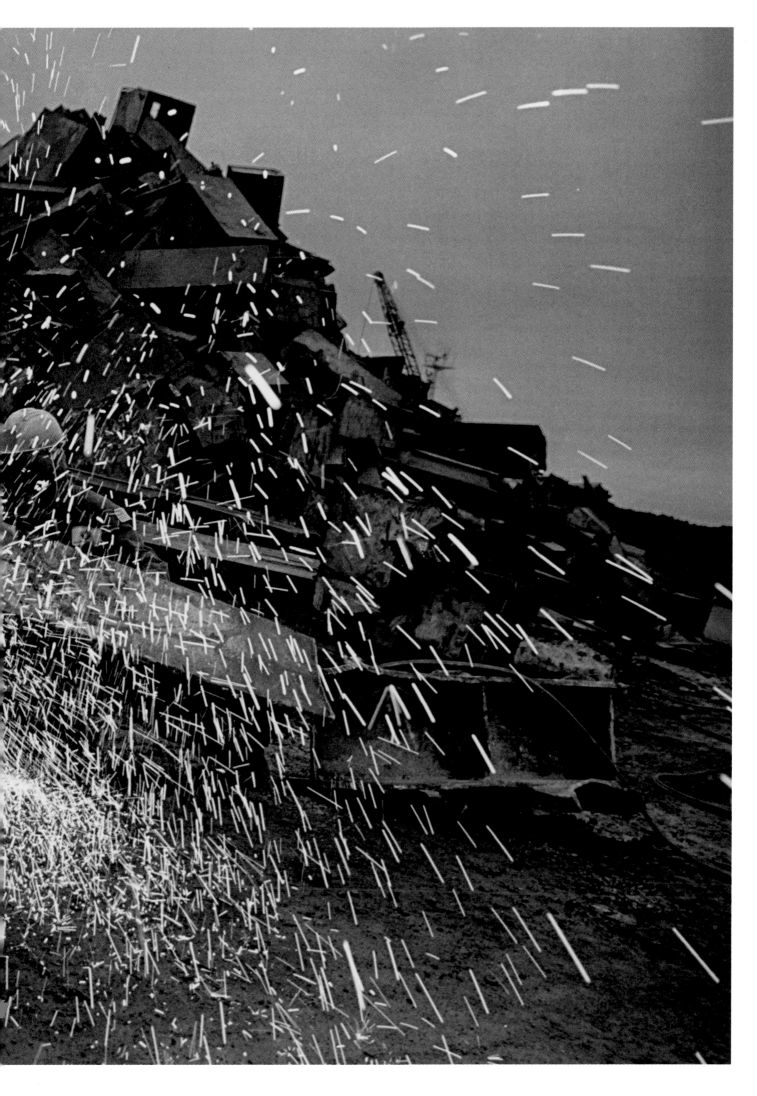

161

ARJAN MIRPURI: This is a habit that I like. My wife do once in a day, I do all the time. I just touch the feet of the gods and take blessings. Go in front of the gods' pictures and bow down. And I kiss my son's picture. That I do maybe twenty times in a day.

We believe in karma, you know. Many times a person has to be born before coming to this body, four hundred thousand, before he come back to human form. But if his karma is good, he comes immediately. Immediately means twelve months. Or if his karma is very good, then he never comes back to the world, he goes to the gods.

Many times I feel that Rajesh is sitting in the room, and I should not put my TV volume up because he's sleeping. This is how we feel, you know. And he's always with us. He's always with us. . . .

KAMILA MILEWSKA: My brother's friend from Poland, he told me, "You know, I still can't believe that Lukasz died. I just tell myself, 'He's in United States; he just decided to stay with his parents.'" And in the same way, I try to explain to myself, "He didn't die; he's in Poland."

We still have in Poland our house, but my parents, they know they want to stay here. It may be strange, but I think that now they are waiting till next September 11th, to see memorial on the great World Trade Center. And especially my father. He often goes to Ground Zero. Maybe not every day, but very often. I know that when we came back from Poland in November, sometimes he didn't tell us anything, but we knew that he went to Ground Zero.

Sometimes for me, the most difficult thing is I have to see my parents' eyes, and they are sad all the time. Even when they are smiling, their eyes feel sad, really sad. I know that my family will never be the same. I am only twenty-three. Maybe some day I will have children, but I know that I will never be happy for 100 percent. It's the same with my parents. When I have to look at them when they are crying, it's like my household is dying.

OFFICER MITCHELL COTO: I'm the only one from my command who was up there the day that the Trade Center fell. And I'm restricted now, because I have a little posttraumatic stress syndrome; the department took my guns. Actually, I voluntarily surrendered them. The people I work with don't really understand what it was like to experience that, so they think, "Oh, you can get over it. You can resume this, you can do that. Why do you feel this way?" Until you're actually standing underneath one of the tallest buildings in the world and have it fall on top of you, and you survive, and you survive this knowing that everyone else perished, you'll never know what's called "survivor's guilt." At the time, and I think up until two months ago, I was still feeling guilty for surviving. Even going back there, a couple of times I went back and I started crying. This is March now, and I still have problems talking about it. I think the worst part will be the one-year anniversary.

Being on patrol after that, most people were loving us but there's still the people that hate us. We've been hated for such a long time, the police department, with all the things that have happened over the last couple of years. The corruption scandals, the beatings, the everything. Everybody feels the aftereffects trickling down. The Rodney King thing—that's three thousand miles away—we were here in vans, waiting for riots to spread out because they were happening in L.A. Then we had shootings. . . . The Diallo thing, that put us in the limelight again. But if you've ever been in a confrontational situation, which those guys felt they were in, and if you've ever been shot at. . . . One year we had . . . there was a poster that said, "Twelve police officers killed this year; one was killed by a bullet." Because the rest of them took their own lives.

Right after the World Trade Center, everybody was loving us. But there's going to be a time that . . . not that it's going to go back to the way it was, but they're going to hate us again, because this will all go away. With time, everybody forgets. It becomes history. People are getting laid off, stocks are falling, people are getting fired all the time—they're going to start hating somebody. And who's the one governmental representative that wears the colors? The police department. Especially transit, because we deal with the public up front. So we become a target for everybody's misery. They're going to hate us to death.

Crime is going up, because it always goes up when things start happening bad. So that's another thing that can be attributed to the World Trade Center, to what these guys did. After that, if you rode the subway cars and you saw a guy wearing a kufi, everybody took a stare; everybody looked. All the Muslims were looked at and . . . and for the most part, they're great people. It's not the Muslims. If you start thinking that way. . . . Look at what's happening now in Israel. You can attribute that to terrorism and 9/11. Because before that, some peacekeeping was going on.

RITA LASAR: We saw the houses that were bombed. We saw the craters that were left. We saw the cluster bombs that were detonated. We saw the women who were widows. We heard the descriptions of people being in their homes and having a bomb come through the window, and seeing a brother and his wife, who had just gotten married, dead. We saw people who had one leg, one arm. We saw shell-shocked children who no longer spoke, who had to be carried, who were traumatized.

Afghanistan is an incredible country that has been at war for over twenty-three years, that has suffered a drought for the last three and a half years. Imagine a sandcastle on the beach where the water comes and reclaims the sand. What you have left is what most of Afghanistan looks like. In Kabul and the outskirts, the people are beautiful, they're resilient, they're smart, and they're sad beyond our belief, justifiably sad. If you look at the eyes of any-body twenty-three or under, you see the same set of eyes. They're huge, they're round, and they're sad. They've known nothing but war. There's a beggar society where there never was one before. Kids are orphans, women are widows. The schools have begun to be open, but there are no desks, no paper, no pencils. There's no heat, no water. There's a curfew every night. The electricity goes off whenever; there's no rhyme or reason for it.

Everybody in Kabul seems to know about September 11th. Everybody is sorry for it, and everybody is glad about what our government did, because it liberated them from a regime that was just adding to more of their grief and sorrow. But what they are hoping is that we won't abandon them again, the way we did after the Russian campaign, that we will stay there, help rebuild, and take responsibility for the erroneous killing of innocents. And what I am about since I've come back from that country is to try to make sure that America takes responsibility for those people. And more than that, to say to the American people: If you want to be safe, stop lying to yourself. Start thinking about why there is such fertile ground for this kind of violence against us, and don't allow the clichés to be your answer, because they're not going to make you safe. Our bombing in Afghanistan hasn't made you feel safe. Being perceived as caring people who have other ways of solving problems is a first step. Entering into dialogue is a first step. Not using our might immediately is a first step.

OFFICER MITCHELL COTO: After September 11th, that same Friday there were protestors, because the U.S. was firing missiles and stuff. And people were protesting against it, and spitting, and as a police officer, I didn't want to march with these people, knowing that I had to go down there pulling. . . . We should be down there pulling people out. Why are you protesting? What gives you the right to protest? I mean, yeah, First Amendment right to freedom of speech, but you're stopping us from doing what we have to do. They had six or seven demonstrations within one week, within the first week. How do you . . . I mean, don't protest. Grab a shovel and start digging.

In the beginning it was great. But then afterwards, man, the people just don't listen. Trying to climb over the fence, just to take pictures. And the bystanders, you would think they would have some type of respect. That was the bad part of going to the World Trade Center to do security. To keep the people from coming in was the hardest job. You had to stand out there in the cold, and people would try to sneak in to take pictures, pretend they were work-ers, all kinds of things. And the foreigners, they'd climb over the fence. If we tried to go after them, we had two or three other people sneaking around us. I think the best thing they did was construct the viewing stand. That actually controlled a lot of it. But before that, it was chaotic. Chaotic.

JOHN CARTIER: My brothers and sisters, we went from going to a meeting that was just for widows of the firefighters, where nobody wanted to talk to us, to meeting the president of the United States. We handed the president a picture of James, and said, "This is our brother; he's not here now because of all this." And the president looked at us and said, "We're gonna get 'em; we're gonna get 'em all." And I believe him.

RITA LASAR: Here in this country, people are very careful about what they say to me because of the way my brother died. So I have not been confronted by very much hostility. But since I've returned, I have been confronted by silence. I can't imagine knowing somebody in my building had gone to Afghanistan, and not knocking on his or her door and saying, "What was it like?" Most of the people who live in this building at most say, "Welcome back," which leads me to understand what they think.

CHRISTOPHER JOHNS: At Harmon Home, we handled close to forty—between memorial services and full funerals—forty for World Trade Center people. And sometimes there were two services for one person. That happened with Keith Roma, who was a fire prevention officer. His family had a huge memorial for him in November. But Mr. Roma, Keith's father, a retired fire prevention officer, kept going up to Ground Zero almost every day to look for his son's body, and he became . . . I don't want to say superstitious, but he would always wear the same gloves, the same boots.

It was right before Christmas, I believe, that he was up there all day, looking, digging, I mean, really working. He got home and got a call that his son was found. He rushed right back to Ground Zero, and said, "You've got to take me to where he was." So they took him down, and within about five feet of where his son's body was found, there was his glove, just sitting there. One that he lost that day.

So the family went through it all over again. But for Mr. Roma, one of the greatest things happened a few weeks after the memorial service. Photographs surfaced of his son carrying people several times out of the World Trade Center. Keith came out, went back in, came out. Now the whole world knows what kind of man Mr. Roma's son was.

MARIAN FONTANA: Everyone says the first year is the hardest. Well, where do you begin to count your year? The day you had your memorial? The day you had to bury them? The day they were found? Or the 11th? . . . You know what I mean? It's not your usual situation. I think I attended fourteen funerals, so I don't think I even had a chance to take it all in. It's not like a regular death where you're just, "My husband died in an isolated way, and then I can live on." It's like, "My husband died, and eleven of his friends, and some friends of my own from Cantor, and just so many. . . ." Actually, it's more than eleven of his friends. There were guys from other fire companies.

There was one point when I was at a wake, and I saw my husband's friends from this other company across the hall. So I was like, "What's going on?" They were like, "We're waking Stevie Harrell." I was like, "Stevie Harrell?" I had no idea. "I thought Stevie Harrell. . . ." "No, he transferred to this company last year, and he was killed." I was like, "Oh my God." So I ended up going back and forth to the two wakes.

FF CHRISTOPHER GUNN: Where we work, being surrounded by the project houses, having a kid from the projects come down with his piggybank with five dollars in it and give it to us, because that's what he could do. . . . Or having a woman in the projects who's got a couple of kids come down with an envelope with ten dollars. She felt bad because "This is all I have." To a person living in the projects, ten dollars could mean eating that week. And to give it up. . . . We even had a cop come with a big watercooler full of change that he had saved his whole career. He must have had twenty years on the job. He came around the corner and gave it to us, in honor of the lost guys. And there was like $1,700 in it. When we told him the final number, I think he almost passed out. He said, "How much?" "Like $1,700 in change." And he gave it up.

JOHN CARTIER: I spent days at Ground Zero on "the hill"; that's what we called it in those early days. You went on a line and they handed you safety equipment, this and that. Then you went to the other line, where you got your bucket so you could go on bucket brigades. They told you, "This is for dirt; if you find any human remains, you put it in the bucket and you pass the bucket down." I may in fact have held the remains of my brother in my hands. I'll never know. But being on the hill made me realize that the skilled tradesmen made that earth move. Nothing could have moved without them. No policeman with his gun or his badge, and no fireman with his fireman hose.

It's been almost six months now, and it never ends for us. Every day is September 11th. Every day. We don't have my brother James. So there's going to come a day when we're going to reach a plateau, another level of heartache as a family. Maybe we're going to receive him in body; his spirit isn't there anymore. But if we receive his body, we'll suffer his homecoming and we'll bury him, put him in a nice place. Personally, I'd like to put him under a tree, so when people go there, they'll have shade and comfort.

But the next stage of our horror is if they say, "Okay, Ground Zero is done." And then we hear from the Medical Examiner, and he says, "No James." How do I face my father and tell him, "I couldn't do what you wanted. I couldn't do it"?

CHRISTOPHER JOHNS: At Fresh Kills, where all the debris was transported and sorted, what they were finding was a lot of bone. Again, just graduating from embalming school and having been studying anatomy, I knew which bones they were finding. Forensic anthropologists identify the bone and, of course, the whole object is to get DNA. There's a special DNA in bones, like the maxillary canal DNA. The bone . . . let's say a femur bone. If you've ever held a femur bone, it's somewhat heavy. Well, at Fresh Kills, you took this bone and you picked it up, and it was like picking up a piece of paper. Instead of being creamy white, it was ash-gray. If you hit it hard, it would just turn into powder.

These people were incinerated in the blink of an eye. You can't get anything out of these bones. You can't. There's nothing in the maxillary canal. It would be like taking ash and trying to get DNA out of it. You know, we cremate bodies at around three hundred degrees Fahrenheit. For the steel at the Trade Center to bend and melt the way it did, the temperatures were in excess of two thousand degrees.

The initial bodies that we got here were the rescuers, who were just going in as the building collapsed. So they weren't people who were already up on the 100th floor or down below in the basement. They were firefighters who just went in. That's why they were recovered quickly. But if it took two months to get a body here at the funeral home, it doesn't mean it wasn't found the very next day; it means they couldn't identify it. It takes eight, nine hours to do a DNA sample. We had to go to private labs that do this work. Now, how do you tell them, "Drop everything you're doing." So it's going to take *years* to accomplish this. Years.

FF JOHN SORRENTINO: We found Joey Agnello on the 30th, December 30th. Some of the guys from our company found him, called the firehouse; we ran down there without brakes. We carried Joey out. And the next morning we found Pete, Pete Vega. Same thing, a few guys down there. . . . That same afternoon I was down there with two other guys, and we found Mark Regan. Made a phone call, everybody came down; we got him out. We found Vernon Cherry's coat, but no Leon. Leon Smith is the only one from Ladder 118 who's still missing.

Pete and Joey are buried in the same plot, right next to each other. And Vernon's grave is reserved, so once we get Vernon between them, they'll rest right next to each other. Which is fitting. We find comfort and the wives find comfort. They died together, they'll rest together. . . .

We had six guys who were working on Ladder 118. All six of those guys died. We also had Marty Egan, who had been a lieutenant here. He was at headquarters, jumped in a car and went down. He got killed. And Lieutenant Bobby Wallace, from Engine 205, he got killed along with three other guys from 226.

Just from where Ladder 118's fire truck was parked, we always figured they were . . . it turns out that where we went every day and dug is where we found them. But we were on a pile forty feet high and we found them twenty feet below ground level. It turns out that they were in the Marriott. There was a picture of the truck going over the Brooklyn Bridge on the 11th that was on the cover of the *Daily News*. And there was an elevator mechanic who worked at the Marriott who read that and got in touch with our firehouse. He was in there with our guys. He said they pretty much emptied the whole hotel, that they formed a human wall. They didn't let anybody exit onto West Street because of all the debris that was falling; they were making everybody leave through that restaurant on Liberty Street.

And this elevator mechanic said our guys were not leaving that building. That it was like that place was the Titanic and they were the band that played on. They were just not leaving until everybody got out. This guy, the elevator mechanic, was still inside the Marriott, but he was in a different spot. Then the South Tower came down and wiped them all out. He got out, those guys didn't.

Could I have stayed in that building? I don't know. Could anybody stay in those buildings, thinking that they might come down? I don't know, but all those guys did.

FF CHRISTOPHER GUNN: I know a guy from Battalion 8, who was in the North Tower when the South Tower came down. You've seen how the stuff blew in? He was in that lobby. He got thrown, literally lifted and thrown like twenty feet under the desk, under the white marble counter. Then he had just gotten outside when the North Tower came down, and it threw him across the parking lot into a fence. He's wondering why he's alive. He can't believe he's alive. He says, "Why me and why not them?" He's like, "Why am I alive? If I'm alive now and I'm not going to do anything good with my life, God saved me for no reason."

A lot of them, they feel guilty that they're alive. It's a lot to deal with. Once I get back to the firehouse, I really have to sit down with each guy who was there and say, "How are you? Honestly. Me and you alone. How are you? How is it at home? Are you holding it together? Are you holding this in? Are you drinking?" Really. That's my job in the firehouse, to make sure guys are okay. You can't do this job and not be okay. You have to be all right. But there are a lot of guys who aren't. And when they close down the site, and the fact that you're not getting your friends back comes into your head, it's going to be a lot worse.

I just talked to another guy. He's retired, got three-quarters; he was badly hurt in a fire, and he's working for the counseling unit. He's not getting paid, but he's doing it to help out. He can't fight fires any more; he had his back broken. And he was talking to the counseling unit, a friend of his is there, and he said, "We normally get about forty visits a month, and it's usually because of alcohol. . . ." The job orders you. If you get caught D.W.I. or you get into a fight in a bar, they order you to go to counseling. Or if a guy had a fight with his wife, a domestic dispute. So this guy goes, "Now we're getting five hundred guys a month." Those guys are making the phone call and are making the effort to meet with the counselor, and they're telling him, "I've got problems, I can't sleep, I'm having nightmares." I mean, all kinds of things. It's good to know. It was good to hear this guy say, "We're getting five hundred guys a month."

DAVID PAGAN: I remember running into buildings when I was maybe fifteen years old, in the south side of Brooklyn, where the Williamsburg Bridge is. That was a Spanish area that was really ghetto, really bad in the seventies. The Jewish flats—that's what we called them—were on fire. And I remember going into flames, I remember pulling people out of there, I remember coughing, I remember falling out. I remember firemen . . . when I woke up, the firemen had the mask on my face telling me, "What are you stupid? Are you crazy? Why did you run in there?" I remember going up the fire escape, and jumping off the fire escape. It was so hot, my sneakers were burning.

So it's not that I was afraid to go by the Twin Towers. Still I kept saying, "Why didn't I go?" Then as I saw everything unfolding and unfolding from up on the roof, I kept feeling that maybe I wasn't meant to go. Maybe I was supposed to see what happened. I don't know.

I'm not a person that's afraid. If I see a car that's crashing, that's on fire, I'm the one that goes and helps. If someone's in the water drowning, I'm the one that don't know how to swim, but I would jump in the water.

I did my part, but I felt I should have done more. Was I supposed to do more? I don't know. I don't feel too bad that I didn't run into the buildings to help people. A lot of Christians tell me, "God has his plan. Your job was to do what you had to do and see what you had to see and that was it. You couldn't do anything else. No more, no less. You did what you were supposed to do."

Kamila Milewska: I can't understand why I'm dreaming about Lukasz all the time. My mother said, "Maybe you are not praying, and he wants you to pray for him." Before September 11th, I lit candles, sat and prayed for my grandmother, for everyone, and now I can't pray. I can't pray. Because I feel that if I start to pray, it's not honest. Like saying something, but you don't believe in it. But I was dreaming about him so many times, so many nights. I remember one dream that when I woke up, I felt calm, because during the dream, my brother was so happy. Everything was green and blue. It was in the forest. All the next day I was just smiling all the time. I was just smiling. I liked this dream, because I am so afraid that some day I will . . . well, not forget about my brother, but it will be not the same. Because now I remember him clearly: his eyes, his mouth, everything.

Lt. William Ryan: I have the craziest dreams. I slept the other night, but most nights I don't get all the way through; I'll wake up a couple of times. The one thread that seems to run through all my dreams is I'm in a confined space. I'm trapped. I was in a spaceship trapped, I was somewhere else trapped, I was in a hole, a bird on me . . . very weird. Just trapped. The dreams wake me up all the time.

I took this detail at headquarters, not realizing one of the jobs there is World Trade Center Family Notification. We're the first link when they identify a body part, the ones they've got to call to notify the family. Like, holy shit! I can't get away from this!

It's hard for everyone. The reality is setting in. And then the other thing that's going on is all this money crap. It's degrading to the firemen, to the guys who died. It pisses me off. I try not to get involved, but I know a couple of widows, and I talk to them, and they're like embarrassed. What is it anybody's business if they get money, you know what I'm saying? Their husbands are dead. Their kids' fathers are gone. What good is money going to do them? The rest of society seems to want to move on already. "Let's move on, let's move on; it's four months, it's time to move on." Yeah, move on! Hah, good luck. I don't think I'm finished grieving yet.

There's twenty-one funerals they've never had, twenty-one guys they haven't done any-thing for. And there's two hundred-something guys who are unconfirmed dead. They haven't found a bone or a piece of DNA that can identify them. Where are they? The pile is almost gone. Where is everybody? They're all pulverized. That dust cloud. They're all up in that dust cloud that flew over Manhattan and went somewhere else.

FF Christopher Gunn: See, when a firefighter dies, the department picks somebody and makes him a family liaison; they just take you off the chart, and you get paid your regular pay, but you don't have to come to work, you just take care of their family. Whatever they need, wher-ever they've got to go, whatever they've got to do, you do. So I was off the charts. The first month, in September, I was going down to the site, but I guess in October sometime they pulled me off. But my wife will tell you, I was so nasty until I got back down there. I was there Friday night, when we recovered twelve people. I figured the area right behind us was where our guys were, the guys from 207, but when I came back yesterday, that area had been totally cleaned out. And they didn't find them. So I was like, "God. . . . " We were down there with one of the kids' fathers; Kevin Reilly's father, who's retired, is down there digging with us every day. What do we say to this man? "Pretty discouraging day, huh?"

So I went down in March, which turned out to be a better month than February. Just about every day we found people . . . ten, twelve. . . . The night doesn't seem so long when you're finding people and bringing them out and having services. But all the guys we recovered this month were from Manhattan. We're just not finding any people from Brooklyn. There's a good six or seven whole companies that are totally missing. Companies 236, 207, 132, 105, 101, 279. . . . We're like, "Where are the Brooklyn companies? Just show me a tool or an axe." Some guys down there say, "I like to think I'm gonna wake up and find that all these Brooklyn companies have been on the beach all this time. They all just played a joke and went to the Bahamas."

NORMA MARGIOTTA: Harlem was his heart. That was his heart. Engine 40, 125th Street, that was the place where he was happy. It was a tough job, with a lot of kids, poor families. During the holidays, that's when he usually talked about it. He'd go into a building, everything's burned . . . all the toys. He usually didn't talk about the job, I guess not to worry me, but he said they were always running, always running.

There's not a minute that we don't think of him. My daughter, Norma Jean, she's going to graduation, confirmation, father and daughter dances; it's so hard for her. And Charlie, he misses his father. He carries Chuck's cell phone. And my husband was a hunter. Charlie walks around a lot with his hunting outfit on.

Norma Jean, she's all him. She's all him—everything. Personality, the way she's built. She says she wants to be a lawyer, or a doctor; she's not sure. Charlie, he wants to be a detective, solving cases, like on TV. But Charlie's all me. Personality. He's all me. I hope he turns out to be like his father, you know? Big and strong and . . . I mean, Chuck would do anything for anyone, and with Charlie, maybe not. He'll be very careful, very leery of everything. With Chuck, there was no hesitation, even with us in the car. If there was a 911 situation, he would just pull over, always. Women, anything. Men, old men. Change a tire, even if he had to be somewhere at a certain time. His suit on, all dressed up, he would pull over and help. "What the hell are you doing? We have to be at a wedding." "Nah." No, no hesitation.

SUZANNE RYAN: Every day death bells would go off. They went on for a long time. Thirty-five funerals in this parish, Our Lady Star of the Sea, and every time I would hear the bells I'd be like, "Okay, there they go again." And the bagpipes. The bagpipes always reminded me of St. Patrick's Day; that was the day when all the firemen put on their uniforms and . . . now, when you hear the bagpipes, you think of a funeral. . . .Yeah, those death bells.

LT. WILLIAM RYAN: When I was at Battery Park, I was thinking of Tommy Hannafin for some reason. I don't know why he came to mind, but I was thinking of him and his wife and kids, you know, how they're not going to be together. But different things trigger it. It could be a song. If I'm driving my car and a certain song comes on the radio. If I'm watching TV, if I open up a paper and there's a picture of something. Or when I'm on the train, this or that flying over Manhattan. Or I notice the skyline is missing. On the ferry, just the feeling of being on it that day. The ferry is a big one, because I was standing on the bow of the ferry watching that South Tower collapse right in front of my eyes. I swear, when the ferry comes in next to Governor's Island, it comes in straight and then it turns. If it went straight, it would drive right up West Street. And it seems like it was right there. Like, I'm watching it, and the replay goes through my brain in slow motion. I watch ten floors . . . I was standing next to the chief, and nothing was said, it was just like . . . I don't know. I've seen it, I know what happened. I watched it go.I just don't believe it.

KAREN DOWNES SILBERMAN: There are a lot of people who don't understand—people in my own office, who weren't there—because they feel it's time for me to move on. How could I be in the middle of an office and try to explain, "Oh God, I'm getting this feeling"? Or if we go into a crowded restaurant, I don't want to stay there. I have to have more open space. If there's too many people, I can't be there. A loud noise, somebody too close to me. As I read "New Bodies Recovered," that affects me. They recovered one, two, three body parts. That's hard,

too; it sends me over the edge. A beautiful girl. Beautiful, beautiful, just got engaged. They didn't find all of her. They just found her leg.

I can't stand the sound of planes, I can't deal with sirens. The building we're in now, on Park Avenue, it's evacuated at least twice a week. The first week we were there, we had to go down thirty-nine flights. My girlfriend literally had to pull me out of my chair, because I said, "I can't do this again." Then once I got on the stairwell, I was pulling her down.

FF CHRISTOPHER GUNN: I've tried to compare the situation that the families are going through waiting to find their loved ones to something else, like being in wartime, back to Vietnam. Your husband is in the war in Vietnam and now he's MIA, officially Missing in Action. You say, "Maybe he's alive and he's in the jungle or maybe he's in a prisoner-of-war camp, but someday he'll be home." But these wives here know their husbands are dead. These kids know their fathers are dead. But they have no bodies. They're in this limbo stage, just waiting for them to be found. All through this I was thinking, fifty-fifty; there's a 50 percent chance we're going to find them. Now it's getting to be an 80 percent chance we're *not* going to find them. So it's real . . . you know, it's real discouraging.

I know for Maureen, Paul Mitchell's wife, there's nothing she wants more than for me to be down there; she knows I'll do what I can. But what do I tell her? Now I have to start easing her in, preparing her for the fact that we may never find him, or any . . . you know, any kind of fibers, any kind of tool or clothes or anything. She'll have nothing to bury. For her, having a gravesite would mean so much, to have a place to go. . . . She went back to work; she was off a couple of months, but she went back. She had to, for her sanity. Both of her daughters are away, in Boston College. But on the weekends, she goes to the Trade Center by herself. She was there Saturday and she was there Sunday. They have the platform for the families now, but you can't see anything. You're just looking out over a big empty hole. But she knows that's where her husband was last, and that's where she wants to be.

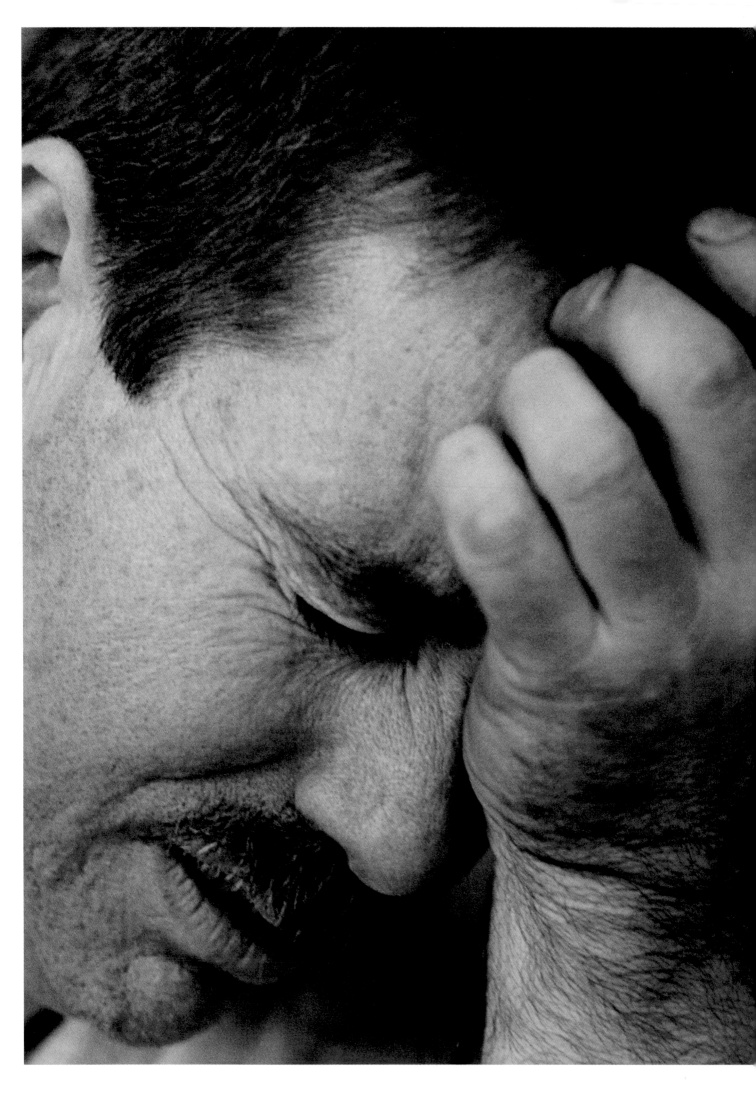

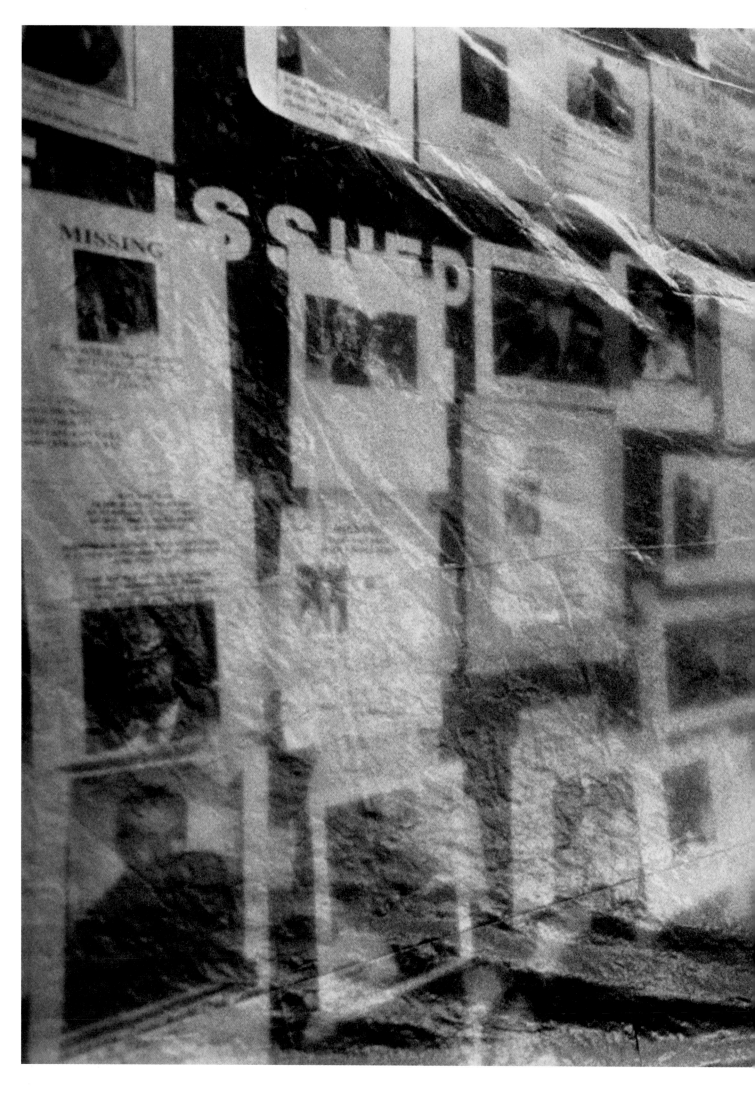

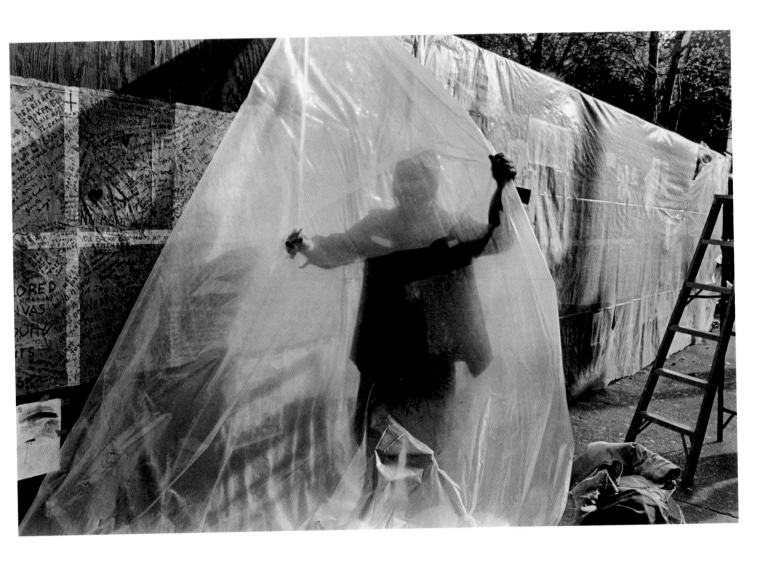

The fires that burned for 99 days are extinguished, much of what had been the World Trade Center has been hauled

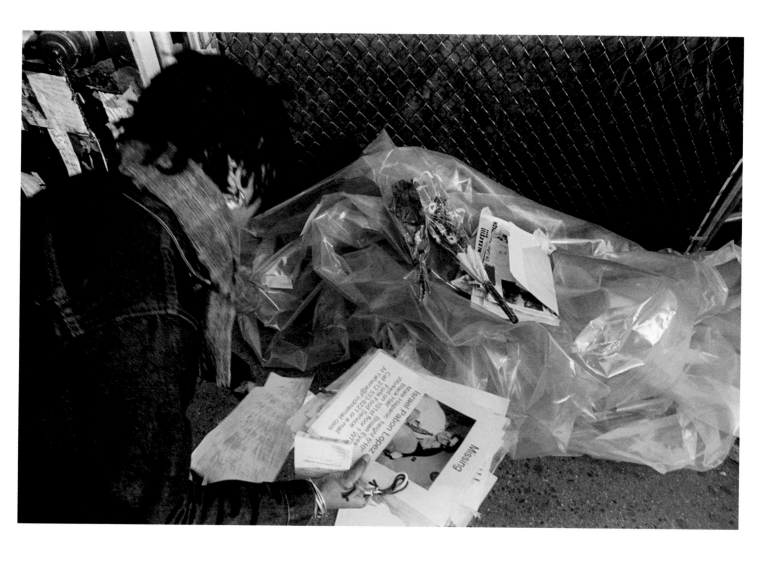

away, recovery efforts are ending. City officials say that 2,672 people are confirmed dead, 158 are still missing.

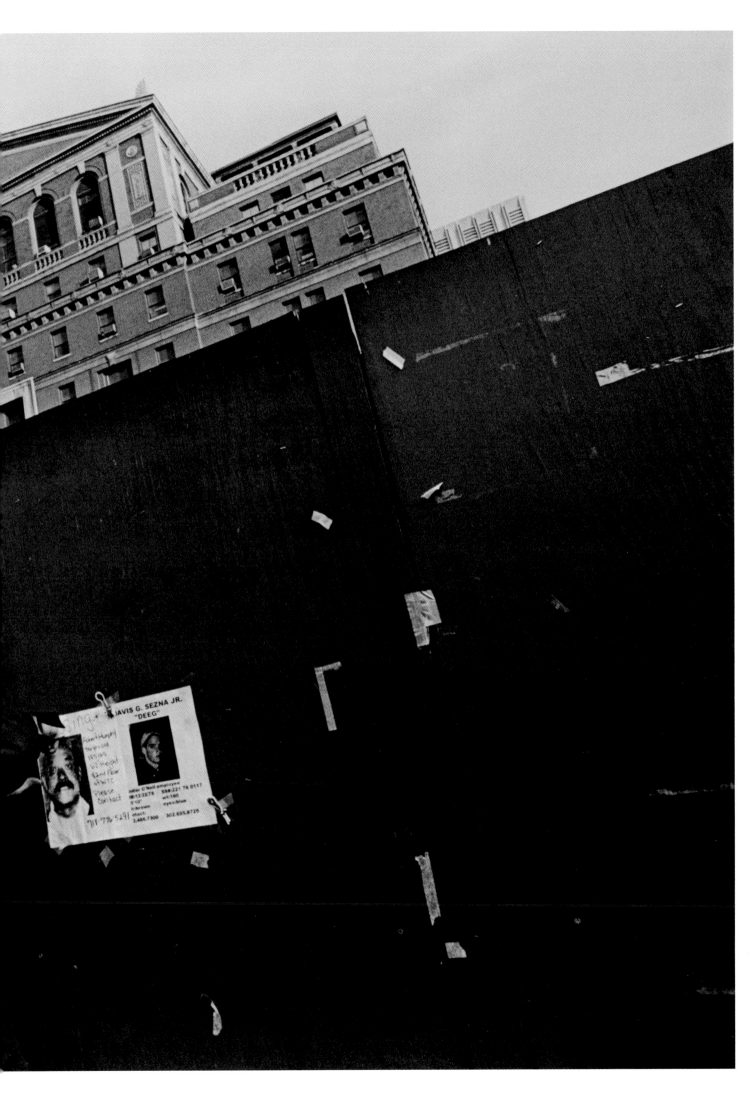

SHTIME IS A SPRAWLING FIRETRAP of a psychiatric hospital located in war-troubled Kosovo. The team of doctors and human-rights activists I was to assist set to work there early the morning of September 9th, 2001. While the administrators and staff were being questioned about their use of electroshock treatments, four-way restraints, and psychotropic drugs, I was ducking into the dismal rooms, leaning over the beds, photographing patients who were crawling, weeping, walking aimlessly about, and lying together in heaps.

Two days later, on the 11th, our group slipped into another psychiatric hospital, this one in Budapest. With the emotions of the last investigation still welling up in us, we were afraid of what we might find. But here, there was no urine smell in the stairways. There seemed to be little overcrowding. There was sunlight; the nearly floor-to-ceiling windows gleamed. And except for the expected Tourette's-like mutterings and cursing of a few patients, it was quiet. Still, we were cautioned to watch for signs. Up until two or two and a half years ago, "unruly" patients were oftentimes confined in dog-sized cages.

As I wandered about the upper floor of the asylum, I was met by the charge nurse. In an apparent effort to avoid the others in my group, she began pointing out "the more interesting patients" to me. The elderly man stumbling across the ward had been a physician. The man staring up at the ceiling had been in a car accident, damaging his brain. "Look close," she said, pointing at a bed in the corner, just inside the door. All I could see was what looked like a clump of bedclothes. "There are two people there. One of them, you might want to know, was born in Auschwitz. Yes, Auschwitz," she added chattily, when I gave her a questioning look. "They've been right here, together like this for ten years, so now they can't be apart."

I heard someone moan; I should have said stop. But I was curious, morbidly so, I suppose. If there really were two whole people under there, they would have to be only knees and elbows, barely a few inches of darkness between them. When the nurse lifted up the covers, I caught a glimpse of a woman in her thirties, napping in a fetal position. The nurse moved to the top of the bed. In a great hurry now, she yanked at the sheet and I got a look at the woman "born in Auschwitz." The poor woman's eyes were open, but she didn't blink. She had thin lips, pulled back over her protuberant teeth, and what seemed, because there was so little flesh on her cheeks, a very long nose. The hair at the back and around the sides of her head looked to have been scraped away with a knife. Contemporary wisdom says there's no such thing as ghosts, so I did some quick math. The Auschwitz death camp was liberated by Soviet troops in 1945. The woman was probably fifty-six, maybe fifty-seven years old. She was my age.

Down a flight was a smaller ward and a recreation room. Twenty or twenty-five patients were gathered there, most of them sitting at a cluster of small tables playing cards with the attendants. You could see out the windows that it was a truly dazzling day, with a brilliant blue sky and swirling patches of light. A man with extremely thick glasses tossed a soft, pink ball at me. I tossed it back, hitting him on the nose. He laughed, and so it went for five minutes, back and forth, until the man lost interest— at least I thought he had—and wandered away, out to where there was a television.

The man had seen what I hadn't, a crush of people at the front of the room who weren't patients. They were my colleagues, Americans, standing with their shoulders hunched, alternately gasping, pointing, clenching their fists. They were clutching onto one another when I came up behind them. Was what we were seeing real? That

thought had to have gone through most everyone's head the first time they saw Tower One furiously burning. Because we were upsetting the patients, causing them to cry, we were escorted down the stairs into a small room where there was another television. We watched the second airplane approaching, then almost everything that happened afterwards.

We'd see them across the street from Ground Zero: people shivering, putting hands to their throats, standing there like they were lost. Because none of them had ever experienced anything as terrifying as this, no one knew what to do. Then, for a brief time after September 11th, New Yorkers did find some solace in trying to comfort one another. We knew that the man right next to us on the subway and the woman on line in front of us at the store had to be having some kind of trouble getting through the day, because we were. So we'd ask them—oftentimes complete strangers—how they were feeling. "You sure you're okay? You sure?"

One afternoon, around the 20th of September, the clerk at a neighborhood bodega asked me if I was feeling all right. She looked me right in the eye as she said this, and I responded not the way I should have, but as if I'd been burnt with a match. "Don't know," I replied. And that's all I said, for I was taken aback that the way I'd been feeling was showing on my face.

Immediately after the terrorist attacks on New York and Washington, all international air travel was canceled. I was stranded. First in Budapest, then, when I couldn't get a flight home from there, in Vienna, where I was put up in a pension that had these stubbly white walls that somehow—as the hours and days ticked by—became like movie screens for me. I could see horrible things on them: the hijacked planes exploding, people tumbling from roofs, other airliners darting under the radar and sweeping up the Hudson River toward the city. Hour after hour I tried calling my home in Brooklyn; the lines were jammed. I did finally get a call through to a friend in Boston, and learned that Sam and Janine were okay. Still I seldom left the room, fearing that someone with new, more dire information might call me while I was out. The TV—I kept that on day and night, so that I saw the towers falling, falling, maybe a thousand times.

After four days, I did manage to get home, but then I scarcely ventured out. What I'm saying is that once I was home, I—the career photojournalist, still healthy and traveling to tough places—metamorphosed into a bruise. Janine would ask me to come and take a look at the city from the river; I would reply that I couldn't. She'd suggest that we make our way downtown; I'd remind her that the police had closed all access roads into Ground Zero, declaring it a crime scene. She'd suggest that we needn't go all the way down there, just somewhere close so that we could learn something more about what was happening. I'd ignore her. "For just a few minutes," Janine pleaded. So late one rainy afternoon, feeling the guilt of someone who hadn't been doing his job, I followed her into Manhattan on a subway that stopped just blocks from Ground Zero.

It was bewildering, all the gloom, the acrid odor, the police blocking our every step, the smoking ruins that reminded me of Hiroshima, Sarajevo, Beirut, the cranes like praying mantises, the emergency vehicles rushing past, the vast swaths of emptiness, the missing-persons posters. In the midst of the impersonal vastness of Manhattan hung thousands and thousands of portraits of people who had disappeared in the attacks. Taped on the walls of hospitals, on bus shelters, on mailboxes, telephone booths, newsstands, light poles, were copies of graduation pictures, wedding pictures, pictures taken on vacation, pictures that had been lifted from family albums, then cut or cropped with great care to reveal what was most individual or

memorable about the people: the way they smiled, the way their hair was parted or framed their faces, their baldness, the distinctive shape of their eyes, the color, hue, and shine of their skin, their tattoos, moles, scars, their overall demeanor. There was a portrait hanging on the wall over at St. Vincent's Hospital of a young woman named Catherine. Catherine had a smile that spanned the width of her face. The picture next to hers was of a very shy-looking man named Joe. While Catherine appeared wholly confident in her portrait, Joe seemed to be someone who wouldn't have had his picture taken except for the baby in his arms.

The posters, then, weighed heavily on our minds. Over the next few months, Janine and I spent I don't know exactly how many hours on the streets of lower Manhattan and on a roof peering into the piles of rubble that were still exuding an alien, sour-yellow smoke. We visited families who were in mourning and attended memorial services for fallen firefighters—ten of them in all, which isn't really that many, considering. Except that Janine would cry so much during them that I'd have to lead her to the car.

It was out on Staten Island, at one of those services, that I first met Lt. Bill Ryan. I was being careful that morning not to get in the way, after being punched outside of a church only a few days earlier by a senior-looking firefighter, who needed, I suppose, to punch someone. It was my tentativeness, what Bill called my "respectful behavior," that prompted him to pick me out of a group of photographers. He asked me if I would make a picture of the fallen lieutenant's helmets. "They're up at the altar. For Chuck Margiotta's family," he said, leading me inside the church.

After that, Bill began telephoning every once in a while "to get his mind off of things." Then what do you think we'd talk about? I'd recount a news report about the rising number of civilian fatalities in Afghanistan (as many as five thousand), and Bill would reply in a near-whisper that twenty bodies were recovered just last night down at "the pile." Then before we'd hang up, we'd joke that each of us ought to bill the other for psychiatric services.

Bill phoned us on a Friday night to tell us that he'd been scheduled to have surgery, something to do with his neck and shoulders. Digging and searching down at Ground Zero, he'd inflamed earlier, on-the-job injuries. On top of that, his doctors now have him taking five or six medicines for the stuff that's clogging up his throat and lungs. What he didn't mention then were the nightmares he's having that aren't really nightmares. They're memories, of the walls closing in, of finding body parts, of being unable to breathe in the thick smoke, of stumbling across a landscape that had the look of a huge bomb crater one minute, a wound that he could see right into the next.

Tonight, if I were to choose one photograph out of all that I've taken that begins to express what it means to have survived the attacks of September 11th, it would be the one I made of Bill and his infant granddaughter. In the picture, Bill has his head back, all the way back out of the frame, as if he'd just been pushed or punched, which in fact he had been, by the force of what he'd been saying to Janine at that moment. In a voice going hoarse and shaky, Bill was explaining how desperately he had wanted to believe there would be people found alive after the terrorist attacks. But despite all the backbreaking digging, despite the sacrifices made by the cops, the volunteers, the construction workers, and the firefighters, despite all the prayers, no one was found alive down at "the pile." After the first day, no one. "Yet, that's our job, isn't it, saving people?" And as Bill was saying this, in effect putting the blame for what had happened on himself, he reached down and tentatively, wistfully caressed the head of that perfectly beautiful baby.

—EUGENE RICHARDS

PERSONS INTERVIEWED
(in order of appearance)

KAREN DOWNES SILBERMAN: executive secretary at Aon Re, Inc., mother of ten-year-old Ashley

MARIAN FONTANA: widow of FF David Fontana, writer, president of 9–11 Widows' and Victims' Families Association, mother of six-year-old Aidan

DAVID PAGAN: buildings restoration worker, assistant to Bricklayers Union foreman Steve Spavone

FF CHRISTOPHER GUNN: firefighter for ten years, assigned to Brooklyn Ladder Company 110, "The Tillary Street Tigers"

JOHN CARTIER: "big brother looking for his younger brother, James"

PAUL KRIEG: equity trader, former trader for Sovereign Capital Partners on the floor of the American Stock Exchange

NORMA MARGIOTTA: widow of Lt. Charles (Chuck) Margiotta, mother of fourteen-year-old Norma Jean and twelve-year-old Charles Vito Margiotta II

LT. WILLIAM (BILLY) RYAN: firefighter for twenty-three years, assigned to Staten Island Ladder Company 85, currently on light duty at headquarters

OFFICER MITCHELL COTO: police officer for fourteen years, NYPD Transit District #30

ARJAN MIRPURI: retired businessman and proud father of Rajesh Mirpuri

STEVE SPAVONE: foreman in Bricklayers Union doing buildings restoration work

SUZANNE RYAN: wife of firefighter Lt. William Ryan, mother of four children

CHRISTOPHER JOHNS: funeral director at Harmon Home for Funerals, Staten Island

KAMILA MILEWSKA: student, Polish national, sister of Lukasz Milewski

RITA LASAR: retired businesswoman, pacifist, sister of Abe Zelmanowitz

MICHAEL HENDERSON: General Manager—Marine Terminals, Metal Management Northeast

WARREN JENNINGS: General Manager—Special Projects, Metal Management Northeast

FF JOHN SORRENTINO: firefighter for eleven years, assigned to Brooklyn Ladder Company 118, "Fire Under the Bridge"

CAPTIONS

page 3 Children near Ground Zero, trying to shield themselves from the acrid air

pp. 4–5 "Graffiti" left by passersby in the plaster- and bone-laden dust

pp. 6–7, 8–9 Reflections of the ruined buildings

pp. 10, 11 A sale underway inside one jewelry store, wary onlookers watch from another shop

pp. 12–13 What the searchers call "the pile," the media calls "Ground Zero"

pp. 14–15 For sale: a dust-covered snow globe of the city as it once was

p. 25 The exterior framework of a fallen tower

pp. 26–27 Onlookers on Broadway

pp. 28–29 While some onlookers weep, others call for revenge; this group from Massachusetts prays

pp. 30, 31 The air is warm, thick as fog, sour yellow

pp. 32–33 Hollowed-out buildings, reminiscent of past wars

p. 35 Staten Island ferry running through the fog toward Manhattan

pp. 36–37 A reflection in the window of the ferry of the city's new skyline

pp. 38, 39 The remains of a tower seen from Broadway; the Commodities Exchange seen from Greenwich Street

pp. 40–41 View from a roof above Ground Zero

pp. 42–43 Grapplers tear at the rubble around the Commodities Exchange

pp. 44, 45 Shattered beams begin to resemble bones, cranes resemble gigantic insects

p. 46 The remains of an elevator shaft

p. 47 A clawlike shovel the size of a truck

pp. 48–49 Missing-persons posters at the VA Hospital, Manhattan

pp. 50, 51 Poster for thirty-two-year-old mother-to-be Deanna Galante

pp. 52–53 Rita Lasar, who lost her brother Abe Zelmanowitz in the attacks

pp. 54–55 Poster for Erick Sanchez, who worked on the 86th floor of the World Trade Center

pp. 56–57 Poster for Judy H. Fernandez and Maria Santillan, hanging at St. Vincent's Hospital, Manhattan

pp. 58–59 Rita Lasar, recounting her journey to war-torn Afghanistan

pp. 60, 61 Posters at St. Vincent's Hospital for the return of a firefighter; for Joe Roberto

p. 63 Posters for Lukasz Milewski and Mario Nardone in the shadow of the Flatiron building

pp. 64–65 The family of Lukasz Milewski

ACKNOWLEDGMENTS We wish to thank construction worker Rory Walsh, photographer Jason Eskenazi, retired NYPD Transit officer Cynthia Gorrin, realtor Patrice Mack, caregiver Lauren Murduca, and former teacher Susan Faistl for their friendship; Dave Metz and Canon USA for their generous loan of lenses; Warren Jennings of Metal Management Northeast, Steve Shinn of Hugo Neu Schnitzer East, Rudy Wohl of Weeks Marine, Jennie Farrell of Give Your Voice, and building manager Eddie Pichardo for their trust in us; Greg Garneau of the National Press Photographers Association, Wendy Tiefenbacher of *Modern Maturity*, Kathy Ryan of the *New York Times Magazine*, Diana Stoll, Ted Panken, and Steve Baron for their professionalism; our assistant Heidi Zeiger and our son Sam Richards for their technical and research assistance; Melissa Harris for making the book possible, Wendy Byrne for her patience and guidance, Aperture's staff for undertaking this book at a most difficult time of transition.

Deepest gratitude to those people who took the time to speak to us about the events of September 11th; to those who invited us into their homes, churches, and places of business; to the survivors and to the fallen whose lives continue to inspire us.

The timeline of *Stepping Through the Ashes* was drawn from the following websites: www.guardian.co.uk, www.september11news.com, www.timesunion.com, www.abcnews.go.com

The production of *Stepping Through the Ashes* was supported, in part, by the NPPA/Nikon Sabbatical Grant and Many Voices, Inc. Additional support for the Aperture exhibition was provided by The Honickman Foundation.

Printed in China by C & C Offset Printing Co., Ltd

Book and cover design by Eugene Richards

The staff at Aperture for *Stepping Through the Ashes*:
Janice B. Stanton, *Interim Executive Director*
Melissa Harris, *Editor*
Wendy Byrne, *Design Consultant*
Stevan A. Baron, V.P., *Production*
Lisa A. Farmer, *Production Director*
Diana C. Stoll, *Copyeditor*
Andrew Hiller, *Associate Editor*
Michael Famighetti, *Assistant Editor*
Bryonie Wise, *Production Assistant*

Aperture Foundation publishes a magazine, books, and portfolios of fine photography and presents world-class exhibitions to communicate with serious photographers and creative people everywhere. A complete catalog is available upon request.

Aperture Customer Service: 20 East 23rd Street, New York, New York 10010. Phone: (212) 598-4205. Fax: (212) 598-4015. Toll-free: (800) 929-2323. E-mail: customerservice@aperture.org

Aperture Foundation, including Book Center and Burden Gallery: 20 East 23rd Street, New York, New York 10010. Phone: (212) 505-5555, ext. 300. Fax: (212) 979-7759. E-mail: info@aperture.org

Aperture Millerton Book Center: Route 22 North, Millerton, New York, 12546. Phone: (518) 789-9003.

Visit Aperture's website: www.aperture.org

Aperture Foundation books are distributed internationally through:

UNITED KINGDOM, EIRE, SOUTH AFRICA: Aperture c/o Robert Hale, Ltd., Clerkenwell House, 45-47 Clerkenwell Green, London EC1R OHT, United Kingdom. Fax: +44 (207) 490-4958. E-mail: enquire@hale-books.com

WESTERN EUROPE, SCANDINAVIA: Nilsson & Lamm, BV, Pampuslaan 212-214, P.O. Box 195, 1382 JS Weesp, Netherlands. Fax: +31 (29) 441-5054. E-mail: info@nilsson-lamm.nl

AUSTRALIA: Tower Books Pty. Ltd., Unit 9/19 Rodborough Road, Frenchs Forest, Sydney, New South Wales, Australia. Fax: +61 (29) 975-5599. E-mail: towerbks@zipworld.com.au

NEW ZEALAND: Southern Publishers Group, 22 Burleigh Street, Grafton, Auckland, New Zealand. Fax: +64 (9) 309-6170. E-mail: hub@spg.co.nz

INDIA: TBI Publishers, 46 Housing Society, South Extension Part-I, New Delhi 110049, India. Fax: +91 (11) 461-0576. E-mail: tbi@del3vsmp.net.in

To subscribe to *Aperture* magazine write Aperture, P.O. Box 3000, Denville, New Jersey 07834, or call toll-free: (866) 457-4603. One year: $40.00. Two years: $66.00. International subscriptions: (973) 627-2427. Add $10.00 per year.

First Edition
10 9 8 7 6 5 4 3 2 1